ERTÉ
AT NINETY-FIVE

THE
COMPLETE
NEW GRAPHICS

EDITED BY MARSHALL LEE

WITH

INTRODUCTION

BY

E R T É

Preface by David Rogath
and Leslee Halpern-Rogath

A Balance House Book

E. P. DUTTON
New York

Published in the United States by E. P. Dutton,
a division of NAL Penguin Inc.
2 Park Avenue, New York, N.Y. 10016
Library of Congress Catalog Card No. 87-70331
ISBN: 0-525-24560-X
ISBN: 0-525-24612-6 (Limited Edition)
CUSA
Published simultaneously in Canada by Fitzhenry & Whiteside
Limited, Toronto

10 9 8 7 6 5 4 3 2 1

FIRST EDITION

Design: Marshall Lee
Printed in Italy by Amilcare Pizzi, S.p.A.

We acknowledge with gratitude the generous cooperation
of Salomé and Eric Estorick in making
available Erté materials used in the preparation of
this book.

Erté graphics © Sevenarts, Ltd., London

The photographs in the Introduction were taken by
the following: David Lubarsky, pages 9, 10, 11, 12 top;
Leslee Halpern-Rogath, pages 12 bottom, 21, 22;
Richard Benson, page 14 top; Carlo, page 14 bottom.
Eric Estorick, page 17

Contents

Preface
David Rogath
Leslee Halpern-Rogath

7

Introduction by

E R T É

9

T H E

G R A P H I C S

23

Chronology

185

Bibliography

187

Index
Alphabetical list of the works
with technical data

189

EDITOR'S NOTE

Of the 163 Erté works reproduced in this book, by far the largest number, 107, were published by Chalk & Vermilion Fine Arts, Ltd., New York, directed by David Rogath and Leslee Halpern-Rogath. All of these prints are serigraphs, most of them augmented by other graphic techniques. Of the remaining works, 20 were published by Sevenarts, Ltd., London; 7 by Circle Fine Art, Inc., New York and Chicago; 19 by Wellsart, Ltd., New York; and 10 by Kane Fine Art, Ltd., Stamford, Connecticut. The particular works issued by each publisher are identified in the Index, which provides the technical data for each print. At this time, Sevenarts and Chalk & Vermilion are the exclusive publishers of Erté graphics.

M.L.

Preface

A few years ago we took Erté to see Nureyev dance in *The Afternoon of a Faun*. We were fascinated to learn that Erté had attended the ballet's first performance, in 1913, with Nijinsky dancing the faun. He remembered that performance, including the costumes and set designs, in incredible detail. Erté remarked that Nureyev gave a very different performance from that of Nijinsky but Nijinsky's rendition of the role had certainly changed as time passed. It is significant that Erté's treatment of certain images also has changed during his career, and that as he created versions of these images in different mediums, the characteristics of those mediums guided his treatment.

When Chalk & Vermilion was given a contract in 1982 to publish Erté's graphics, the artist's directions were very specific: he wanted to expand the variety of his imagery and to explore the technical potential of the graphic mediums.

Erté's progress to these ends was expedited by an important innovation—the use of black paper. Initially we were interested in black paper because it solved a problem that has always vexed print dealers—serigraphs with large areas printed in black damage easily. At the same time, Erté was pleased that he could now more readily emphasize the importance of black in his work. Ultimately, the decision was justified by the spectacular results. The black paper provides a much denser background than printed black, and seems to create a visual vacuum that greatly accentuates the printed areas.

To accomplish Erté's aesthetic objectives it has been necessary to extend the technical limits of the serigraph process and to utilize additional techniques, such as embossing and hot-stamping—which have also been stretched to their technical limits and beyond. Some of these methods were used in earlier graphic works by Erté, such as *Samson and Delilah* and *Salomé*, but it was not until the period covered by this book that the artist made a concentrated effort to exploit fully the available techniques. This effort was encouraged and expedited by Erté's agents and our good friends, Salomé and Eric Estorick.

We are told of a fruit that is both sweet and tart, which has a taste that brings to mind the flavors of many others but is still unique. Erté's imagination has created a similarly elusive concoction for his graphic works, and we who participate in its production feel privileged indeed.

David Rogath
Leslee Halpern-Rogath

Introduction

by ERTÉ

I am delighted that a book about my new graphics, which were created between 1982 and 1987—that is, since the publication of *Erté at Ninety*—is now appearing, in my ninety-fifth year. When I compare my early graphics with those I produced during this period and those on which I am presently working, I am struck by the advances I have made in this medium. To a large extent, these advances are related to the development of new printmaking techniques. In the last few years the art of serigraphy has developed substantially. New processes involving the use of embossing and multicolored foils applied by hot-stamping have been perfected. Embossing, especially, has made it possible to achieve effects of sensational subtlety.

Serigraphy, also known as silkscreen printing, dates back to the early Chinese. More recently, it has been used for its ability to apply bold motifs and colors to posters, banners, and all kinds of packaging and display materials. During the Depression, a U.S. Government project encouraged fine artists to experiment in this medium. The results revealed a new range of technical possibilities that aroused great enthusiasm for the process. In fact, no other medium can produce prints with such detail and color intensity.

The steps involved in making my serigraphs are many and difficult. The artist first creates an original work called a maquette. My maquettes vary from very detailed and complete paintings to simple black-and-white drawings with color indications. Almost invariably I make my serigraphs larger than my original drawings. When the maquette is completed, I discuss with the silkscreen printer the color characteristics and the additional techniques that I wish to use for the edition.

The fifteen to twenty-four colors used in my serigraphs must be separated individually. To do this, a very skilled person traces the

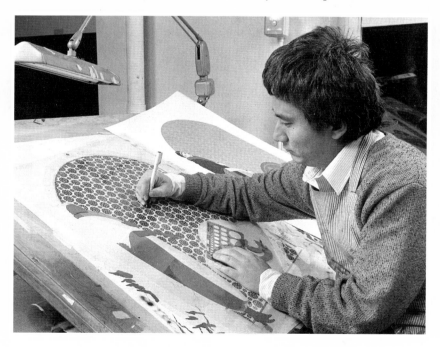

Making a color separation for Emerald Eyes

areas of each color onto a clear polyester sheet with an artist's brush, or occasionally an airbrush, crayon, or sponge. These sheets vary in texture according to the desired effect. It takes months to create all the polyester sheets for one image, and if I make changes on the proof, the process must be repeated in part or in whole.

The separations are then translated into stencils on screens. (These screens used to be silk but are now fine-gauge polyester.) Each screen is coated with a light-sensitive emulsion and exposed to light through the polyester sheet. Where there is no mark on the sheet, the light passes through and hardens the emulsion. The screen is then

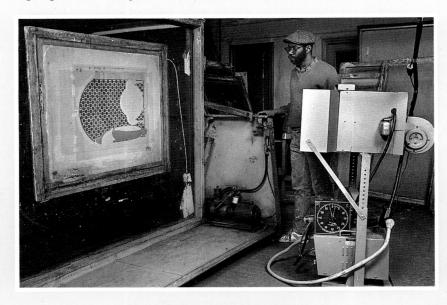

Exposing the separation onto the screen

washed, leaving the nonprinting areas solid and the printing areas open to allow ink to pass through. This is repeated for each color.

The printing is done by squeezing ink through each screen onto the paper below. A complete trial proof is made before the edition is printed. Some images are almost perfect in the first proof; others require many corrections and changes.

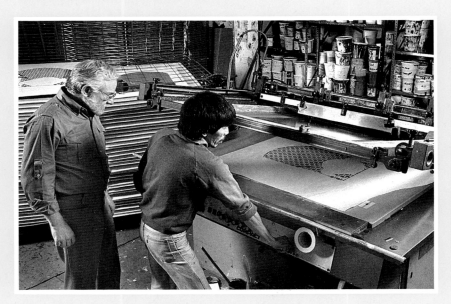

Printing a color under the supervision of Jackson Lowell of Chromacomp. The hinged top holds the screen. When the top is down, the blade above it squeezes ink through the screen onto the paper below. At left are racks for drying the printed sheets.

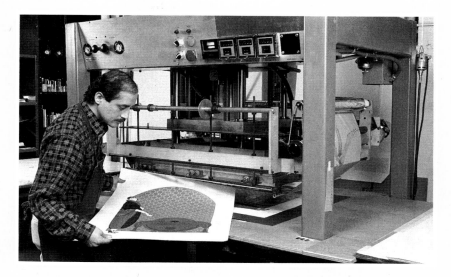

Inspecting a print coming off the hot-stamping press. Note, at right, the roll of foil on the end of the press.

The steps needed to produce a good serigraph proof are intricate and difficult enough. However, in order to achieve the effects that I want it is sometimes necessary to subject the fragile silkscreen print to additional procedures that involve considerable risk of damage. In hot-stamping, heat and pressure are used to make metal foil adhere to a printed image or to the paper. Since the high-quality rag paper that I use for my graphics is more difficult to stamp than the smoother machine-made paper, special techniques had to be developed to make the hot-stamping work properly.

When Chalk & Vermilion started publishing my prints, the available hot-stamping machines were not sensitive enough to create all the effects that I contemplated. At our urging, Jackson and Eunice Lowell of Chromacomp, Inc., in New York, who have printed most of my serigraphs for Chalk & Vermilion, designed a machine that could stamp large images, up to 24″ × 36″, without destroying the underlying delicate serigraph. (This is roughly equivalent to designing a gown of stainless steel and taffeta that is both practical and beautiful.)

The technique that has commanded the most attention besides hot-stamping is embossing. Embossing a print gives it a bas-relief effect, which adds a third dimension to the printed and stamped surface. For the embossing of a work like *Diana*, a skilled artisan must work for a month just to sculpt a brass female plate. Then heat and pressure are applied to produce a steel-reinforced plastic male plate molded from the handmade female. The male plate is mounted on the steel bed of the embossing press, and the female is aligned on the hinged platen that comes down on top of the paper. A steel cylinder passes over the platen, applying the necessary pressure to the print between the plates. Here again, the Lowells designed a special machine to achieve my effects.

I continue to require new effects, and the Lowells and their staff of artist-printers have found new ways to achieve them. One of these techniques is the creation of ''three-dimensional'' lacquers and enamels by the use of multiple layers of coarser pigments to achieve a perceptible thickness. This was used for the broad patterns in the borders of *Veil Gown* and *Fringe Gown*, detailed filigree designs in *Hearts and Zephyrs*, and a floating dragon in *Mah-Jongg*. Another special ef-

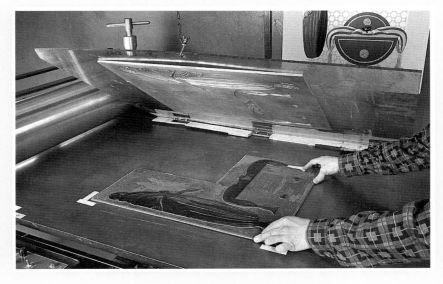

The embossing press, showing the male and female plates

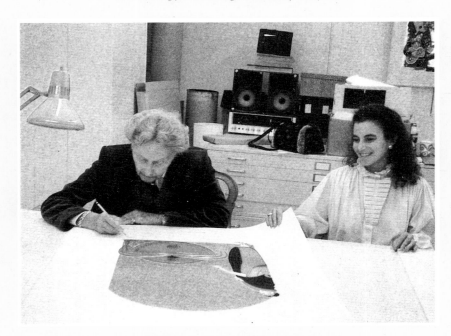

Signing a completed copy of Emerald Eyes

fect is ''shadow printing''. This involves printing a tone where the edges of embossed areas will fall, to enhance the shadows cast by the embossing. A damask effect, such as that in *Spring Shadows*, is achieved by printing over the background color with lines and areas of the same color.

Various hybrid techniques are used for certain images. In *Emerald Eyes*, the background is a ''dimensional'' enamel with an overglaze of the same color to produce a scrim effect. In *Veil Gown*, the alabasterlike translucency of the veils was achieved by using several layers of especially developed transparent ink. The ''pointillist'' background of *Rose Dancer* was created by spattering four colors of paint and then stamping gold and silver in a random spatter pattern.

Many times I have been able to achieve an extraordinary effect only because special techniques were available. In the two *Divas*, I

was able to simulate bird feathers by embossing. Considering the tremendous pressures used in this technique, it is remarkable that it can be controlled with such delicacy as to depict a woman's eyebrows, as in *Rose Dancer*. The effective sunrise in *Statue of Liberty (Day)* was made possible by a ''split-fountain'' technique, in which multiple, blending, colors are printed with a single screen. Combinations of special techniques helped in creating waves in *Statue of Liberty*, fur in *Fox Fur*, and brocade in *Rigoletto*.

Creating graphics for two decades has been an ever-challenging experience. During these years I have learned a great deal about modern methods of printmaking, and so kept developing and expanding my ability to utilize and control these new areas of graphics. As modern methods and techniques have developed, I tried to keep up with them. The need for this awareness has been a challenge to which I have responded with enthusiasm and, I trust, with success.

I started work in the graphics medium rather late in life. I think that graphics (which includes lithographs and serigraphs) is a form of expression that is very close to my heart because it was the medium with which I made my reappearance in the broad, international world of art.

My reputation was already established in 1920 through the reproductions of my designs in various magazines. The first of these was the fashion monthly *Damsky Mir* (Women's World), produced in St. Petersburg. I worked for this magazine after leaving Russia in 1912, sending them my fashion designs from Paris each month. For one year I did fashion designs for the great house of Poiret, and for twenty-two years—from 1915 to 1937—I did monthly covers and illustrations for *Harper's Bazaar*.* During this time and later I did designs for other magazines in various countries, such as *La Gazette du Bon Ton*, *Vogue*, *Cosmopolitan*, *Ladies' Home Journal*, *Illustrated London News*, *The Sketch*, *L'Illustration*, *L'Art et Industrie*, and *Femina*. In between magazine work I executed a steady stream of commissions for costumes and décor for musical theater: the *Ziegfeld Follies*, George White's *Scandals*, the Winter Garden, the Folies-Bergère, the Casino de Paris, the Bal Tabarin, and productions at London's Palladium, Coliseum, Prince of Wales Theatre, and Victoria Palace. I also designed for operas and ballets: the Opéra de Paris, Opéra Comique de Paris, Metropolitan Opera, Chicago Opera Company, Opéra de San Carlo, Théâtre du Palais de Chaillot, Opéra de Marseille, Festival de Lyon, Glyndebourne Festival, and Théâtre de Monte Carlo. Besides all this, there was my work for the cinema and interior decoration.

In 1967, my good friends Salomé and Eric Estorick, who have been my exclusive worldwide representatives for twenty years, organized an exhibition of my works in their New York Grosvenor Gallery. It was an absolute triumph. The Metropolitan Museum of New York bought up the whole exhibition, more than 170 works. It was, I believe, without precedent that a museum bought an entire exhibition of a living artist; certainly it was the first time for the Met. The following year, the museum put on a superb exhibition, including a hundred of these works. At that time the Metropolitan had a rule (since changed) that prohibited one-man shows by living artists. To get around this regulation, they called the show ''Erté and Some Contemporaries'', and included works by Bakst, Goncharova, Dufy, Lepape, Benito, Laurencin, and others.

Some months after the fantastically successful Grosvenor Gallery exhibition in New York, the Estoricks mounted a second one in their

*The original spelling was ''Bazar''. It was not until November 1929 that the third ''a'' was added.

At my ninetieth-birthday party, seated between Claudette Colbert and Gloria Vanderbilt

With Eric and Salomé Estorick and David Rogath

Being photographed by Andy Warhol and others at my ninety-third birthday party, given by Chalk & Vermilion, in the Plaza Hotel, New York

London gallery. It was as successful as the New York show: a sellout. One of the critics wrote: ''If Michelangelo came back to earth, he wouldn't have had more publicity.''

For the London show, the Estoricks wished to exhibit my *Alphabet*, on which I had been working for many years. I was very pleased because this series was a favorite of mine. I thought that I had finished it. Alas, when unwrapping the designs, I found that the ''L'' and the ''Q'' were missing. I set to work designing them straightaway, and finished them just in time for the opening of the show. Wonder of wonders, the lithograph of the letter ''L'' became the best seller of all. Indeed, I think that *The Alphabet* is the most popular se-

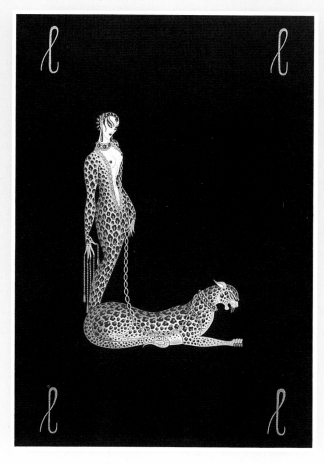

L *from* The Alphabet

ries of drawings I have created. This is fitting, because the theme is very important in my life. Associated with this is my strong feeling for the human body in movement.

Since childhood, when I learned to read and write, I have been fascinated by the alphabet. For me it was a form of design. And when I was an adolescent, I was a balletomane. I had been introduced to the ballet world by my parents, who had a subscription to the ballets and operas performed at the Marinsky Theater in St. Petersburg. From the age of seven I accompanied them every week. I was so taken with the ballet that my parents agreed to arrange instruction for me in choreography, and when I was about twelve years old I took a course in classical dance under the direction of Maria Marioussovna Petipa,

the daughter of the famous choreographer Marius Petipa. From that moment on, I dreamed of becoming a dancer.

Clearly, my parents were not in agreement with this ambition, but nevertheless they thought that a choreographic education would be helpful in my physical development. However, there was never a clash of wills over the matter. After several years of ballet study, and much deep reflection, I decided that I couldn't devote myself to two art forms at the same time, and came to the conclusion that I could live without dancing but I couldn't give up my passion for painting and design. But that period of choreographic studies instilled in me a great love of the human form and its movements. It was my early love of writing combined with my deep feeling for dance that inspired my *Alphabet* of human forms.

Until 1967, my one-man shows contained only original drawings and paintings. Because of the world acclaim the New York and London exhibitions received, the Estoricks suggested that I produce lithographs and serigraphs. They pointed out that with graphics I could reach the very large public that these exhibitions had created.

My first album of lithographs, published by the Grosvenor Gallery in 1968, was on the theme of numbers—zero through nine. I treated the numbers in the same way as the letters of my *Alphabet*, that is, by making them out of the forms of human or mythical characters. *The Numbers* was so successful that it was used subsequently as a basis for the design of playing cards that were commissioned in London by the Gallagher cigarette company for their brand, Sobranie. This version contained new designs for the kings, queens, jacks, jokers, and tens. Every twin pack of cards included a small illustrated book on my life. These packs of cards appeared a few years after my Dunhill playing cards edition in London, which carried designs inspired by the four acts of Verdi's opera *La Traviata*.

On the Dunhill cards, each of the four suits represents one act of the opera. The first act is *Hearts*, the second *Clubs*, the third *Spades*, and the fourth *Diamonds*. Each card is unique, and represents one scene of the opera together with the corresponding music. One joker represents the orchestra and the other the singers. The kings symbolize the images of Rudolpho, the queens those of Violetta. The idea for this design came to me during a rehearsal of the third act of *La*

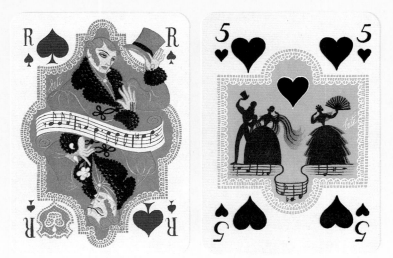

Dunhill playing cards based on La Traviata

Traviata—the card-game scene. The rehearsal was for a production, for which I had designed the décor, at the Opera House in Paris in 1951, to commemorate the fiftieth anniversary of Verdi's death. I worked almost two years on the *Traviata* playing-card idea; each card was a miniature painting, with myriad small details.

I then produced a series based on six precious stones (sapphire, ruby, diamond, emerald, amethyst, and topaz) and another based on the four seasons. These graphics editions were produced for the Grosvenor Gallery by the famous Curwen Press in London. Later I designed four playing-card aces—spades, hearts, clubs, and diamonds—which were produced as lithographs jointly by Berggruen et Cie., Paris, and the Grosvenor Gallery.

The Alphabet, originally done in the gouache-tempera medium, was produced subsequently, in 1976, as graphics. Lord and Lady Beaumont, who had purchased the original *Alphabet*, were prevailed upon to make the set available for a graphics edition when the demand grew for specific letters, and indeed for the entire alphabet. These lithographs were produced in Paris, and a serigraphic black background was added in the United States.

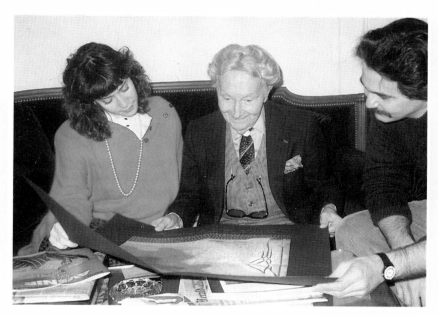

Checking a proof with the Rogaths

While my first lithographs appeared in London in 1968, it was some years before I made my decision to work seriously in graphics. I began this activity with Circle Fine Art of New York and Chicago in 1974, and then in 1982 began working with Chalk & Vermilion of New York. I love my sculpture (a book, *Erté Sculpture*, was published in 1986) and my jewelry no less than graphics, but they are available to smaller numbers of collectors, so I bless the day when Salomé and Eric Estorick pointed a new way in my artistic career—the creation of graphics.

As to the choice of subject matter for my serigraphs, that is never conditioned by questions of technique. Rather, it is the technique that adapts itself to the subjects of my choice. And in that choice I seek variety above all. Sometimes, for ideas, I turn to the cover designs and fashion illustrations I made for *Harper's Bazaar* and my theater cos-

tumes for various productions. But sometimes I use totally new ideas and themes, as, for instance, in *The Numbers*, *The Precious Stones*, *The Alphabet*, *The Seven Deadly Sins*, *Signs of the Zodiac*, *The Four Aces*, and *The Four Elements*. Most of all I like the albums of various graphics that deal with the same subject. Despite their diversity, they are approached with full concern for their unity. This concern is a dominant underlying factor of *The Alphabet*, despite the fact that it was produced over many years.

Two graphics, *Enchantress* and *Circe*, were both inspired by my gouaches in the collection of The Metropolitan Museum of Art in New York; each presented a certain practical problem that frequently arises. In both cases, the original gouache images extend to the edges of the sheet. This could have been the case with the graphics also, but it was not, for two very different reasons. One is that the surfaces of serigraphs are very fragile (especially those that are embossed and hot-stamped) and the blank borders that customarily surround the images provide space for handling. Thus, if the image is printed to the edge it will add to the already considerable possibility of damage. The second reason is simply that I sometimes choose to treat images of the same inspiration differently in different mediums.

The solution I have found to both the practical problem of damage and my inclination to change representations of the same image in different mediums is quite consistent with my artistic principles. For each subject I create columns that surround the image, but I leave blank borders for handling. These columns relate integrally to the costume of the woman in each image by echoing the headdress she wears. One can view this as consistent with a major thread in my fantasies: the costume of the person represented relates to the environment in which the person is situated. (Roland Barthes wrote an essay on this aspect of my work.) I do not find this treatment incompatible

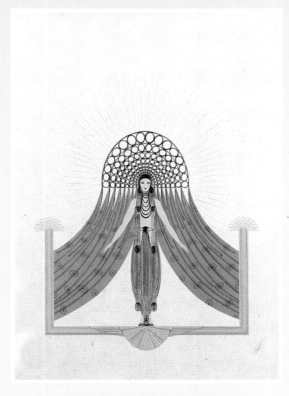

Circe—columns with blank paper borders

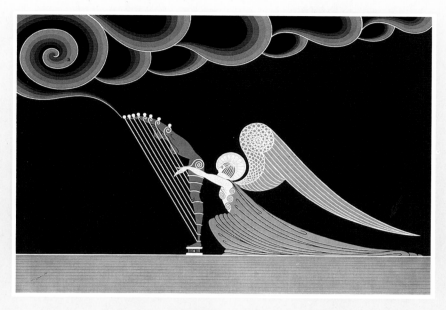

The Angel—*printed to the edge*

with my desire that my designs be practical in their commercial applications. I choose only to consider the physical practicality of each design in such a way as to allow varied and endlessly imaginative settings for each image.

Of course, ultimately the artist's deference to the practical aspects of the business of selling prints must be secondary to the expression of his artistic judgment. Thus, despite the border problems referred to above, *The Angel*, *Mystery of the Mask*, and *The Queen of the Night* all were printed to the edge because it was my judgment in these cases that this was the appropriate way to render the image in the graphics medium.

Many of my collectors have been excited by my ideas regarding treatment of the same image in different ways. For example, in *Emerald Vase* I changed the color of the paper alone, whereas for the two *Diva*s I reversed their relative positions and chose to render a light-skinned *Diva* on a black background and a dark-skinned *Diva* on a white background. Both *Diva*s have a fantastic bird of my own imagination as part of their costume—in fact, holding it up: fantastic and practical at the same time.

The *Statue of Liberty Suite* is an epic story in itself. It took two years and a nearly endless succession of proofs to complete these two graphics. The key problems included the rendering of the fireworks in the night image, the color relationships of the various golds (for example, a bronze gold in the statue and a yellow gold for the sun in the day image), the background silhouettes of Manhattan (abstracted and muted so as not to interfere with the foreground, yet still recognizable), and the treatment of the waves that rise against the statue—implying that Liberty is always threatened from without as she moves upward toward her goals.

My interpretations of the Statue of Liberty are quite stylized and are different from the actual statue both in their appearance and in the position of the statue in its setting. Bartholdi's *Liberty* is static and serene and firmly ensconced on a large island, seemingly impervious to the elements. It is, in fact, a perfect example of nineteenth-century

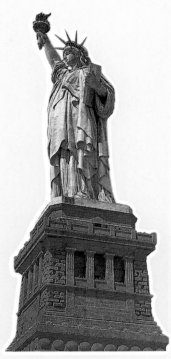

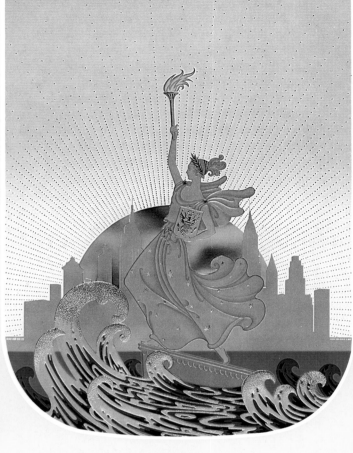

Bartholdi's Statue of Liberty

My Statue of Liberty

French sculpture. My view of Liberty is quite different. I agree with Bartholdi only in his use of a woman as the bearer of this metaphor, but my *Liberty* is the expression of an impetuous movement overcoming all obstacles.

As stylized as my renditions are, however, there is one area where I refused to break with tradition. David Rogath and Leslee Halpern-Rogath suggested that the night image and the day image should face each other. At first this seemed a good idea, since Liberty would then be seen extending her energy in both directions when the two works hung on one wall. At the last moment, however, I decided that Liberty should not hold the torch in her left hand (left in Latin is sinister), so I returned to the present arrangement.

I have often been asked, how long does it take to complete a print from its inception? This is an appropriate question, especially as it relates to serigraph printing, where exceptional circumstances often occur. Before I approved the final version of *The Clasp* I had ordered more than twenty color variations and created and discarded several possible borders that I eventually decided were too distracting. Along the way, my requirements resulted in the development of new printing techniques to achieve the simulation of a woman's evening bag.

A similar, though longer, creative process occurred with *Emerald Eyes*. This image was originally a black-and-white drawing for a 1920

issue of *Harper's Bazar*. In the area above the cat's chair there had appeared lettering stating: ''The World of Fashion Returns to the Beautiful Spas of France'' The colors of the design were no problem, although I changed all the colors that were indicated for the woman's dress in the magazine. The problem that arose, however, was how to treat the too-empty space where the lettering had been. I examined several possible solutions, including various color backgrounds with and without hot-stamping and turning the image into a diptych with components of different size for the woman and the cat. These possibilities and others did not work out, and I did not arrive at a solution until a year later. This turned out to be a textured background that completely integrates the image and makes use of advanced printing techniques at the same time.

Discussing an early version of Emerald Eyes *with David Rogath*

Many of my designs for graphics are completed in a very different fashion. I solved the problem of the path at the bottom of the image of *Wisdom* while I was having tea at Chalk & Vermilion's office. I made the drawing even as we sat there. (To work with the Rogaths is a great pleasure; they are not discouraged by difficulties and are perfectionists to the last detail, as am I.)

I love variety in everything. I loathe wearing the same clothes two days running or eating the same dishes over and over again. I've always loved traveling because it varies the décor of my life. Monotony engenders boredom, and I have never been bored in my life. There is only one thing that has never varied in my habits, and that is my way of working. For that I always need complete solitude, save for the presence of my two cats, Caramelle and Talia, who pretend to be sleeping at my side, but in truth are watching me like hawks. There must be classical music in the background—Bach, Beethoven, Schubert, Mozart, Chopin, Schumann, Brahms, Liszt, Debussy, Ravel. The only light in my workroom is the one that shines on the sheet of paper on which I am drawing.

Erté doesn't let me lie on top of his work

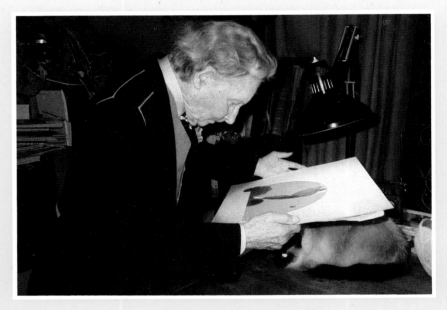

. . . so I lie under it.

Look at me. I'm in another world—a dream world that invites oblivion. People take drugs to achieve such freedom from their daily cares. I've never taken drugs. I've never needed them. I achieve a high through work. Indeed, if by chance the telephone rings, it takes me a while to come down to earth again.

I hope that I shall have the energy to continue dreaming solutions to the various creative and technical problems that I have been facing all my creative life and will confront in the future. For me, creativity is life.

THE
GRAPHICS

EDITOR'S NOTE

The titles of the works are given in English, French, Italian, and German in that order from top to bottom. Erté often gave his prints French titles; for those titles the French appears in both the English and French positions. In some cases, the orginial title is a word or phrase that has been adopted by another country, so for that language the title is given in the original form (e.g., *Tuxedo*). Where a print is part of a series, the series title is printed on the page.

M.L.

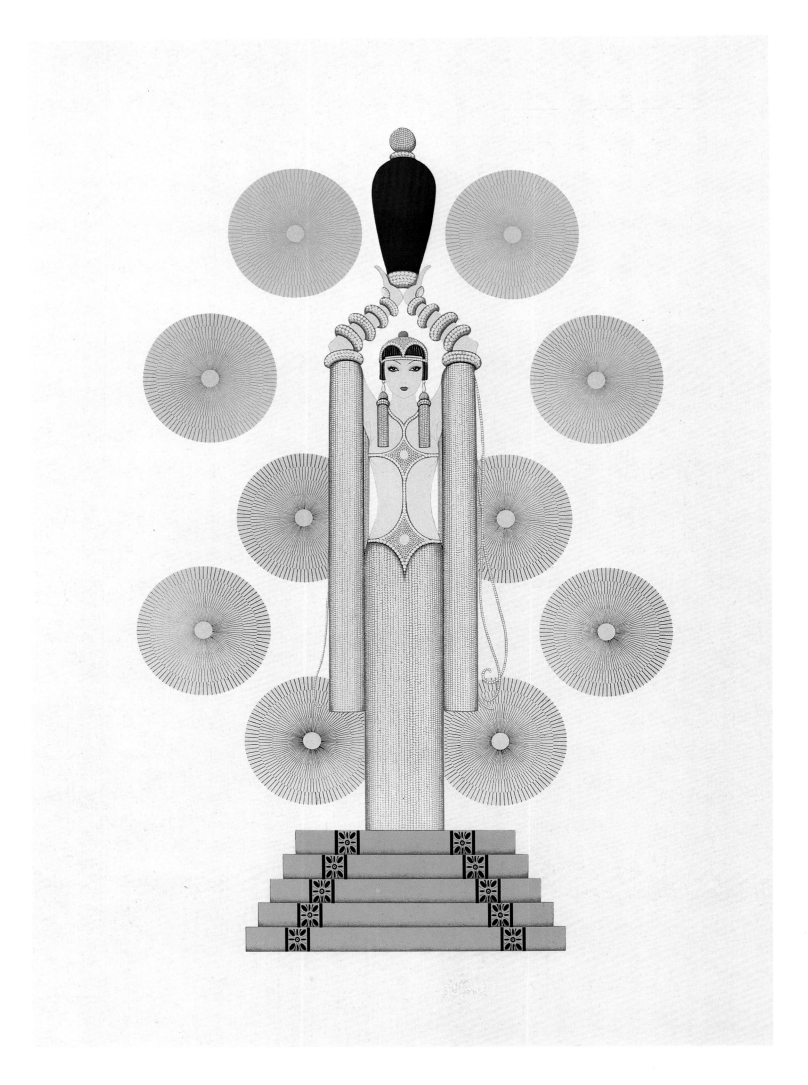

Emerald Vase I
Vase d'émeraude I
Vaso di smeraldo I
Smaragdvase I

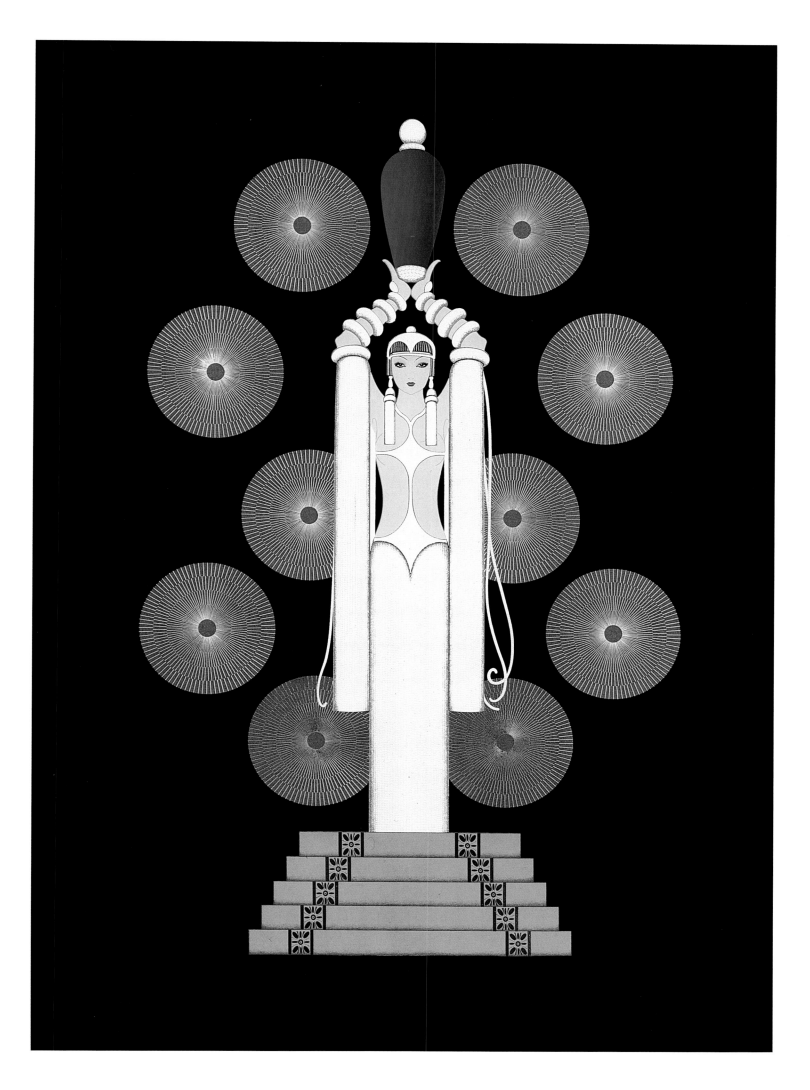

Emerald Vase II
Vase d'émeraude II
Vaso di smeraldo II
Smaragdvase II

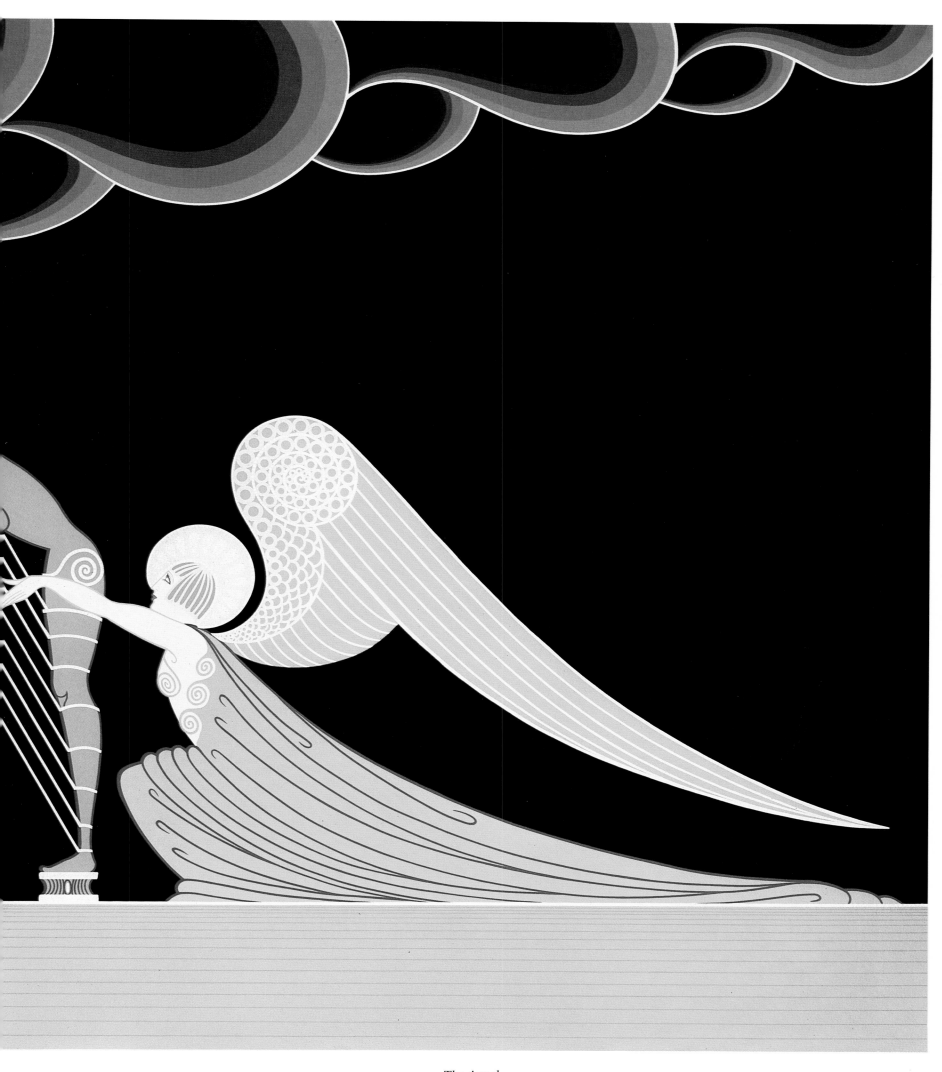

The Angel
L'Ange
L'angelo
Der Engel

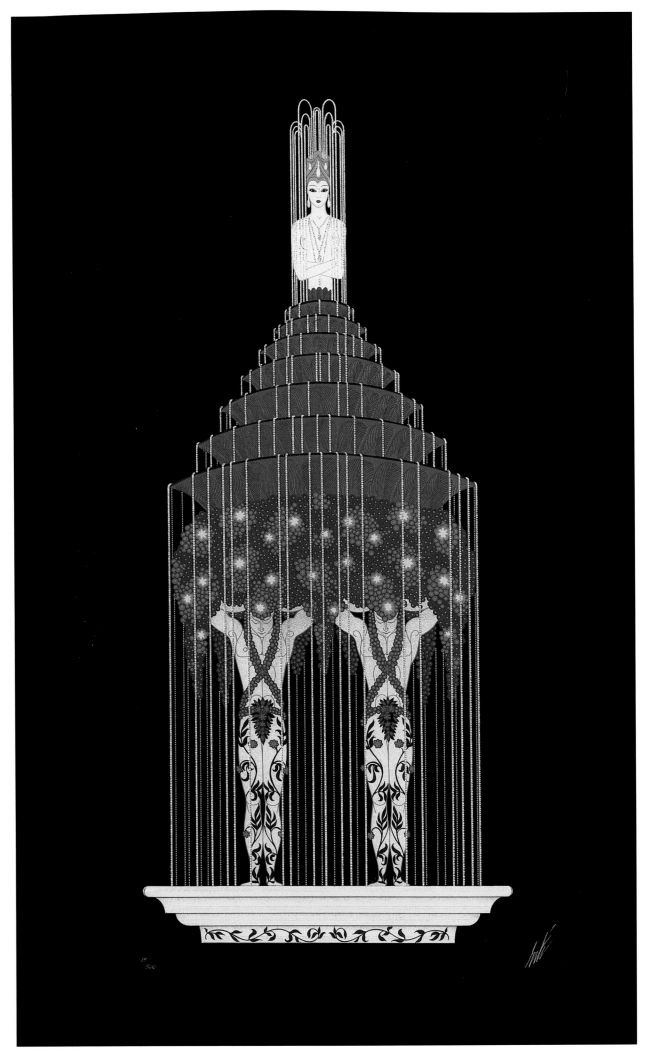

Perfume
Parfum
Profumo
Das Parfüm

30

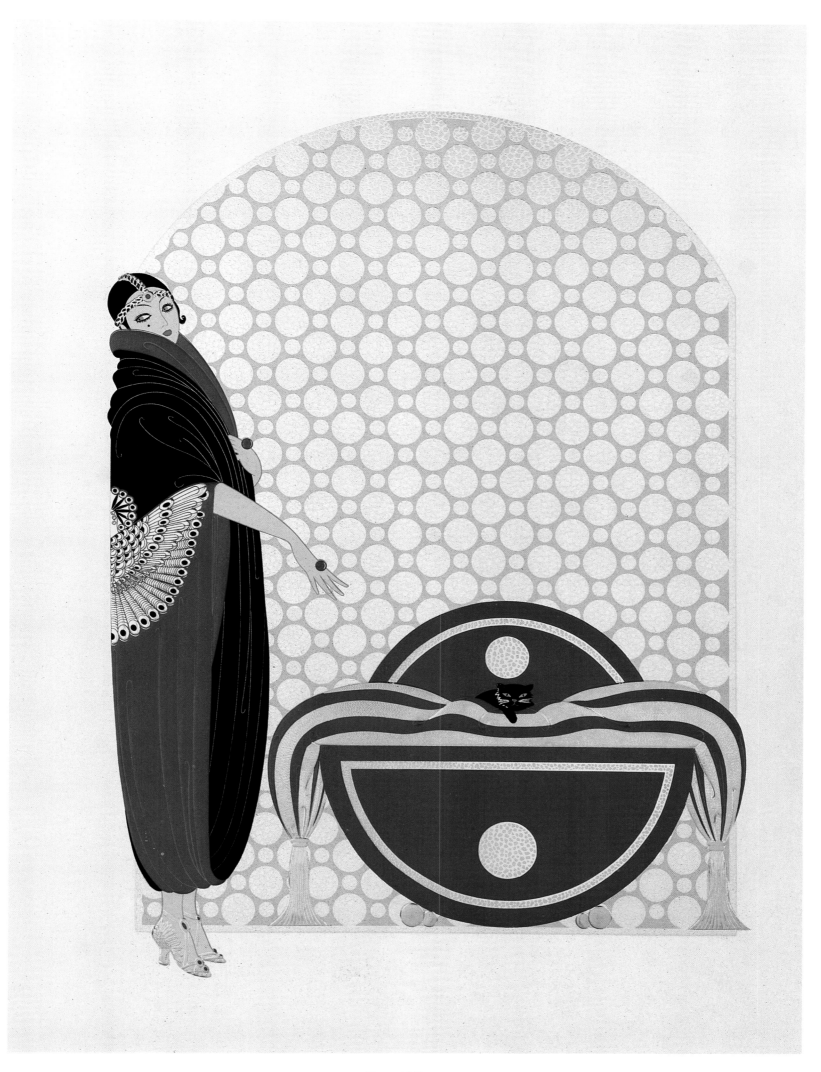

Emerald Eyes
Yeux d'émeraude
Occhi smeraldo
Smaragdaugen

31

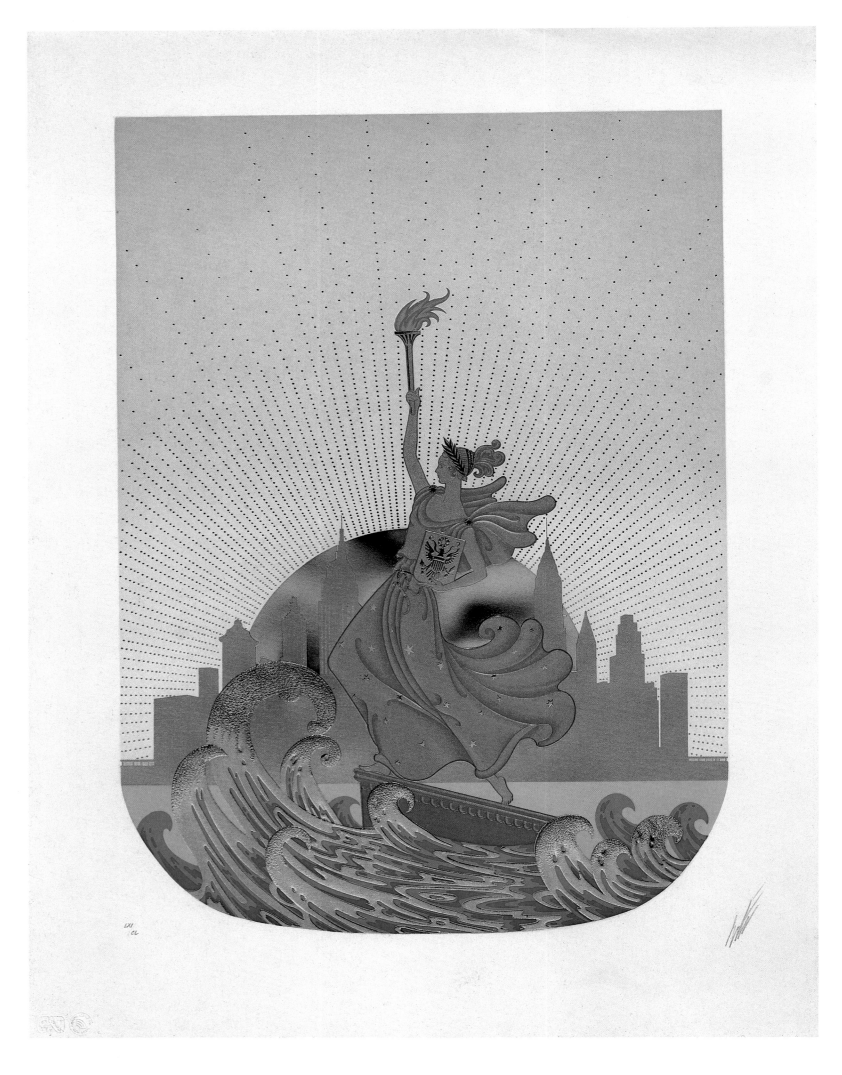

STATUE OF LIBERTY SUITE
SÉRIE DE LA STATUE DE LA LIBERTÉ
SUITE STATUA DELLA LIBERTÀ
DIE FREIHEITSSTATUE

Statue of Liberty (Day)
La Statue de la Liberté (Jour)
Statua della Libertà (Giorno)
Die Freiheitsstatue (Tag)

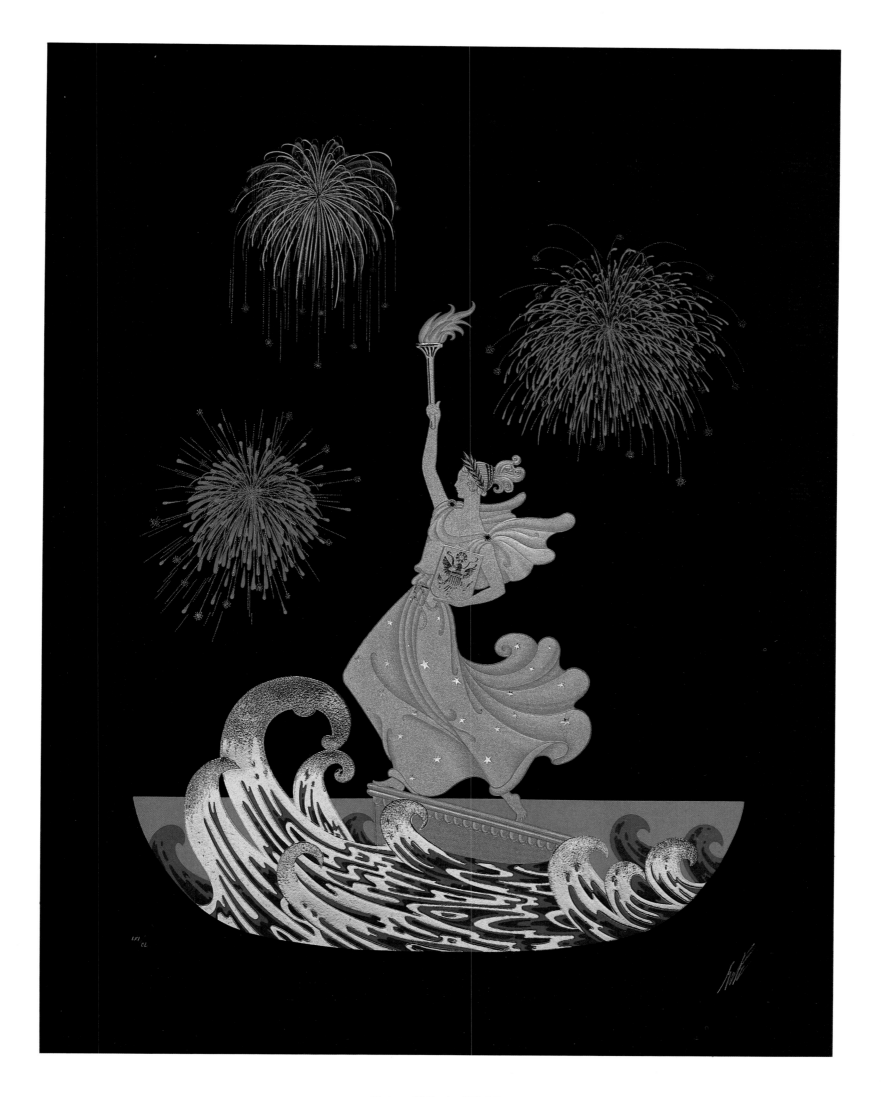

Statue of Liberty (Night)
La Statue de la Liberté (Nuit)
Statua della Libertà (Notte)
Die Freiheitsstatue (Nacht)

STATUE OF LIBERTY SUITE
SÉRIE DE LA STATUE DE LA LIBERTÉ
SUITE STATUA DELLA LIBERTÀ
DIE FREIHEITSSTATUE

33

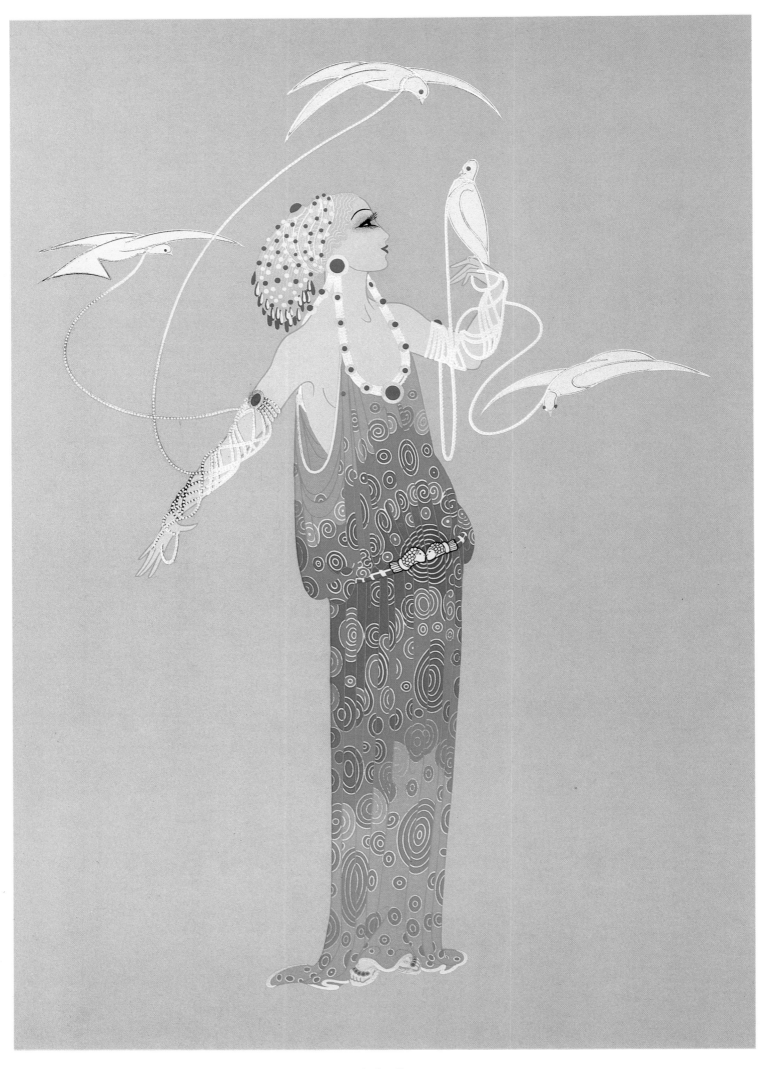

Aphrodite
Aphrodite
Afrodite
Aphrodite

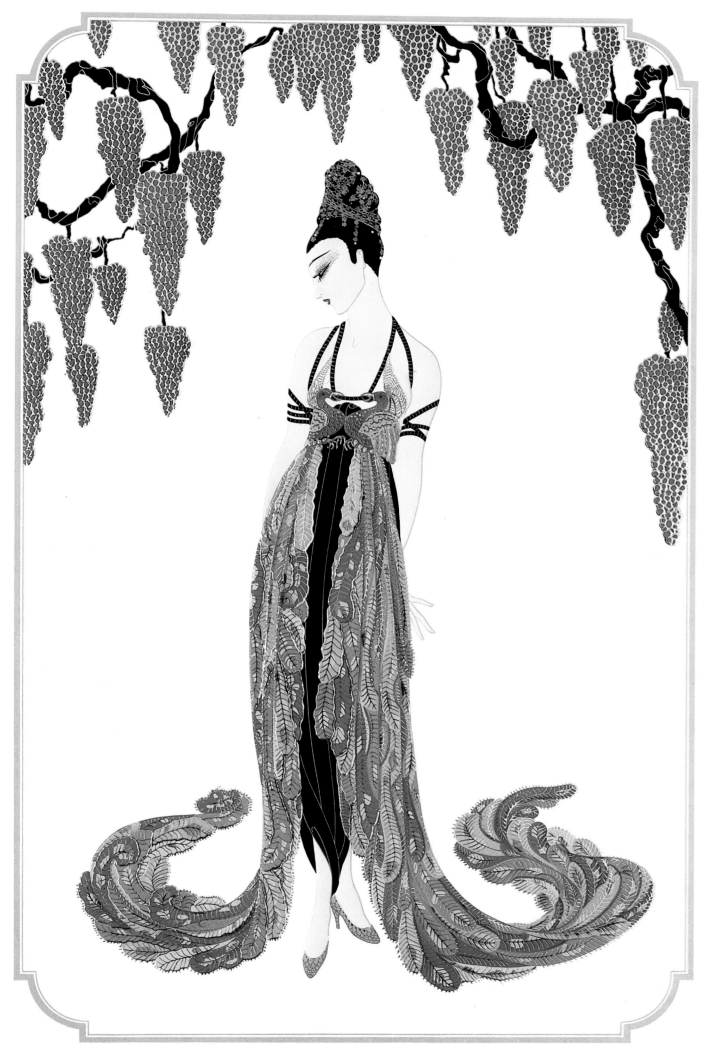

Feather Gown
Robe de plumes
Abito di piume
Federkleid

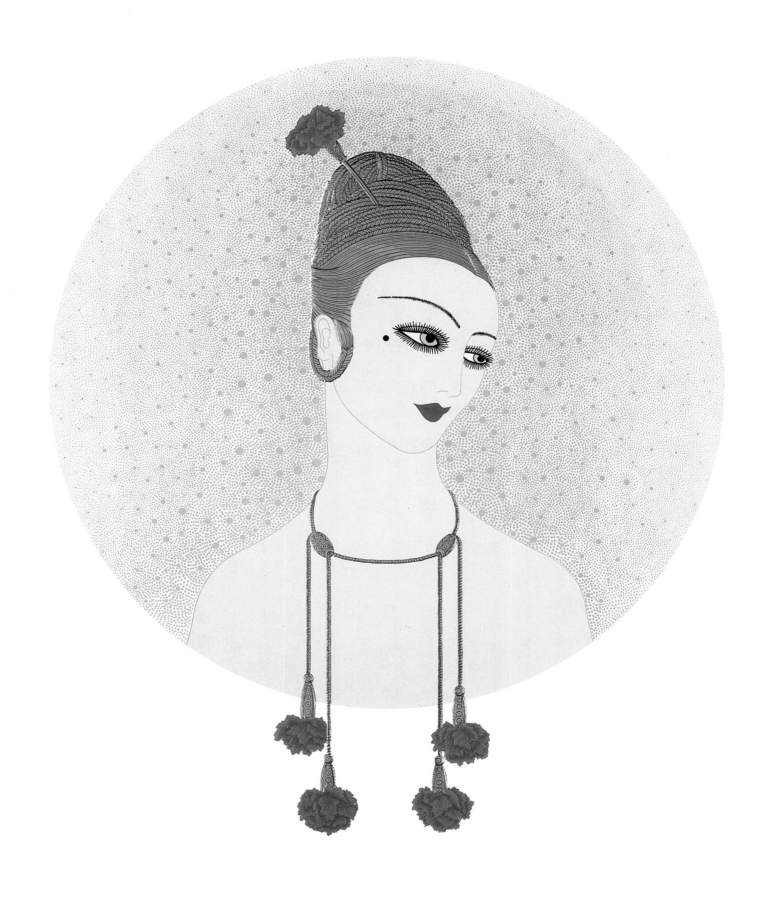

Carnations
Œillets
Garofani
Nelken

36

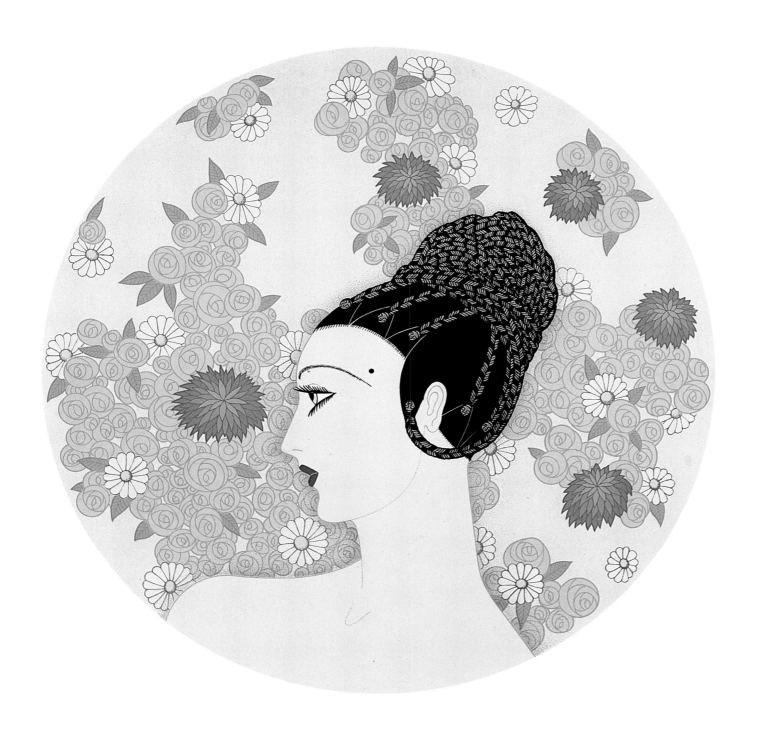

Roses
Roses
Rose
Rosen

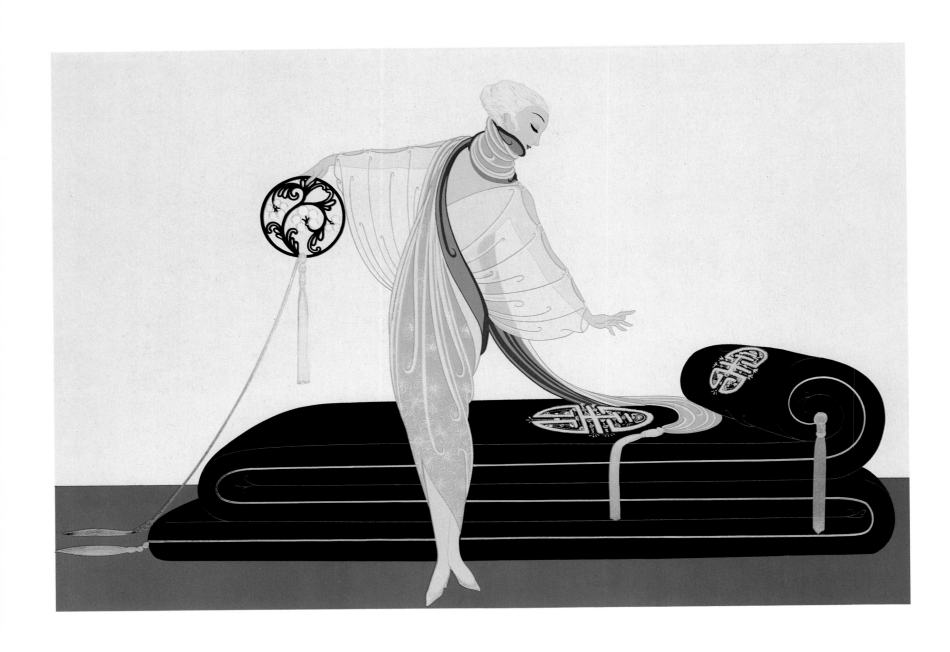

The Salon
Le Salon
Il salotto
Der Salon

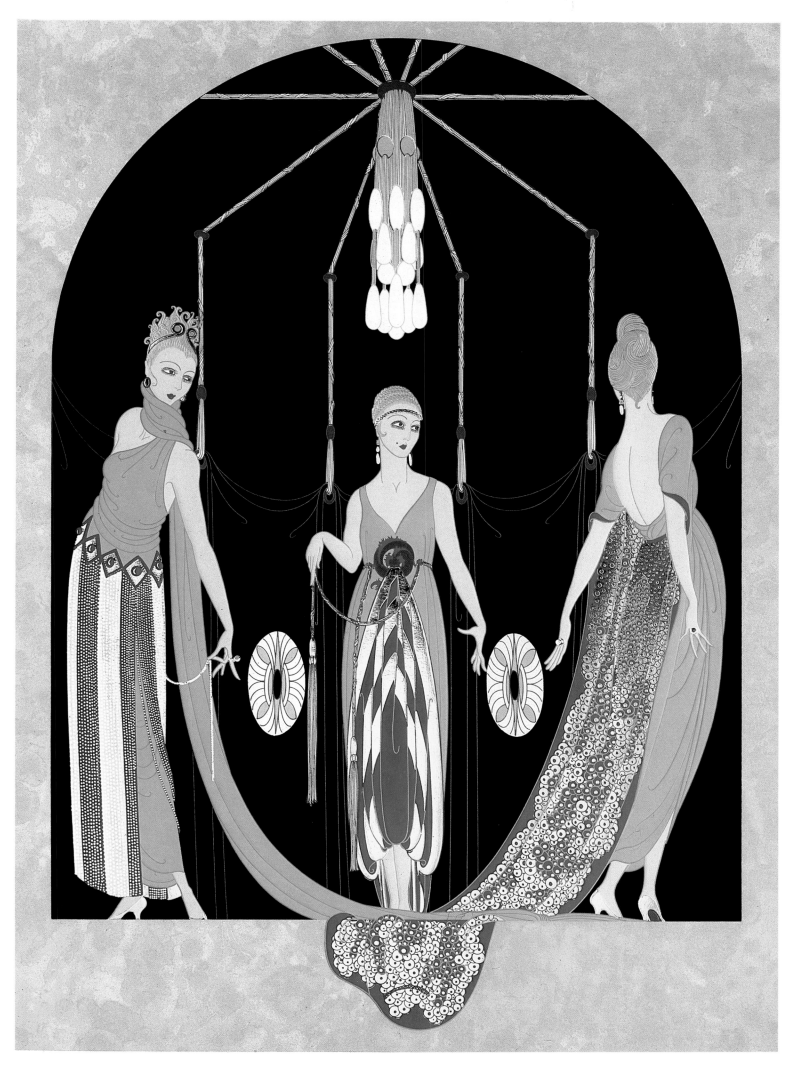

Three Graces
Trois Grâces
Le tre Grazie
Drei Grazien

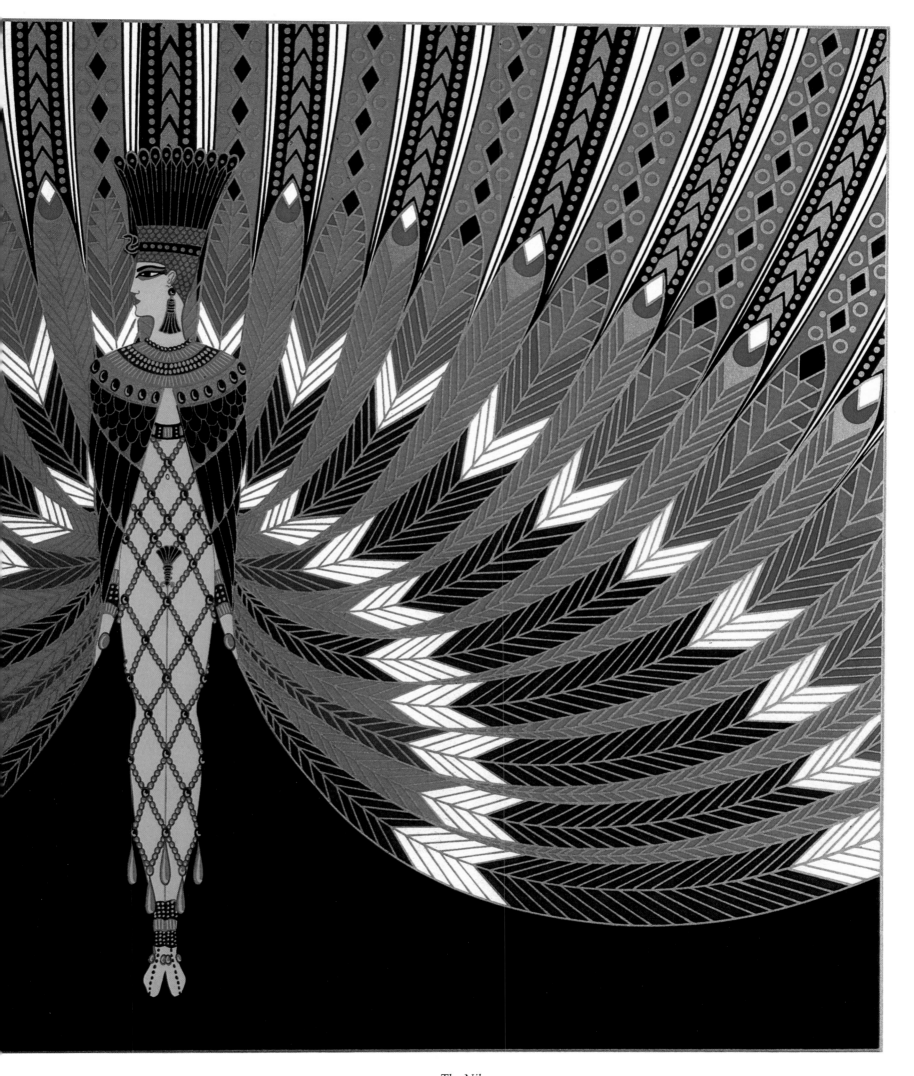

The Nile
Le Nil
Il Nilo
Der Nil

41

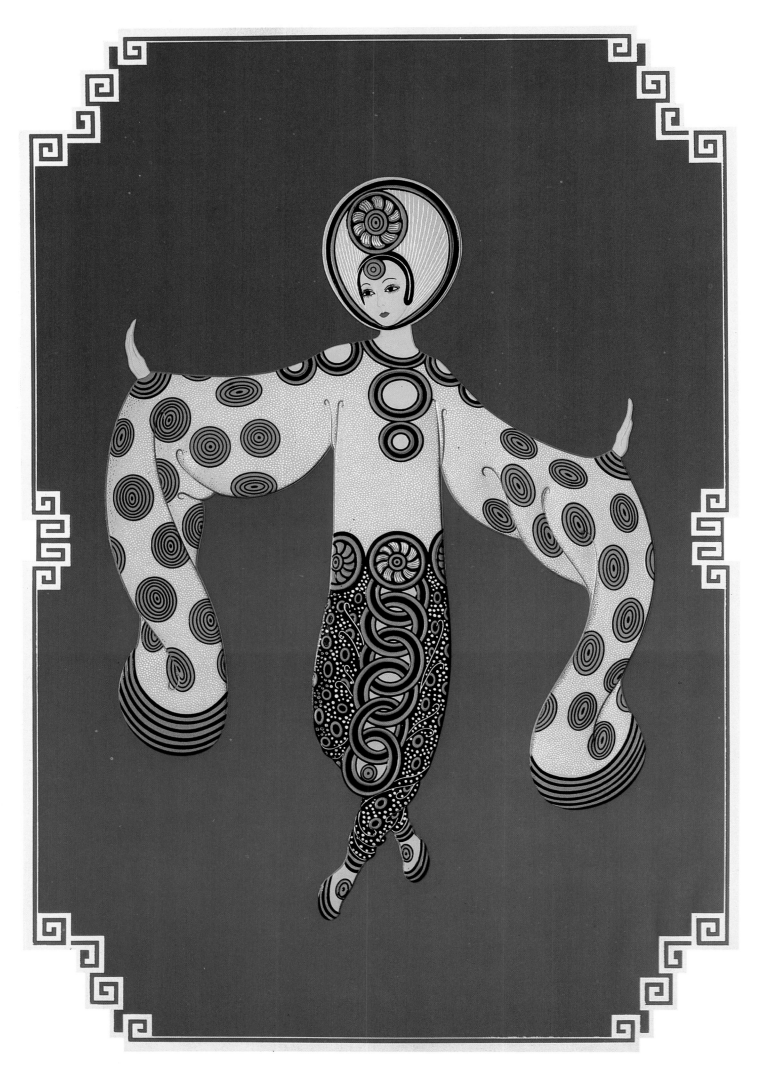

ASIAN PRINCESS SUITE
SÉRIE PRINCESSE ASIATIQUE
SUITE PRINCIPESSA ASIATICA
SUITE ASIATISCHE PRINZESSIN

Willow Tree
Saule
Salice
Weide

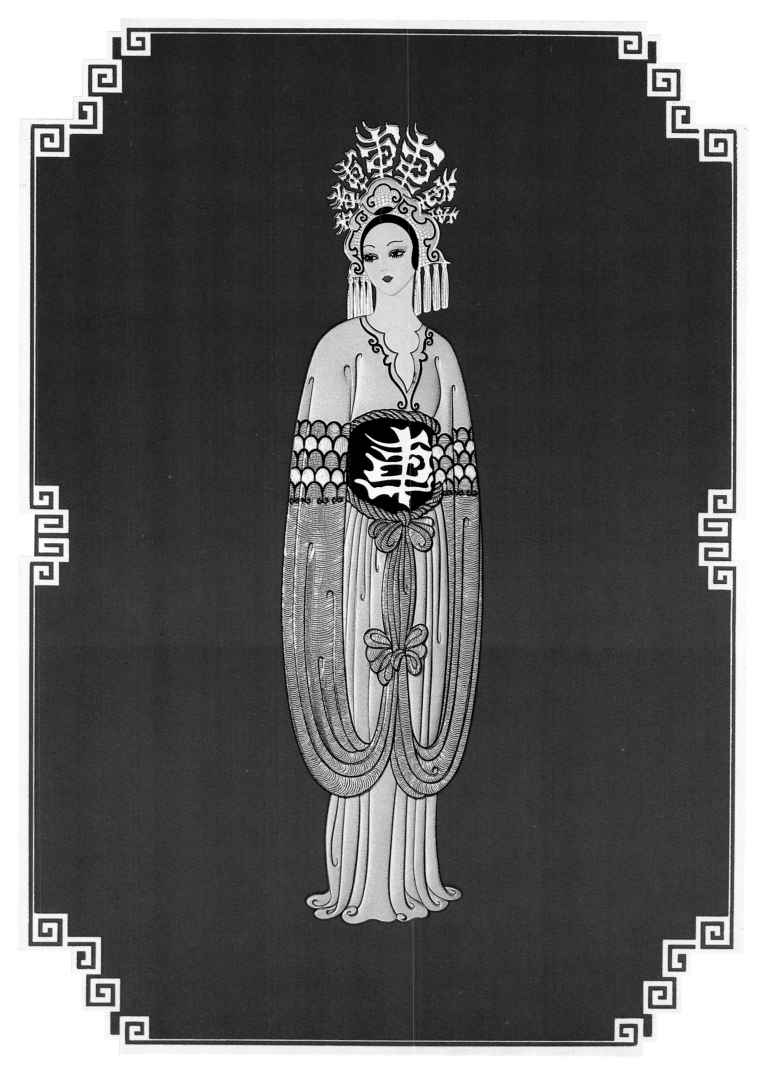

Plum Blossom
Fleur de prunier
Fiore di susino
Pflaumenblüte

ASIAN PRINCESS SUITE
SÉRIE PRINCESSE ASIATIQUE
SUITE PRINCIPESSA ASIATICA
SUITE ASIATISCHE PRINZESSIN

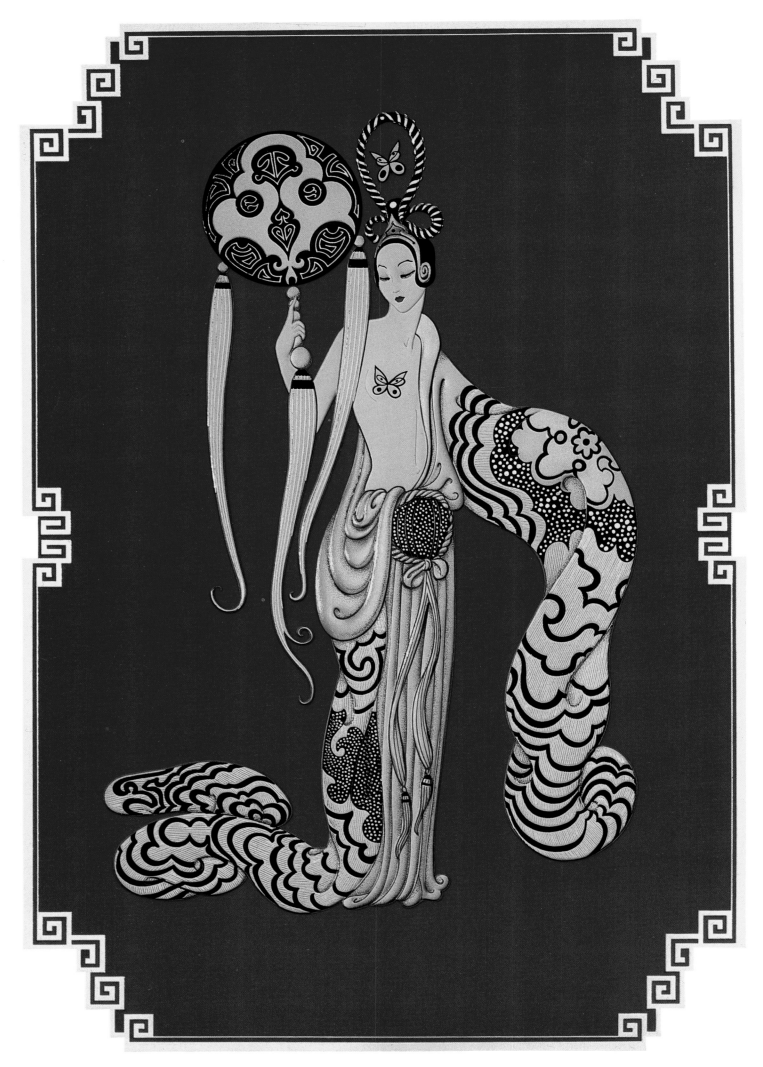

ASIAN PRINCESS SUITE *Bamboo*
SÉRIE PRINCESSE ASIATIQUE *Bambou*
SUITE PRINCIPESSA ASIATICA *Bambù*
SUITE ASIATISCHE PRINZESSIN *Bambus*

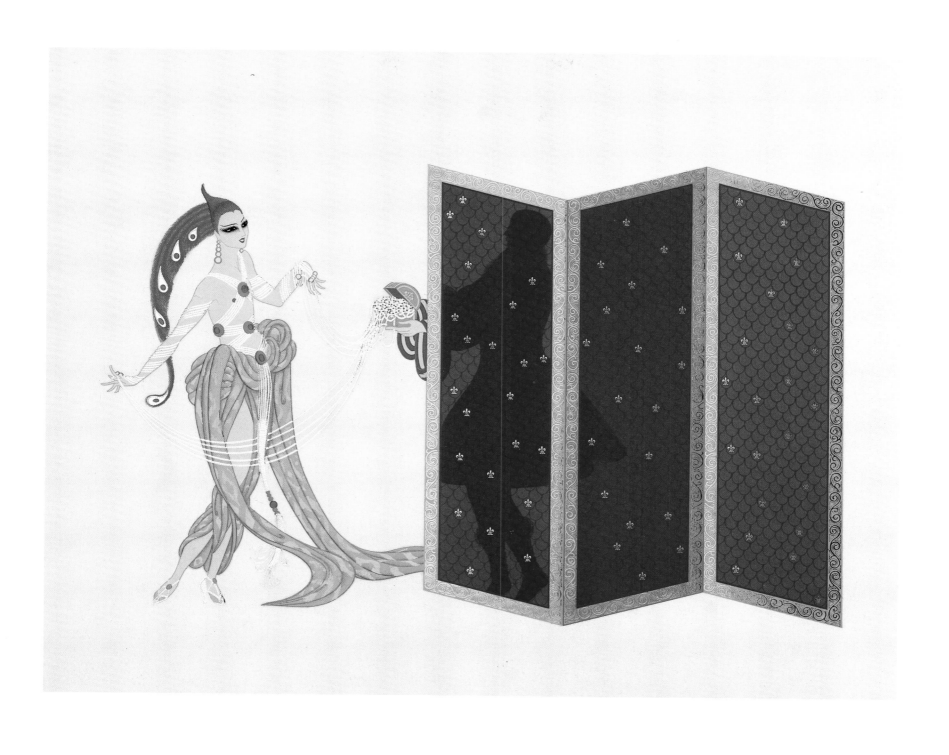

The Mystery of the Courtesan
Le Mystère de la courtisane
Il mistero della cortigiana
Das Geheimnis der Kurtisane

45

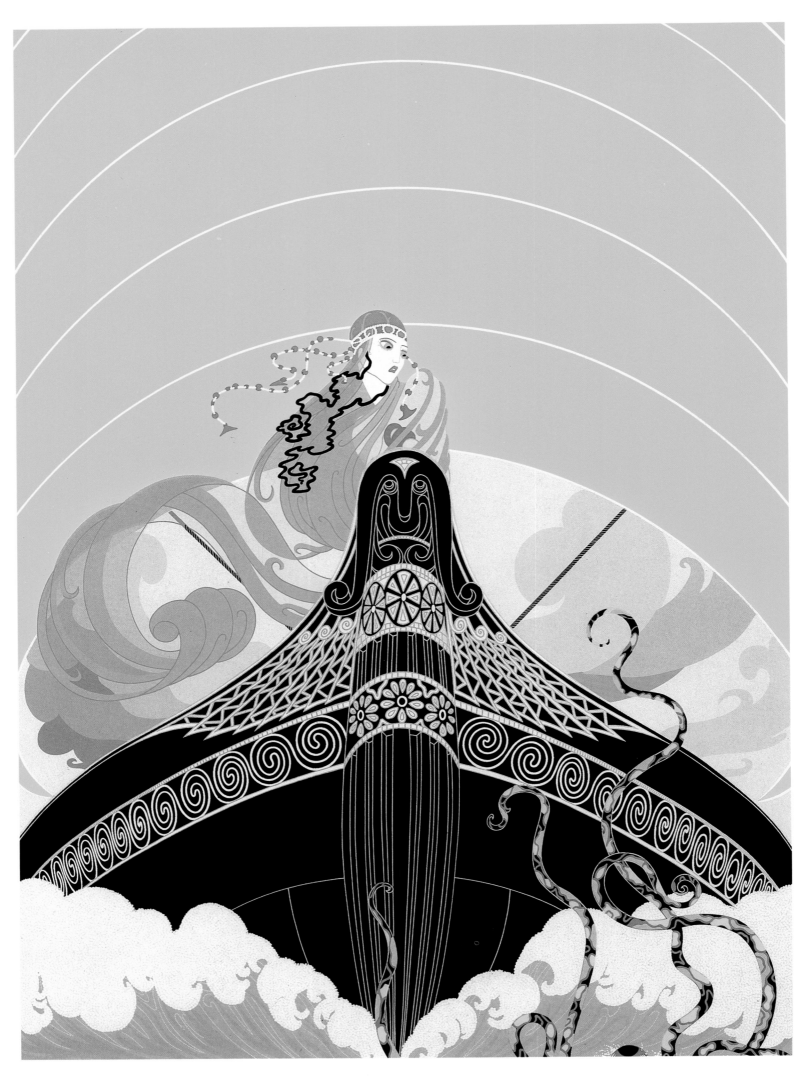

The Surprises of the Sea
Les Surprises de la mer
Le meraviglie del mare
Gefahren der See

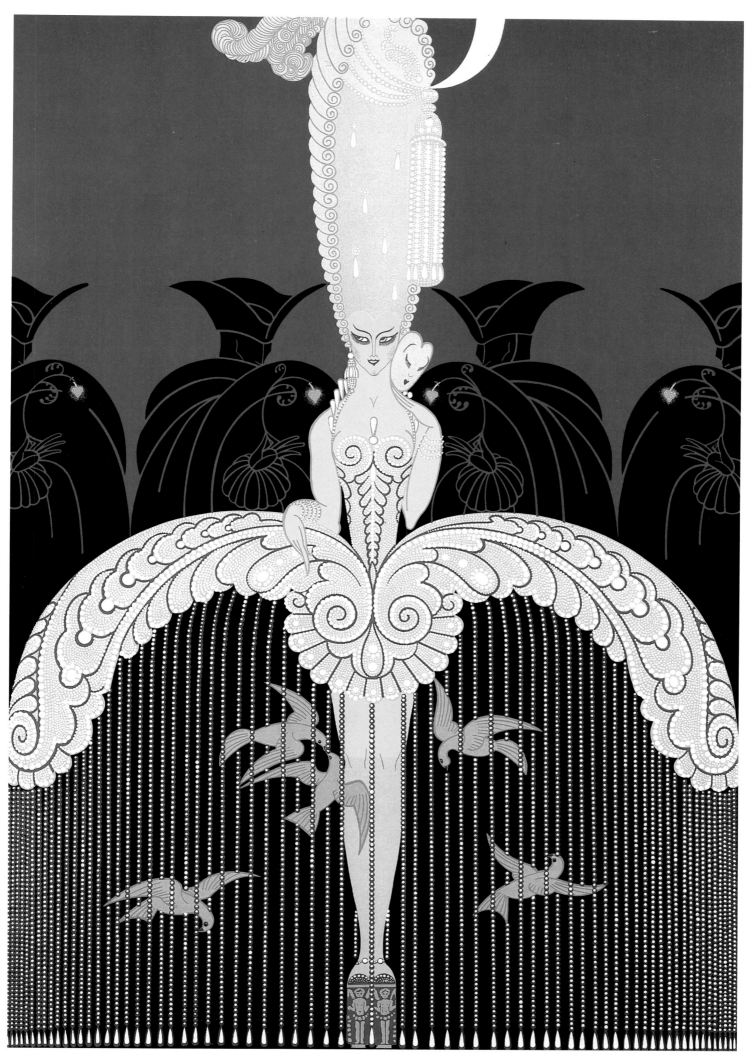

Her Secret Admirers
Admirateurs clandestins
I suoi ammiratori segreti
Ihre heimlichen Bewunderer

47

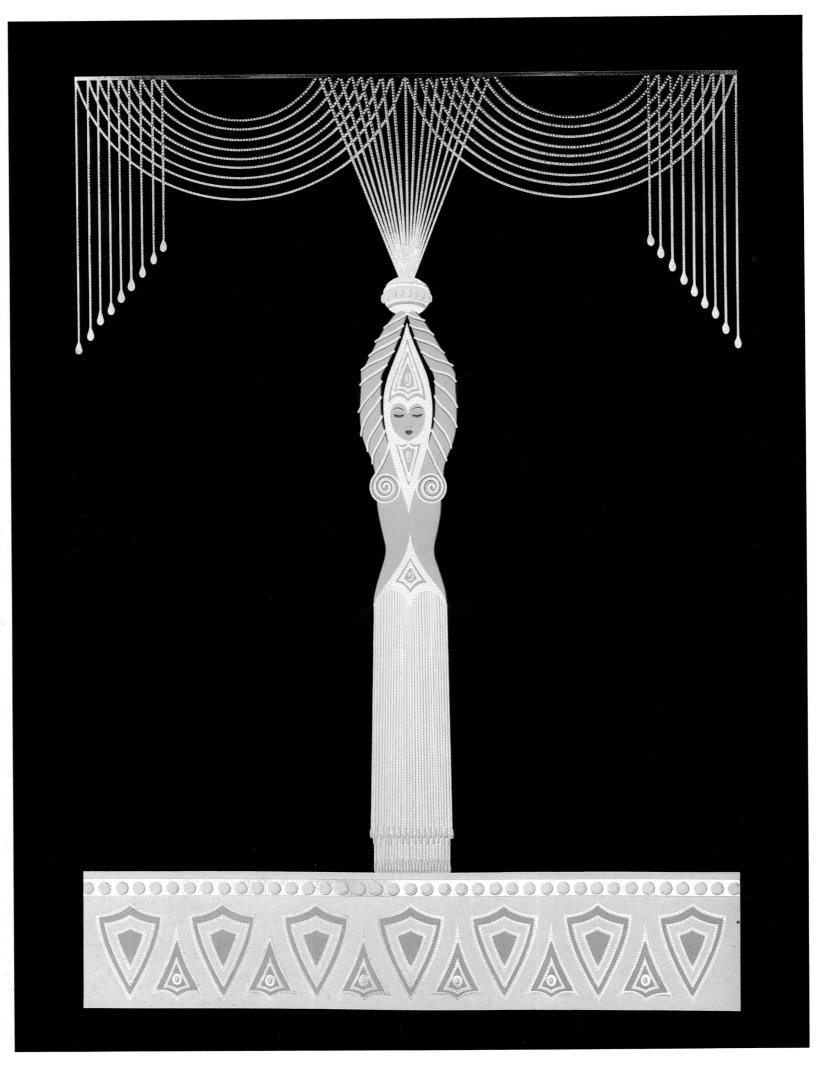

Pearls and Diamonds
Perles et diamants
Perle e diamanti
Perlen und Diamanten

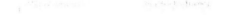

Rigoletto
Rigoletto
Rigoletto
Rigoletto

49

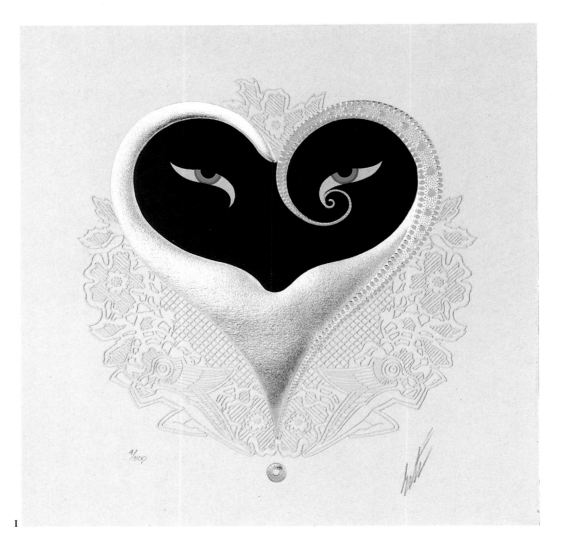

I

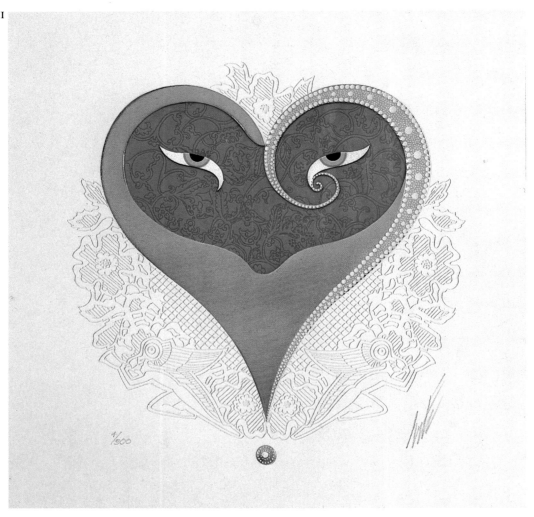

II

HEARTS AND ZEPHYRS SUITE *Heart I* *Heart II*
SÉRIE DES CŒURS ET DES ZEPHYRS *Coeur I* *Coeur II*
SUITE CUORI E ZEFIRI *Cuore I* *Cuore II*
SUITE HERZEN UND ZEPHRE *Herz I* *Herz II*

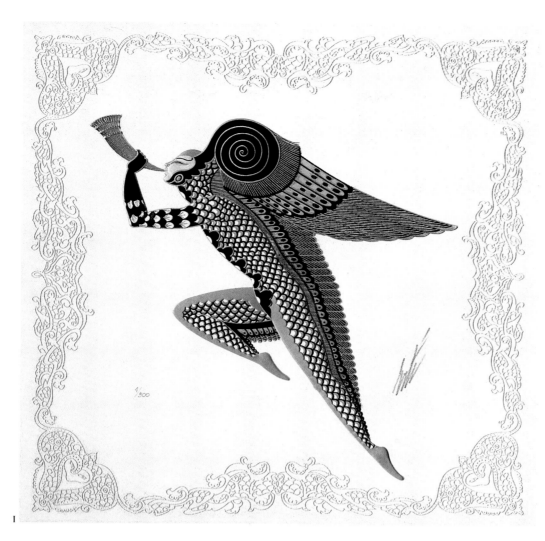

I

II

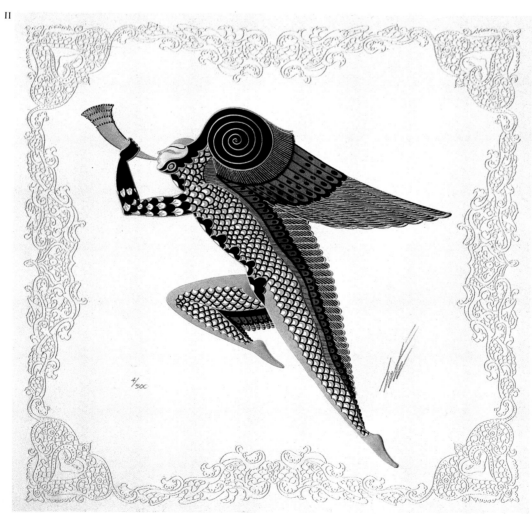

Zephyr I	Zephyr II
Zephyr I	Zephyr II
Zefiro I	Zefiro II
Zephir I	Zephir II

HEARTS AND ZEPHYRS SUITE
SÉRIE DES CŒURS ET DES ZEPHYRS
SUITE CUORI E ZEFIRI
SUITE HERZEN UND ZEPHIRE

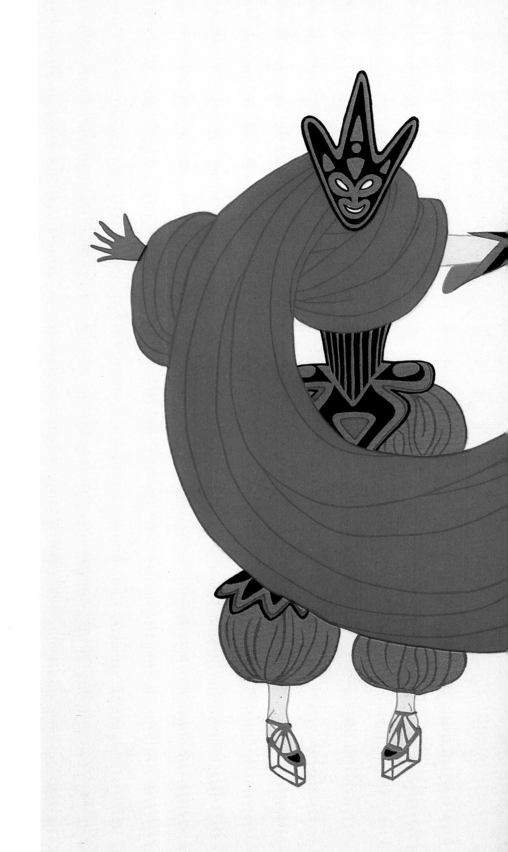

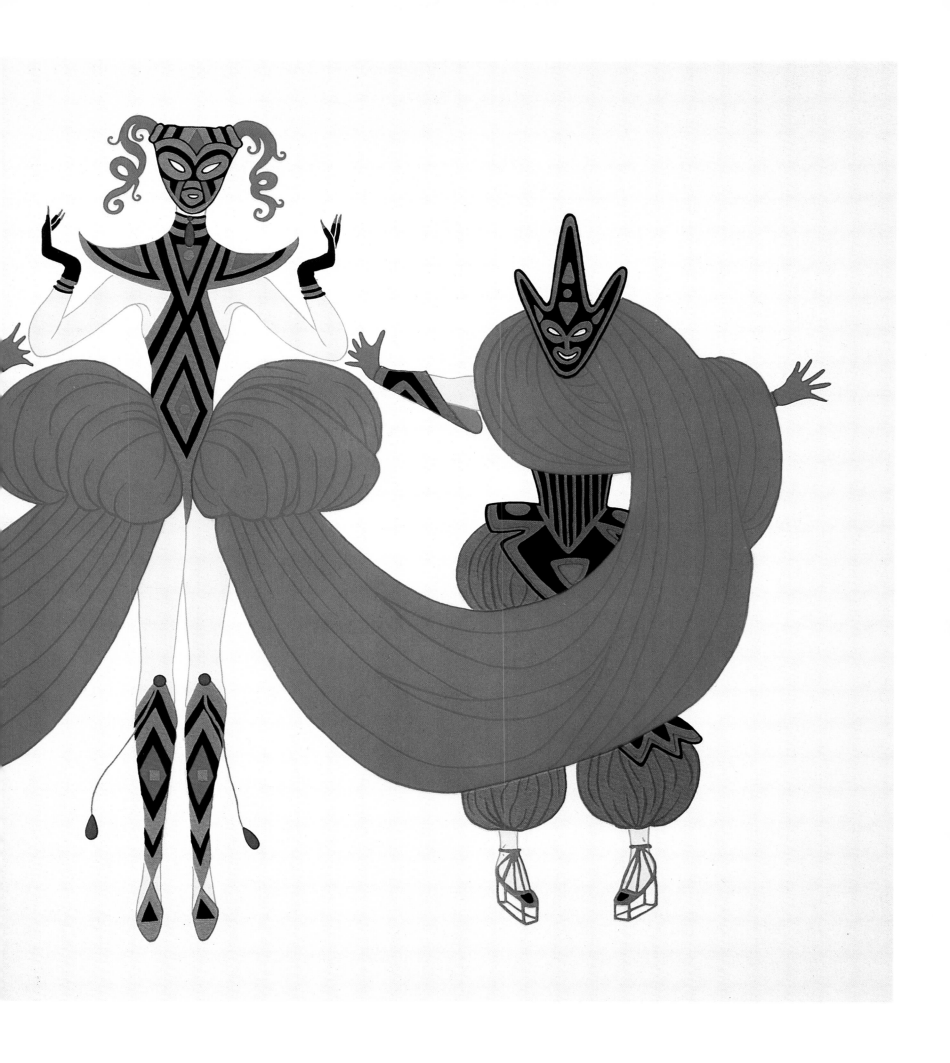

Carnaval
Carnaval
Carnevale
Karneval

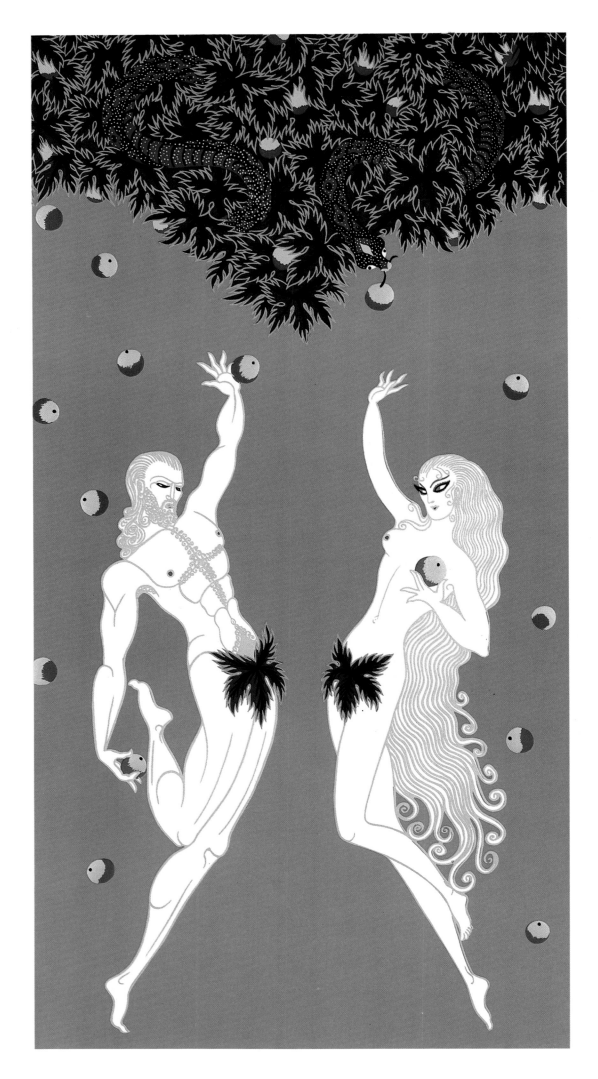

Adam and Eve
Adam et Ève
Adamo ed Eva
Adam und Eva

Daydream
Rêverie
Sogno ad occhi aperti
Tagtraum

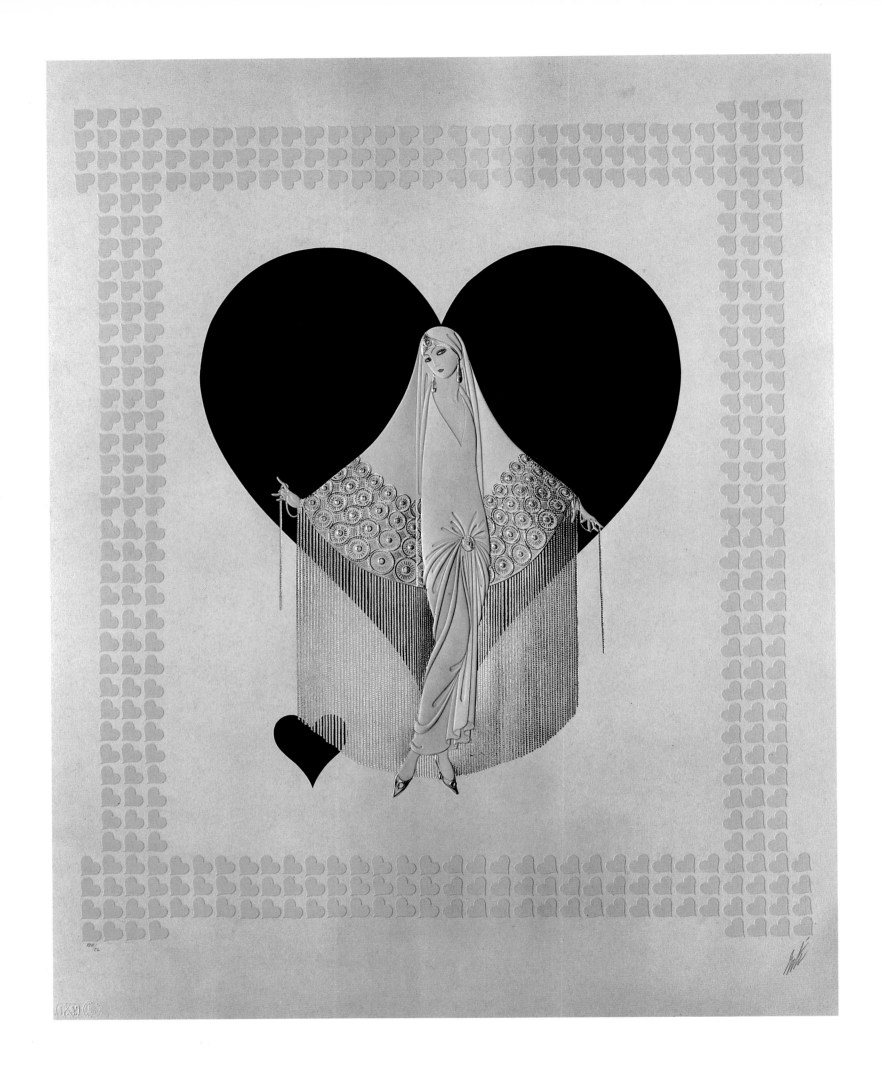

JUNE BRIDES SUITE
SÉRIE DES MARIÉES DE JUIN
SUITE LE SPOSE DI GIUGNO
JUNIBRÄUTE

Fringe Gown
Robe à franges
Veste sfrangiata
Fransenkleid

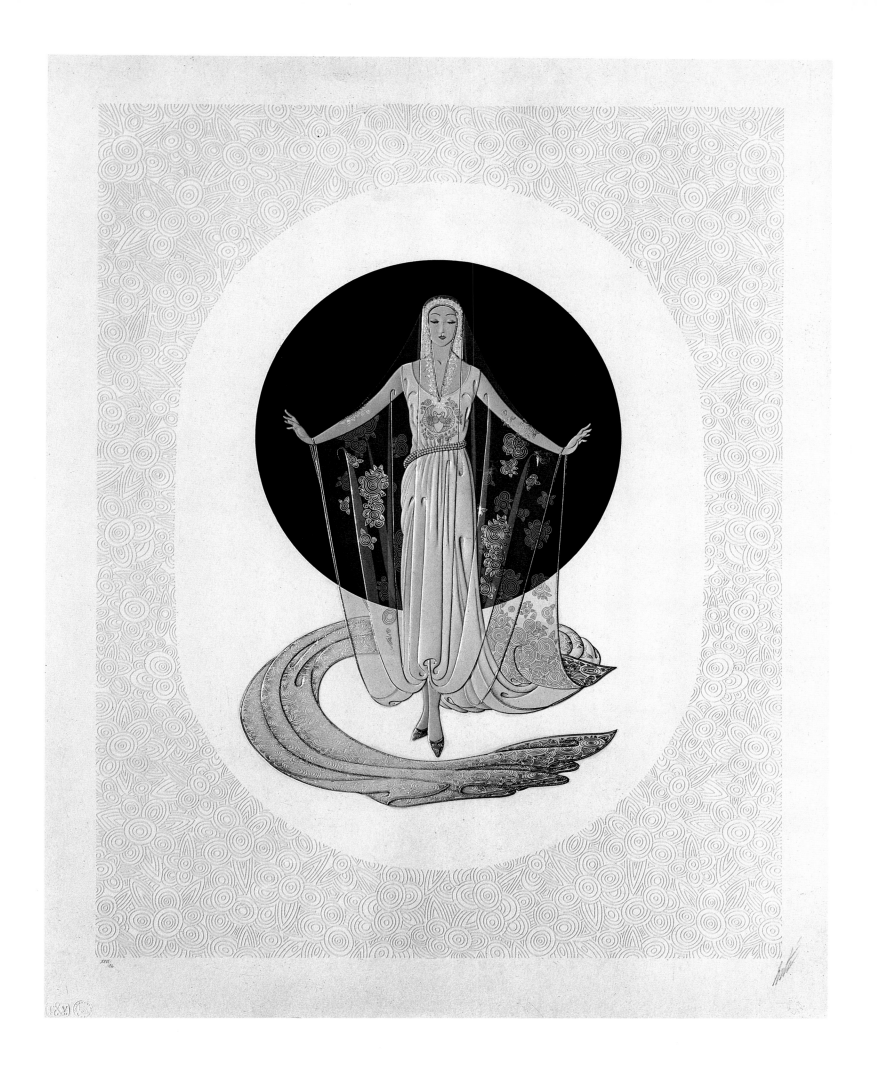

Veil Gown
Robe-voile
Veste con veli
Schleierkleid

JUNE BRIDES SUITE
SÉRIE DES MARIÉES DE JUIN
SUITE LE SPOSE DI GIUGNO
JUNIBRÄUTE

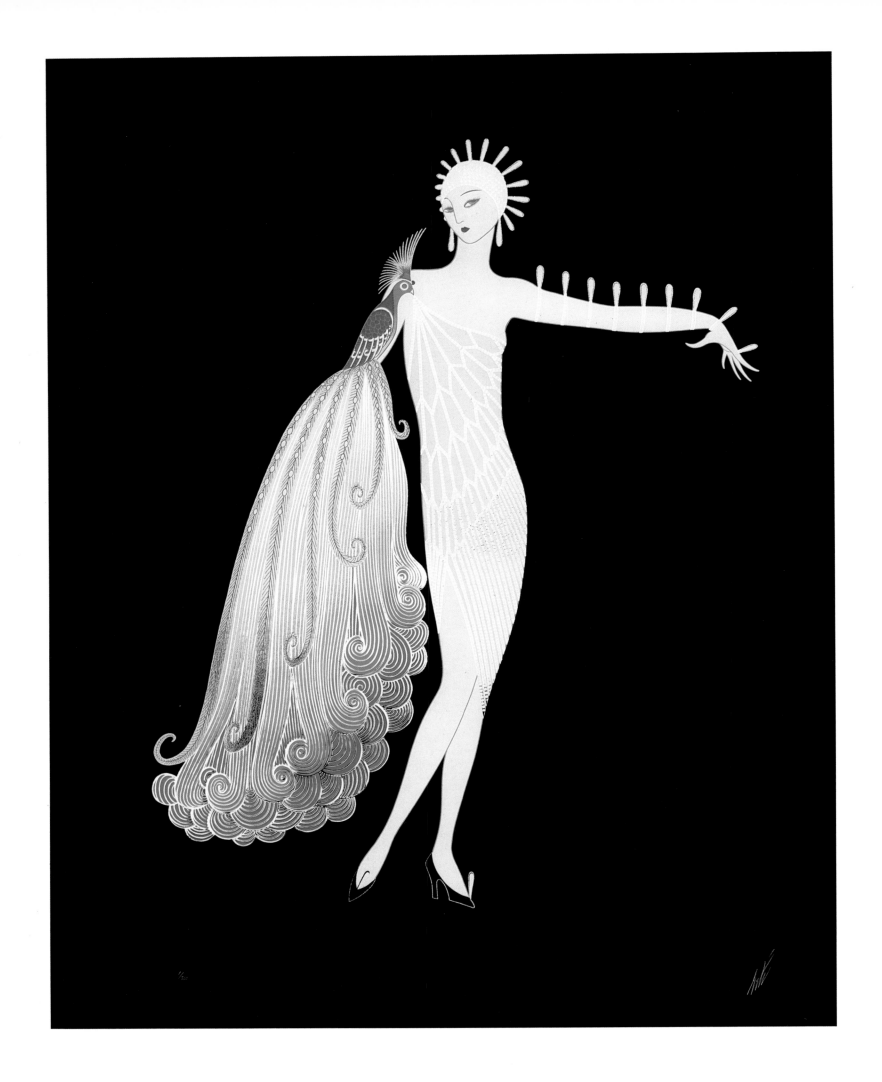

DIVA SUITE *Diva I*

SÉRIE DES DIVAS *Diva I*

SUITE DIVA *Diva I*

DIVA *Diva I*

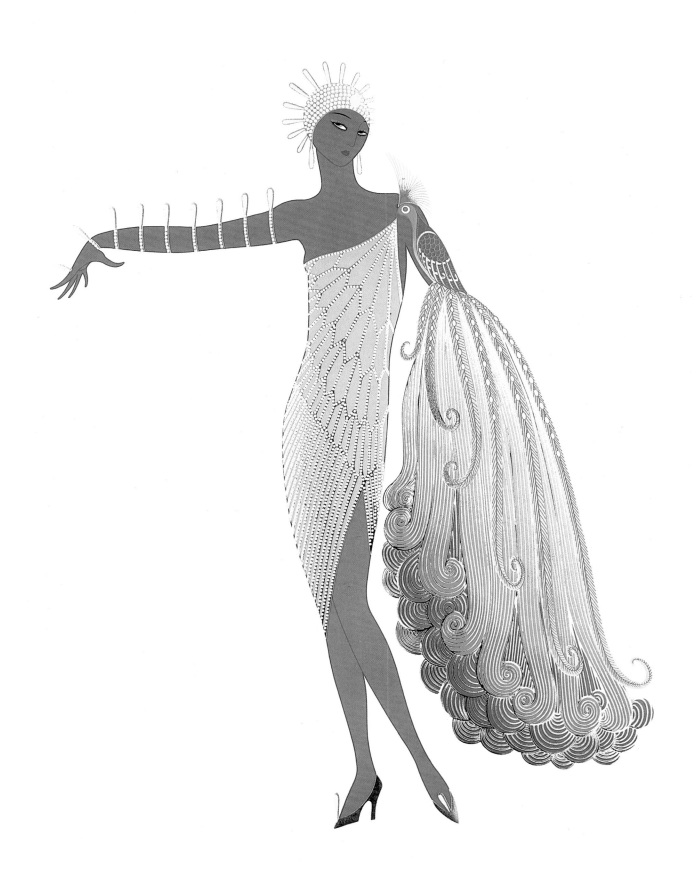

Diva II
Diva II
Diva II
Diva II

DIVA SUITE
SÉRIE DES DIVAS
SUITE DIVA
DIVA

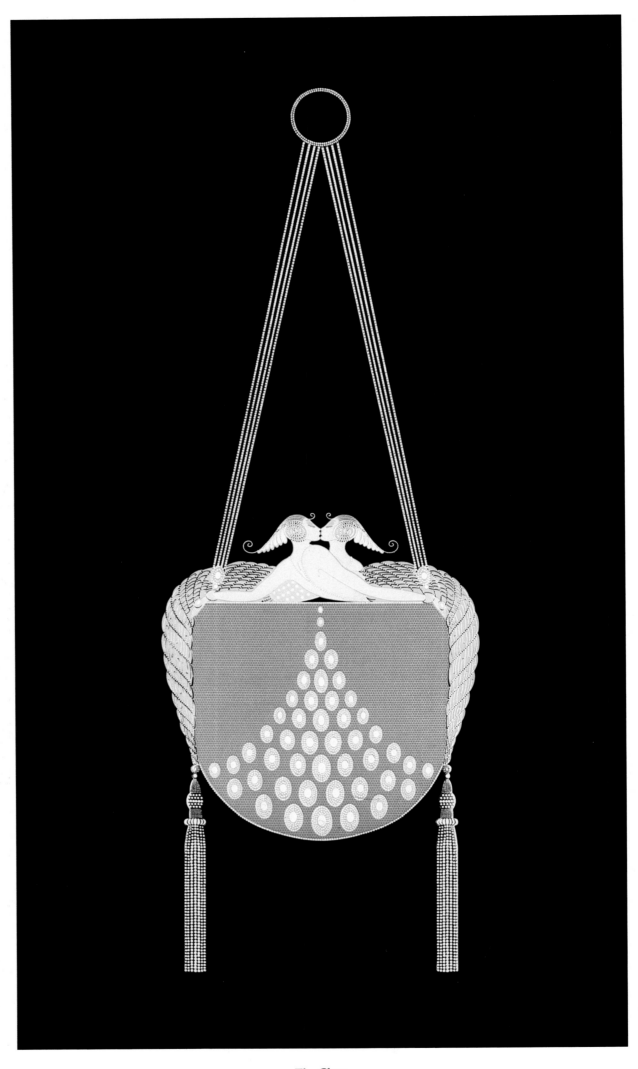

The Clasp
L'Étreinte
Il fermaglio
Gürtelschnalle

60

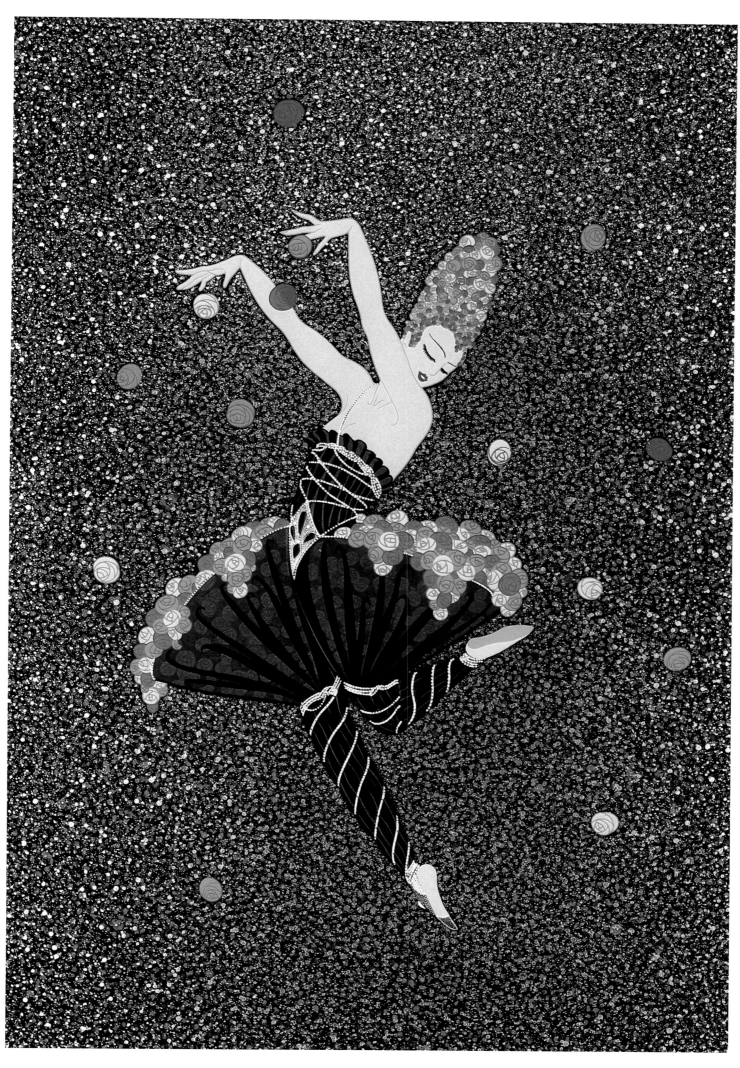

Rose Dancer
Rose dansante
Danzatrice rosa
Rosentänzerin

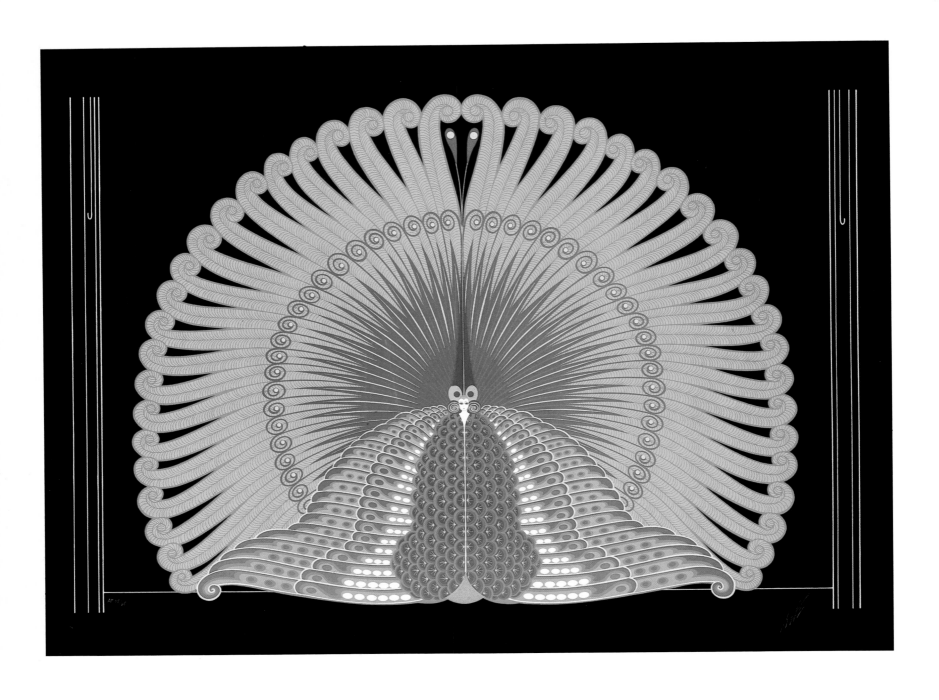

PHOENIX SUITE
SÉRIE DU PHÉNIX
SUITE LA FENICE
PHÖNIX

Phoenix Reborn
Phénix ressuscité
La rinascita della Fenice
Der wiedererstandene Phönix

62

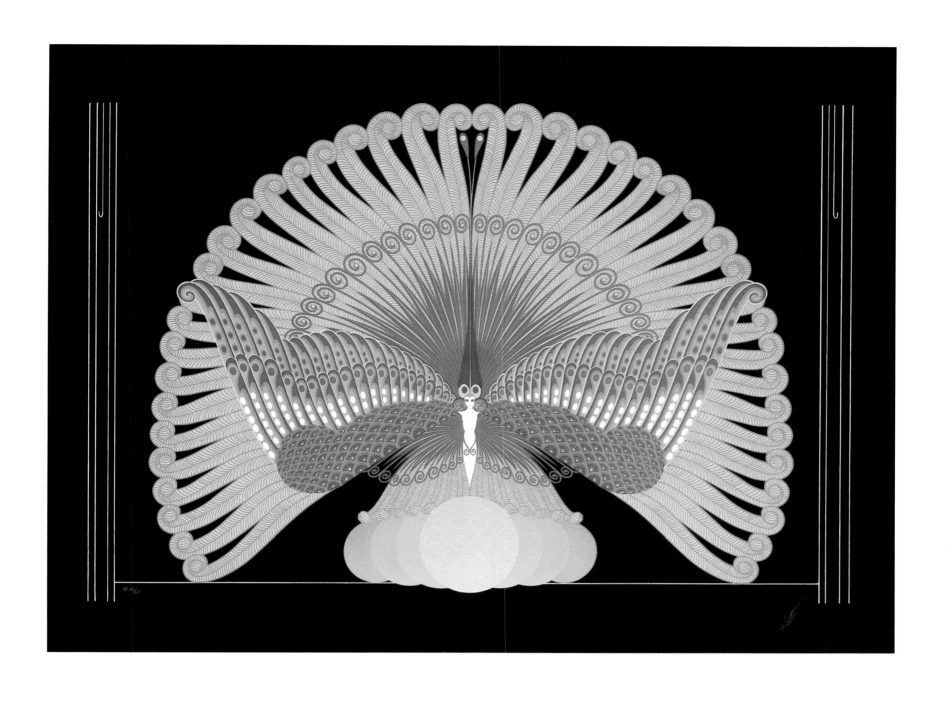

Phoenix Triumphant
Phénix triomphant
Il trionfo della Fenice
Der triumphierende Phönix

PHOENIX SUITE
SÉRIE DU PHÉNIX
SUITE LA FENICE
PHÖNIX

63

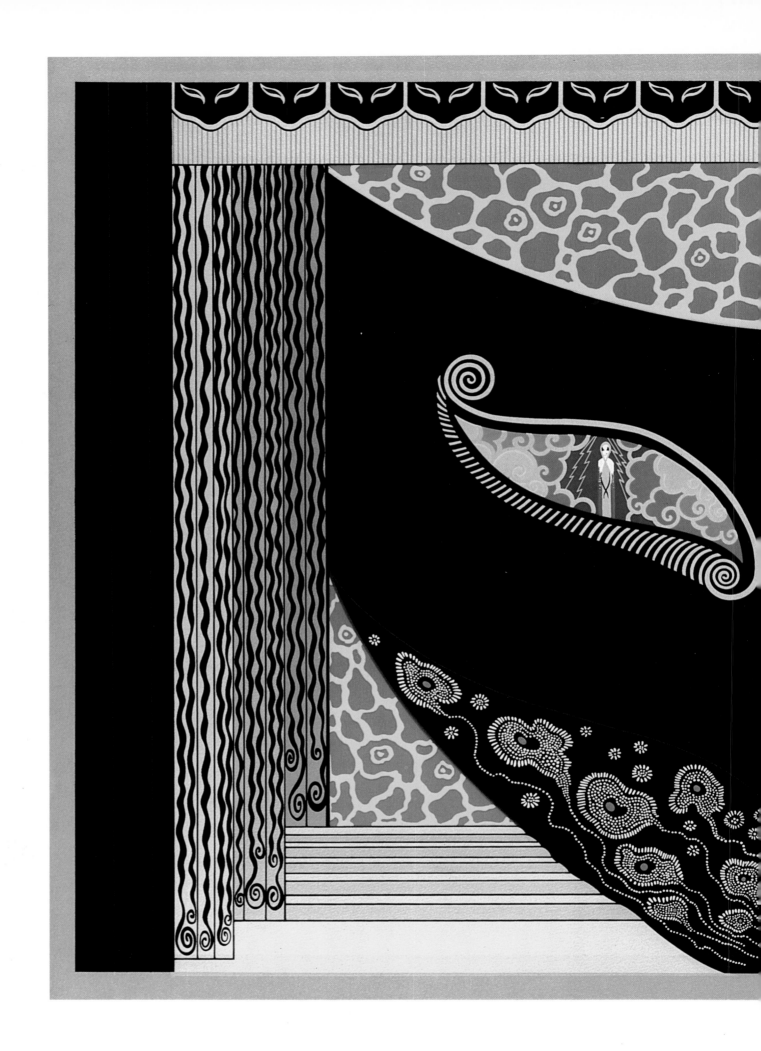

MYSTERIES THROUGH THE EYES OF THE MASK
MYSTÈRES D'UN REGARD DERRIÈRE UN MASQUE
MISTERI NELLO SGUARDO DI UNA MASCHERA
GEHEIMNISSE, ERBLICKT DURCH MASKENAUGEN

Eyes of Jealousy
Les Yeux de la jalousie
Gli occhi della gelosia
Augen der Eifersucht

65

MYSTERIES THROUGH THE EYES OF THE MASK
MYSTÈRES D'UN REGARD DERRIÈRE UN MASQUE
MISTERI NELLO SGUARDO DI UNA MASCHERA
GEHEIMNISSE, ERBLICKT DURCH MASKENAUGEN

Eyes of Love
Les Yeux de l'amour
Gli occhi dell'amore
Augen der Liebe

67

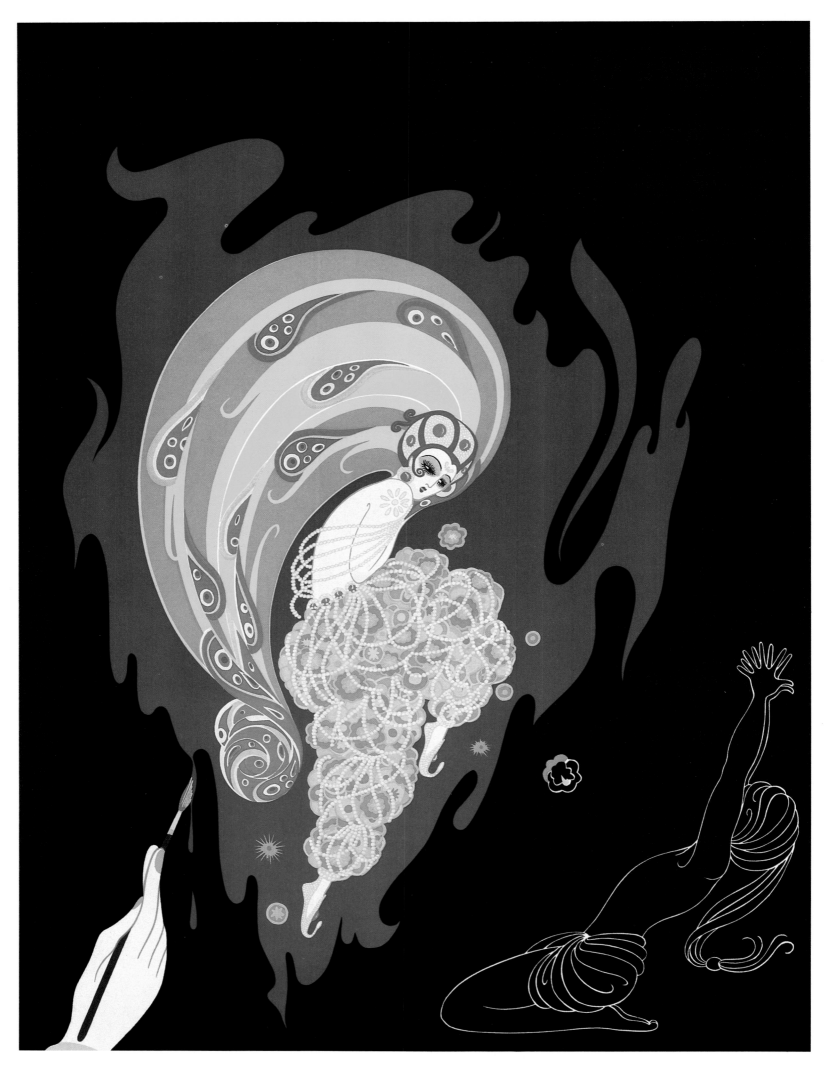

Oriental Tale
Conte oriental
Fiaba orientale
Orientalisches Märchen

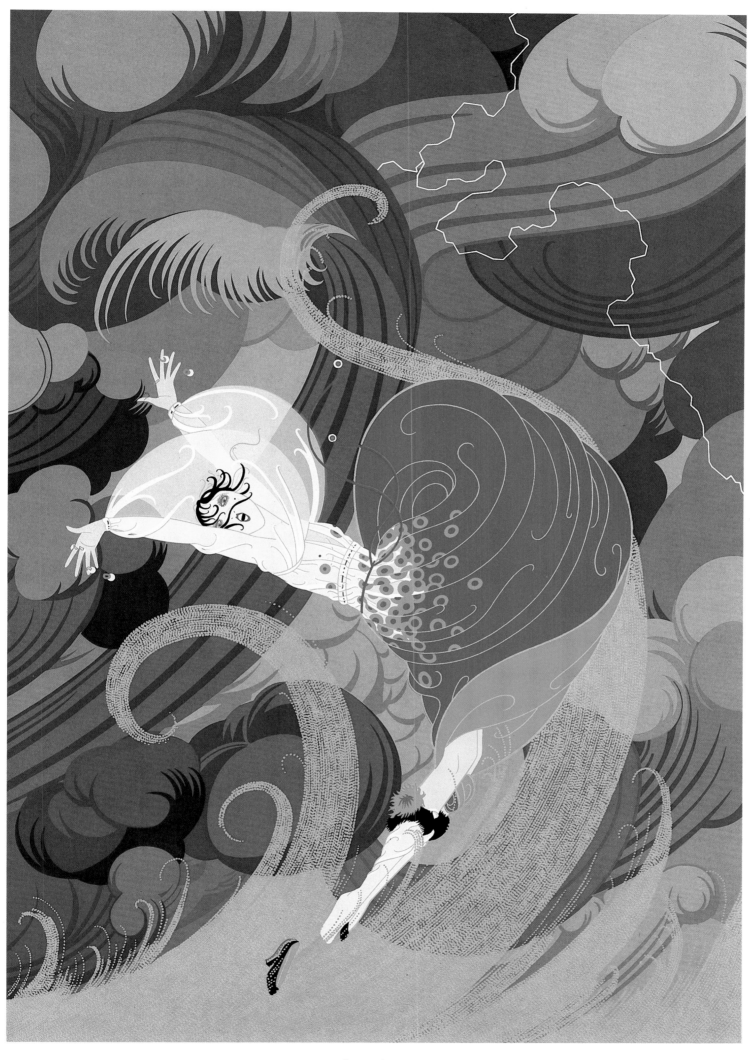

Swept Away
Emportée
Travolta
Fortgerissen

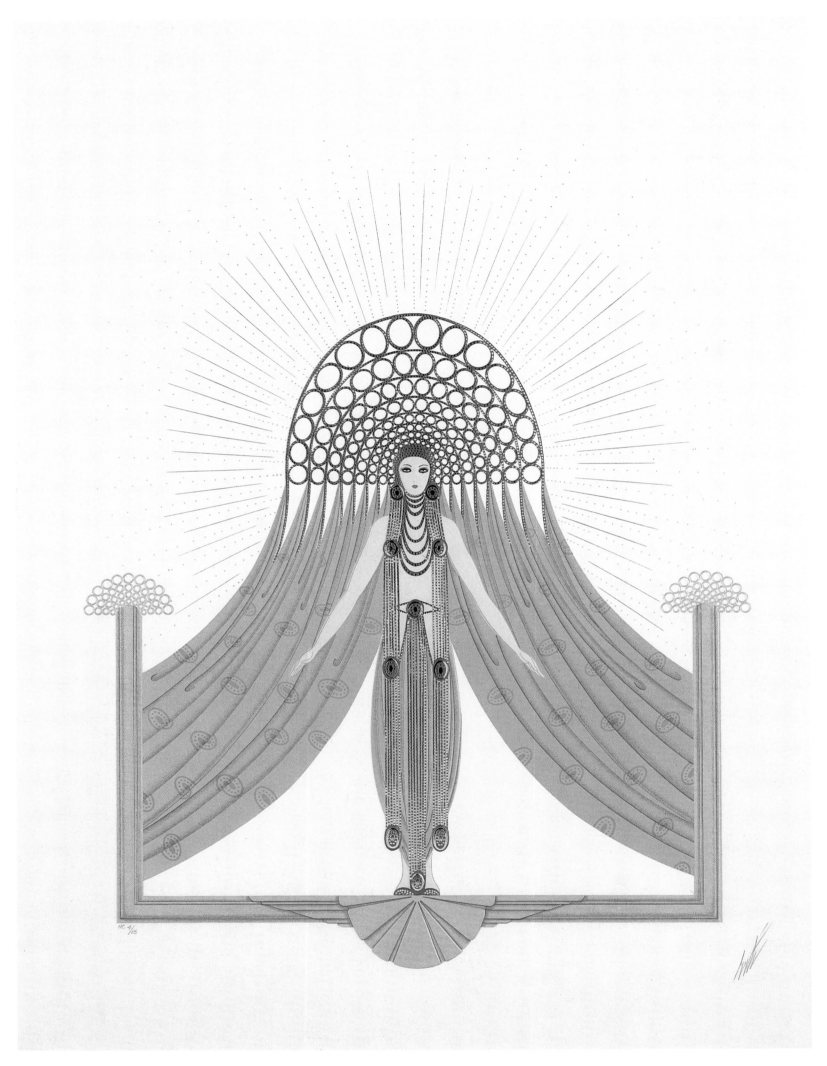

THE MYTHS SUITE	*Circe*
SÉRIE DES MYTHES	*Circé*
SUITE I MITI	*Circe*
DIE MYTHEN	*Circe*

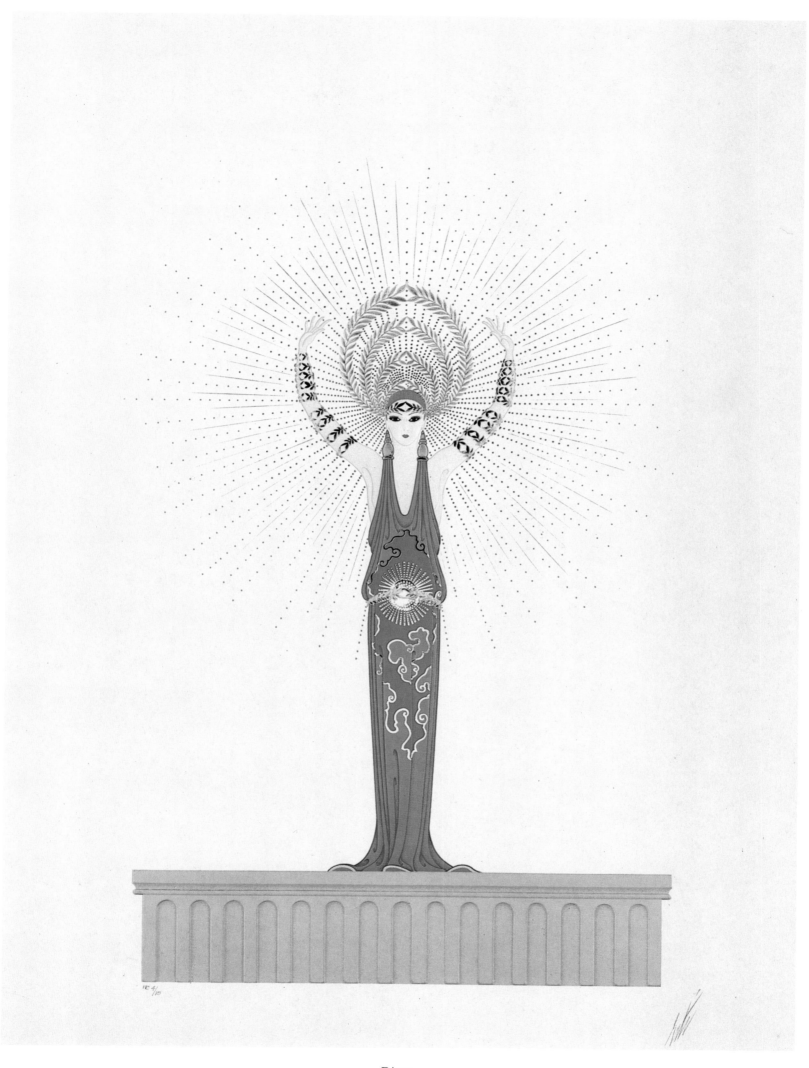

Diana
Diane
Diana
Diana

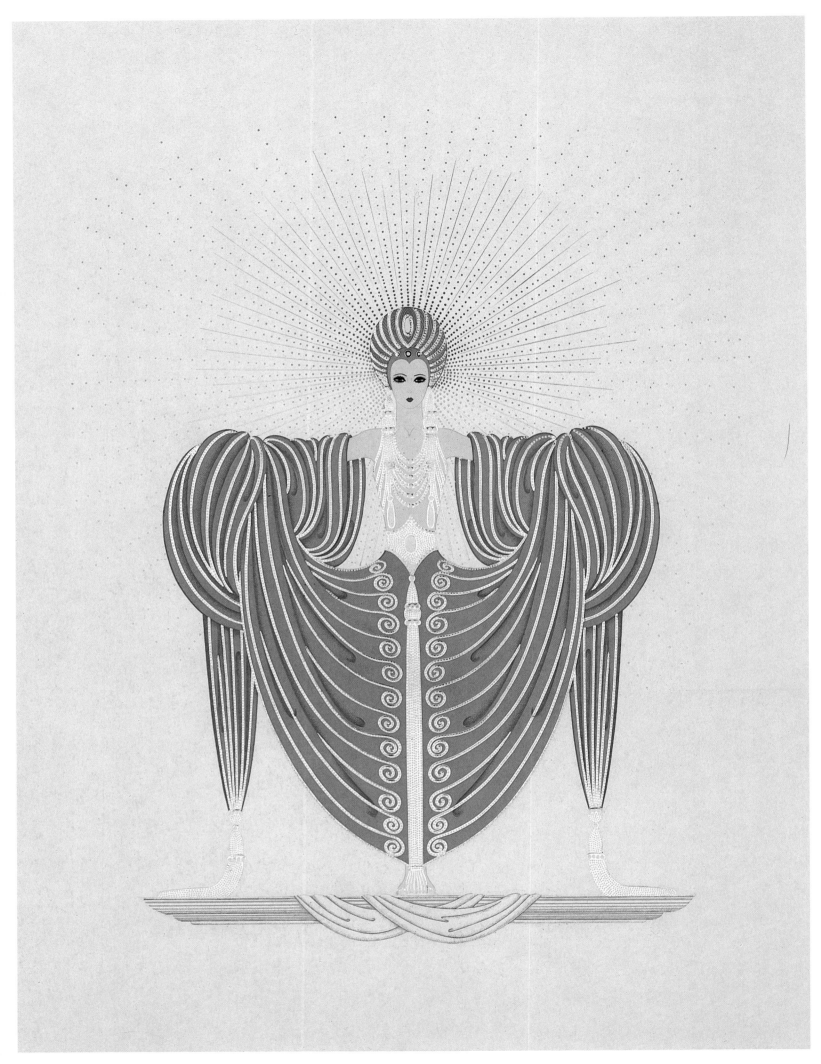

THE CELESTIAL VIRTUES SUITE
SÉRIE DES VERTUS CÉLESTES
SUITE LE VIRTÙ CELESTI
DIE HIMMELSTUGENDEN

Radiance
Rayonnement
Fulgore
Erleuchtung

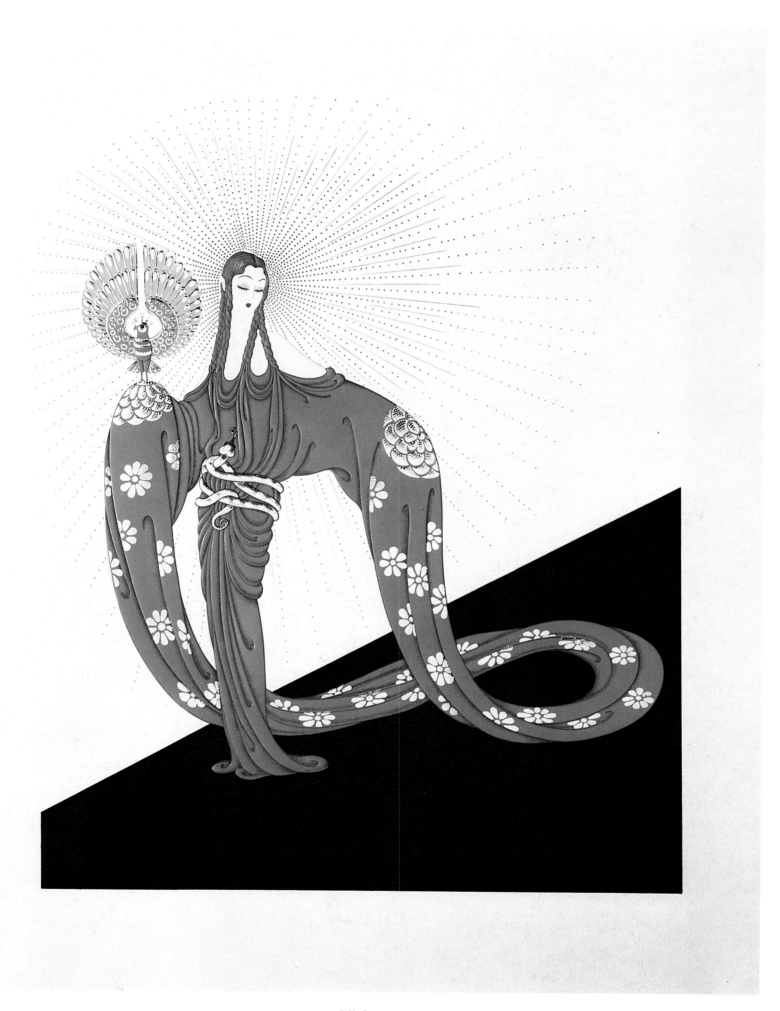

Wisdom
Sagesse
Saggezza
Weisheit

THE CELESTIAL VIRTUES SUITE
SÉRIE DES VERTUS CÉLESTES
SUITE LE VIRTÙ CELESTI
DIE HIMMELSTUGENDEN

73

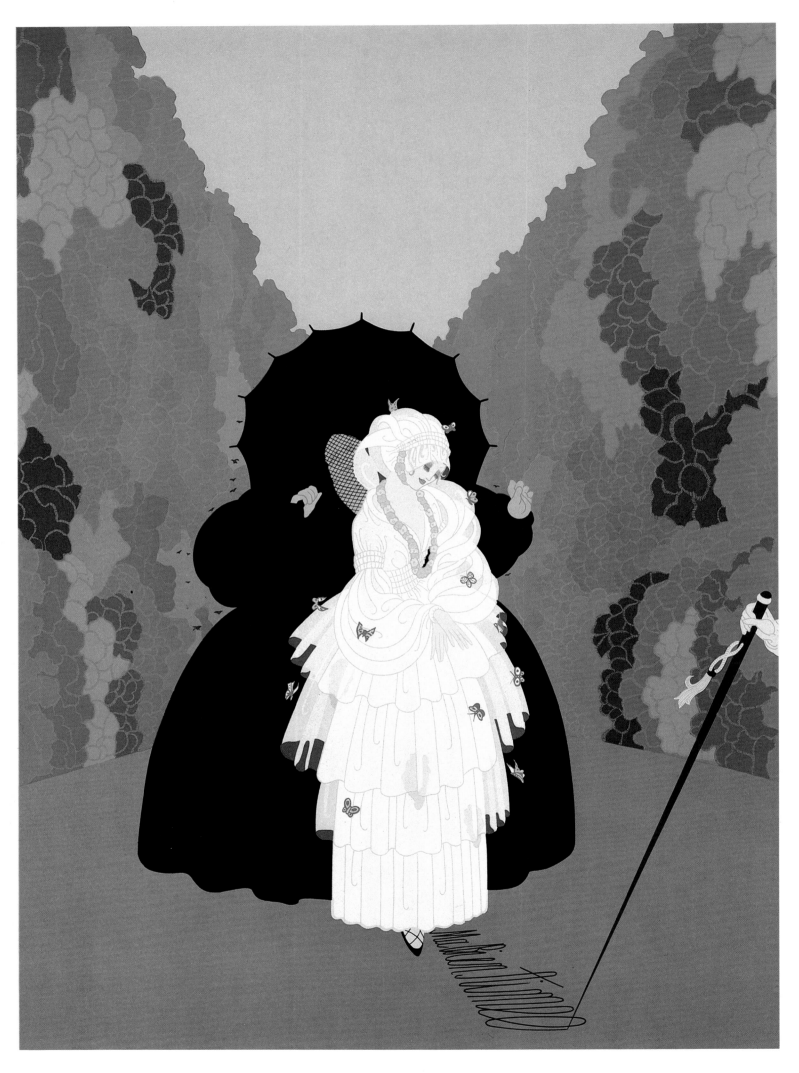

Debutante
Débutante
Debuttante
Die Debütantin

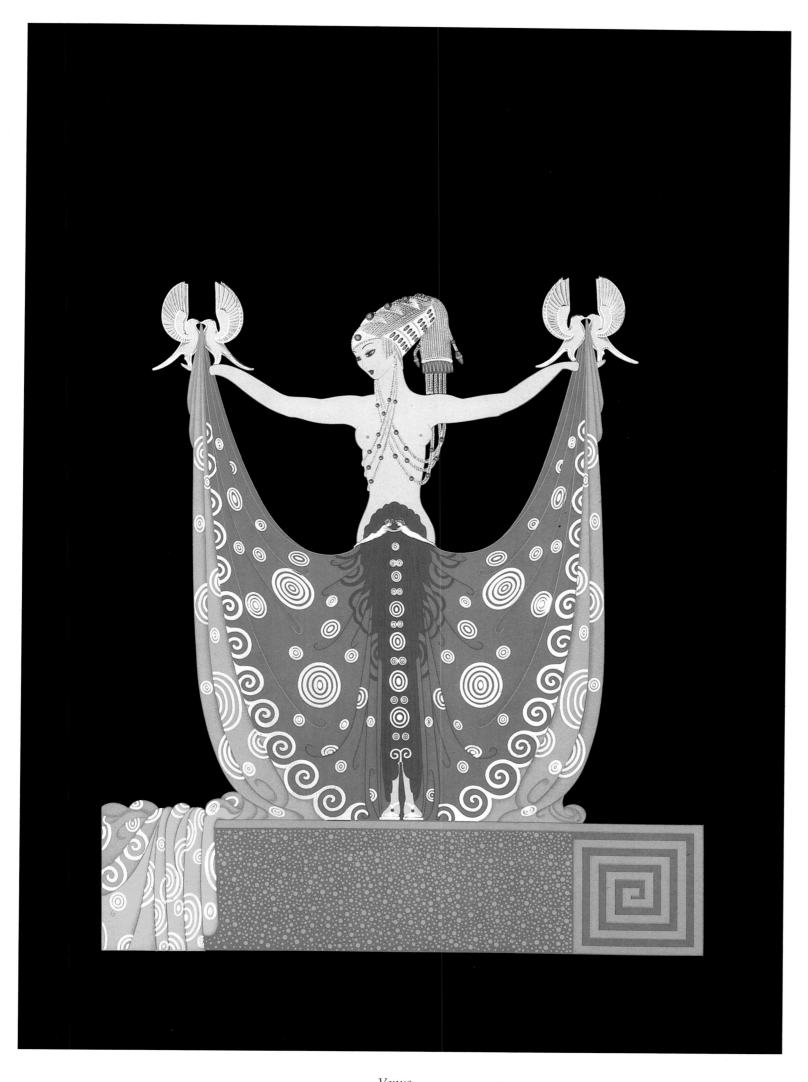

Venus
Vénus
Venere
Venus

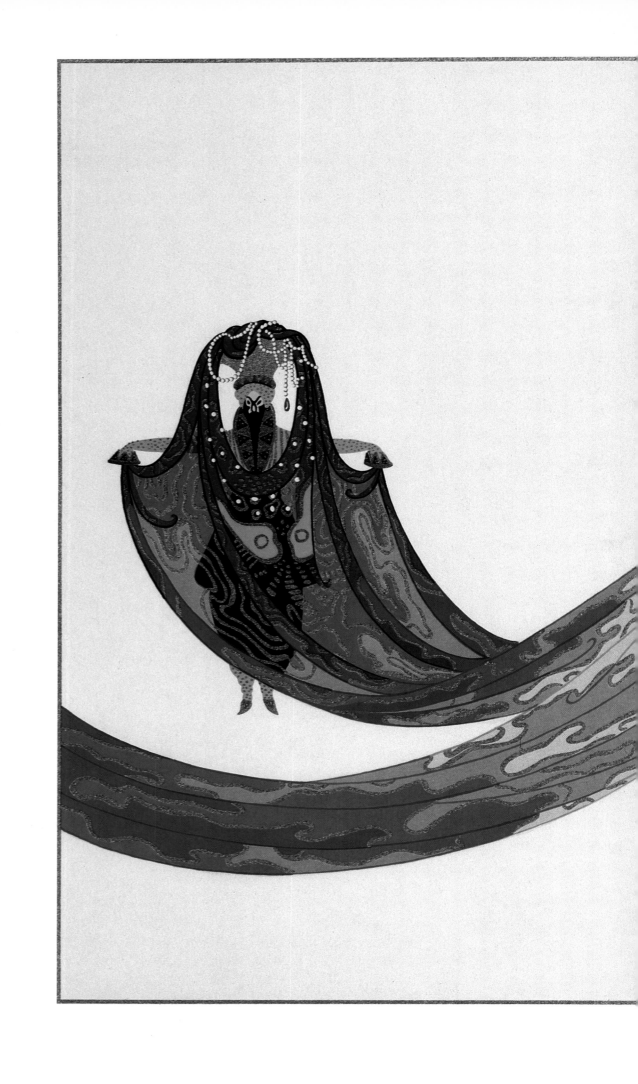

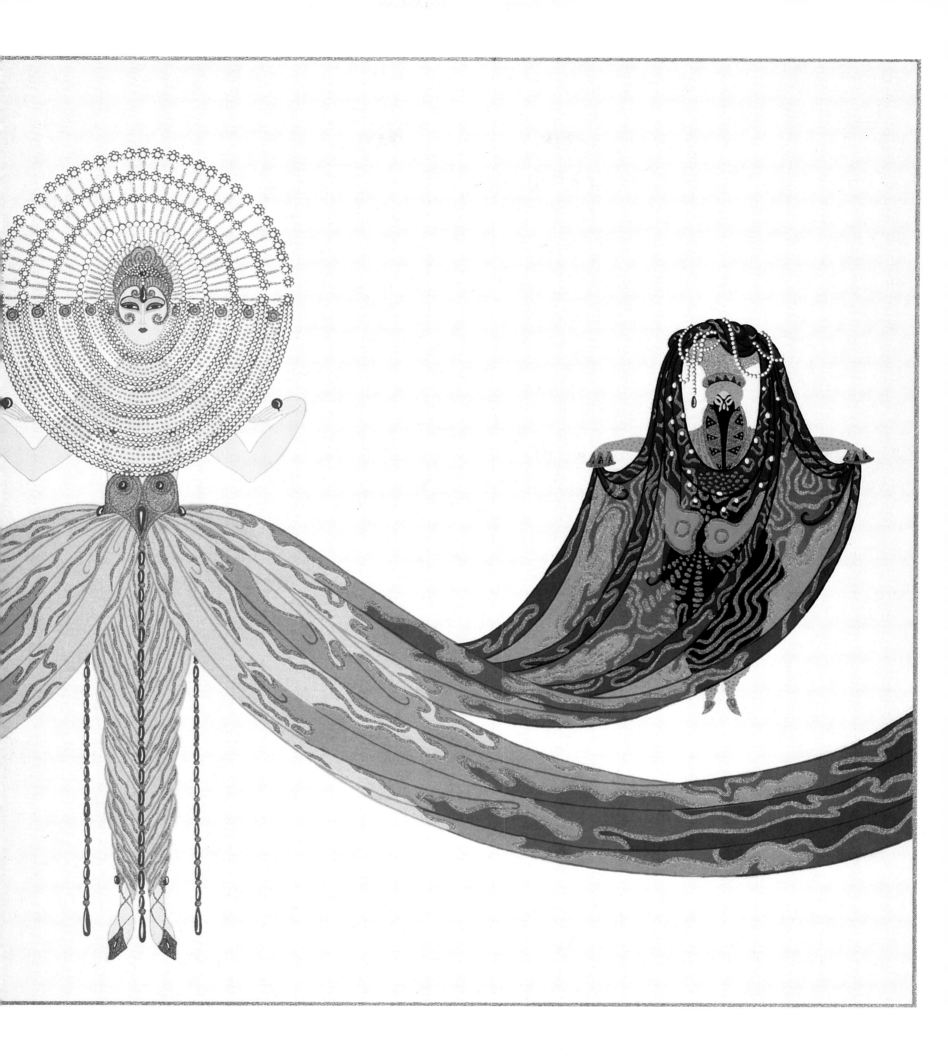

Méditerranée
Méditerranée
Mediterraneo
Das Mittelmeer

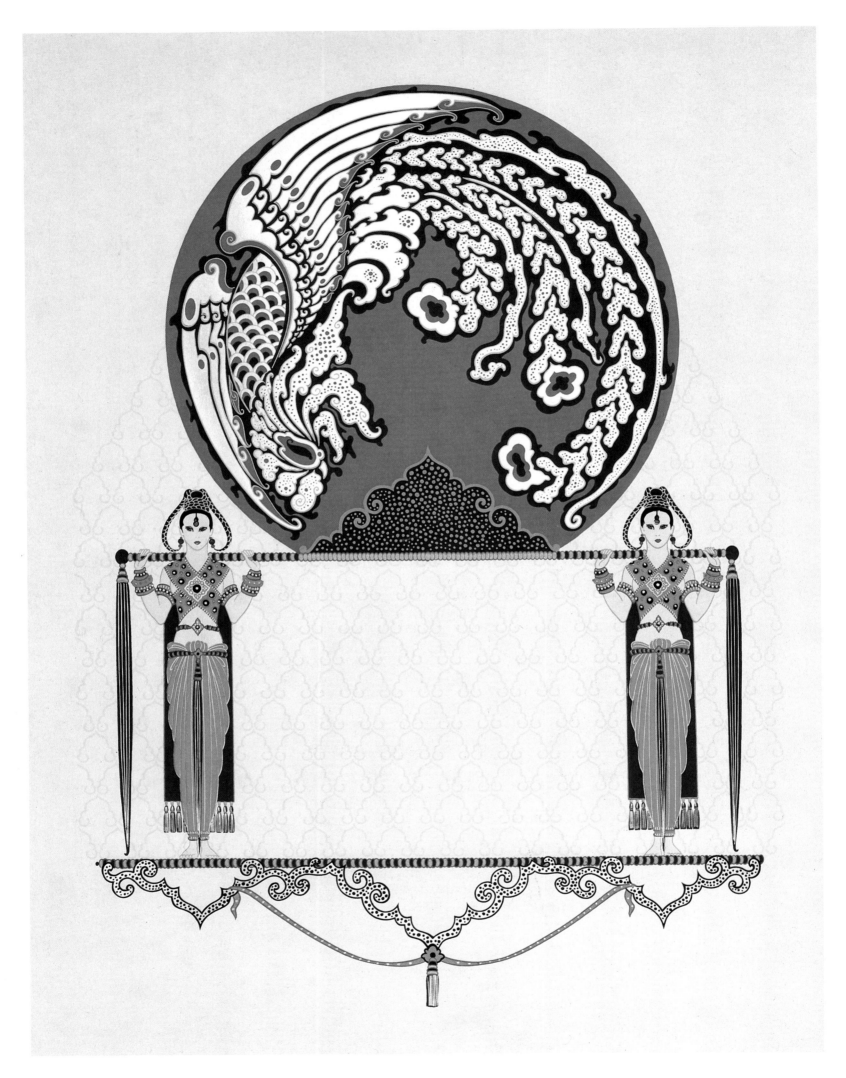

Blue Asia
Asie bleue
Asia azzurra
Asien-Blau

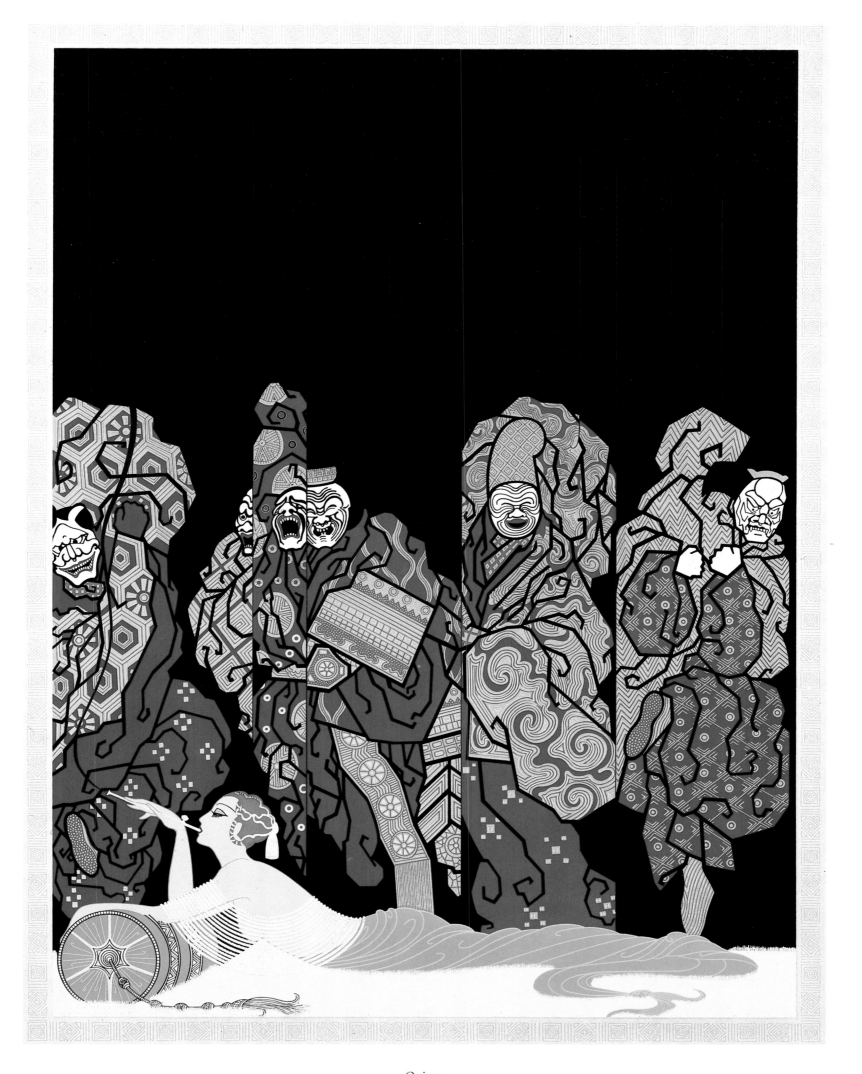

Opium
Opium
Oppio
Opium

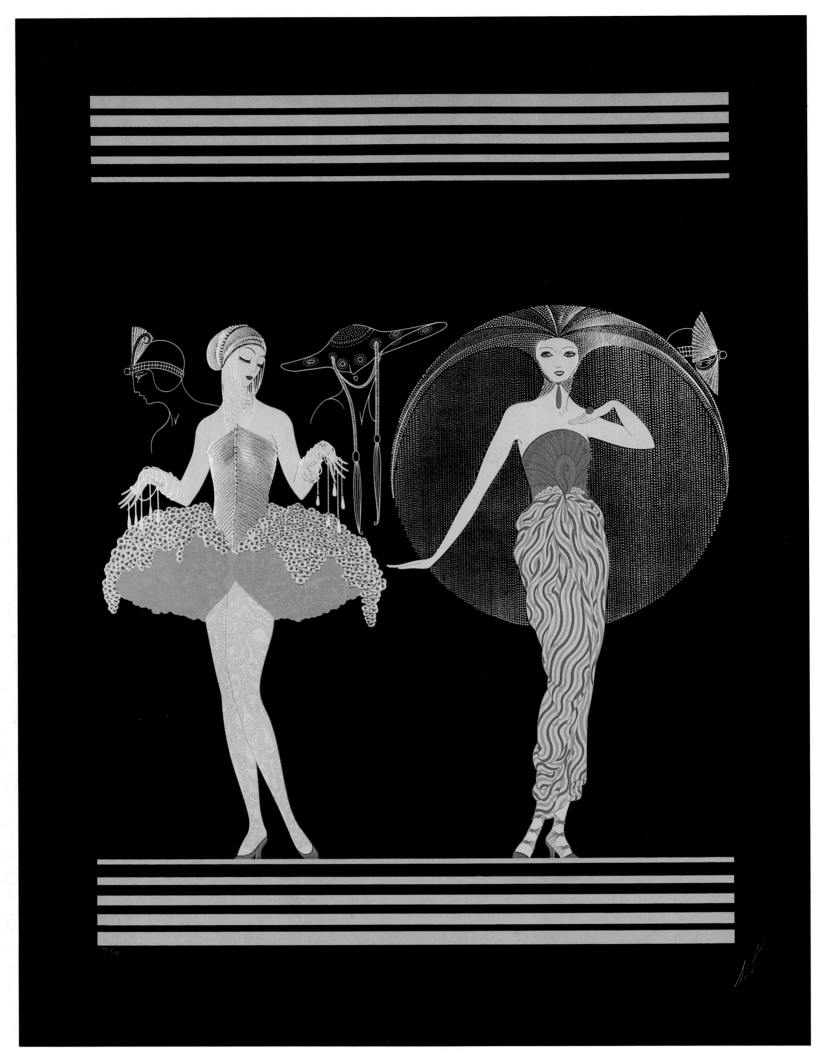

MORNING, DAY, EVENING, NIGHT SUITE
SÉRIE MATIN, JOUR, SOIR, NUIT
SUITE MATTINO, GIORNO, SERA, NOTTE
TAGESZEITEN

Morning, Day
Matin, jour
Mattino, Giorno
Morgen und Tag

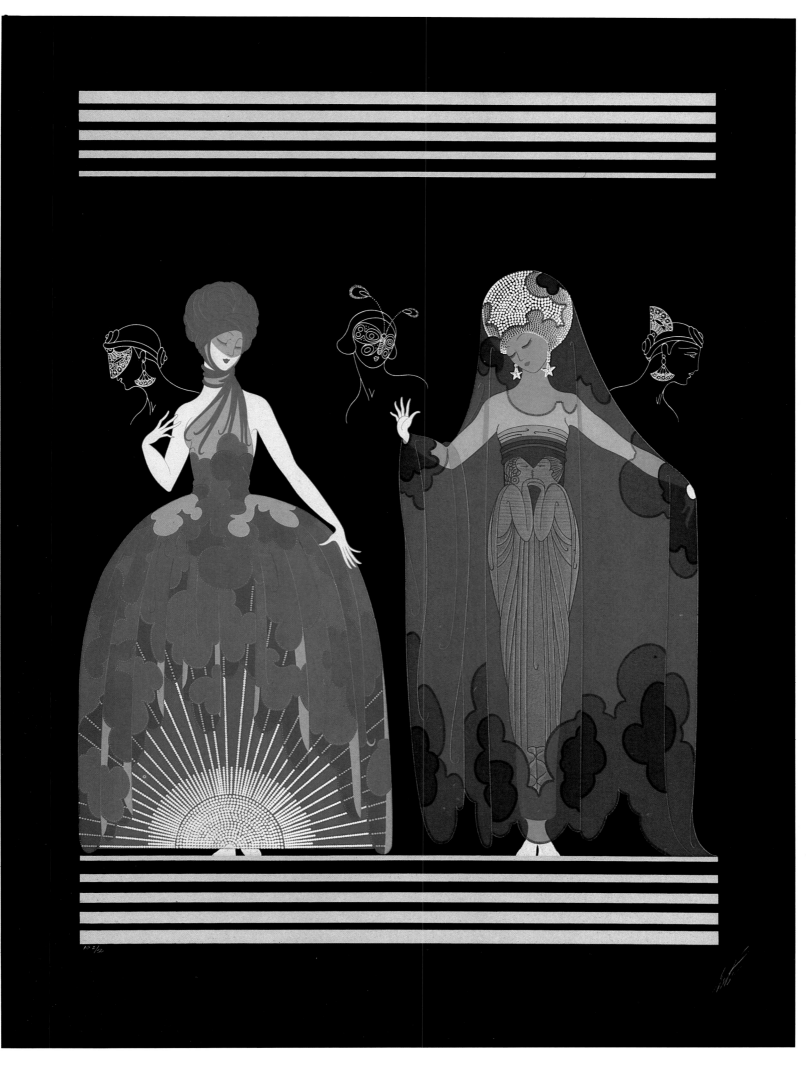

Evening, Night MORNING, DAY, EVENING, NIGHT SUITE
Soir, nuit SÉRIE MATIN, JOUR, SOIR, NUIT
Sera, Notte SUITE MATTINO, GIORNO, SERA, NOTTE
Abend und Nacht TAGESZEITEN

81

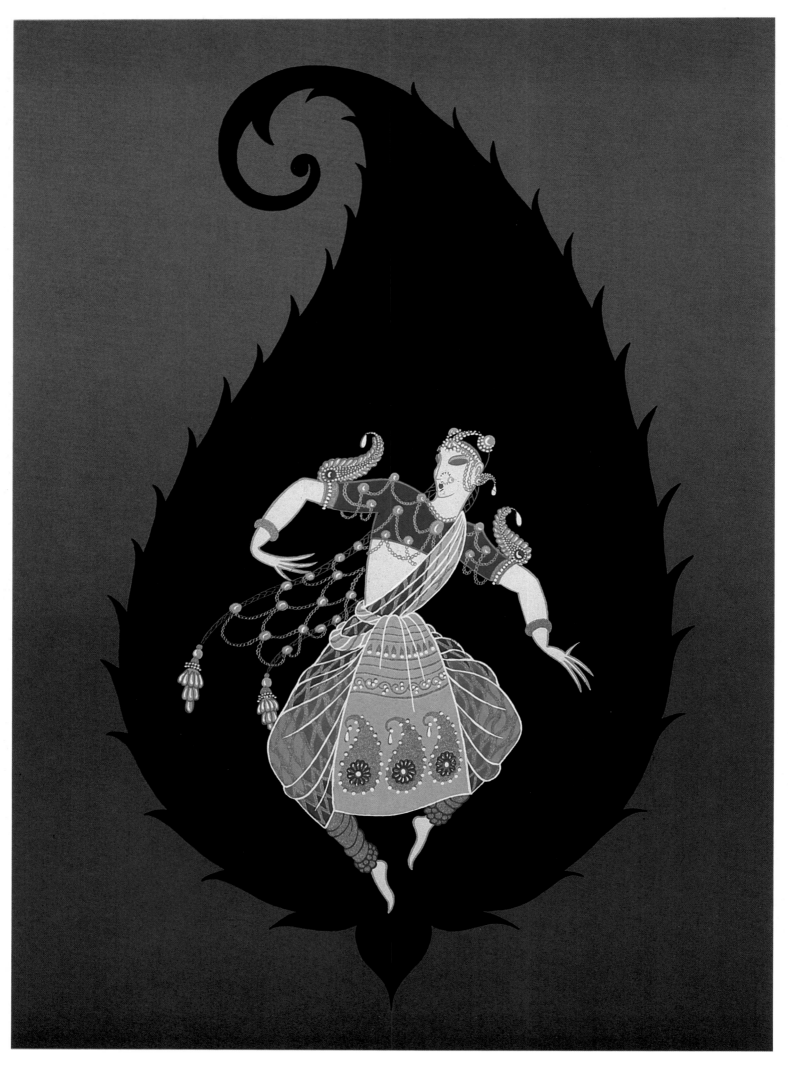

Bayadère
Bayadère
Baiadera
Bajadere

82

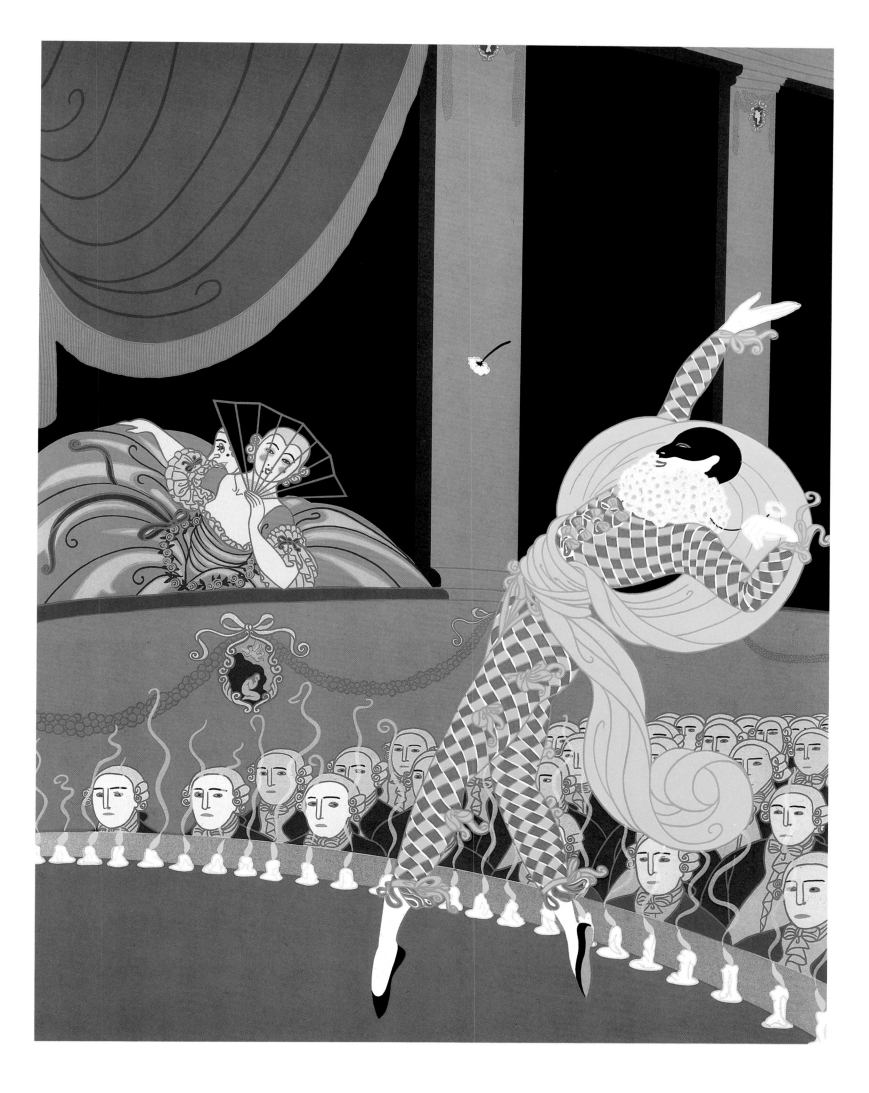

Harlequin
Arlequin
Arlecchino
Harlekin

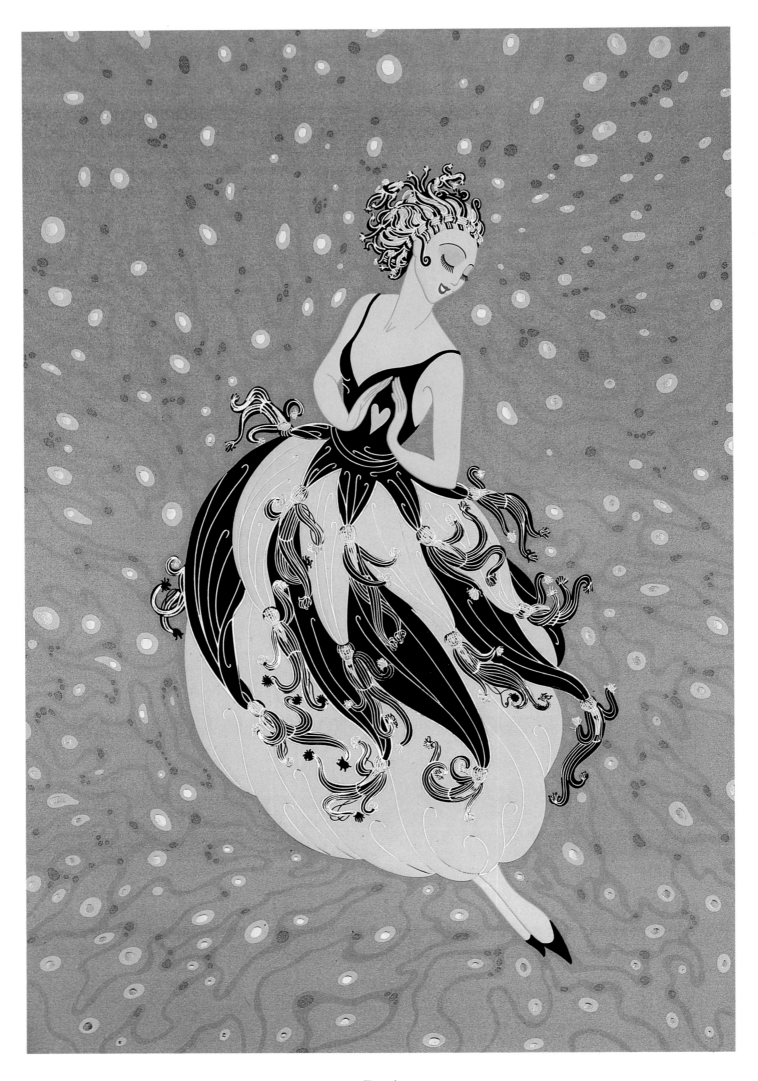

Tuxedo
Smoking
Smoking
Tuxedo

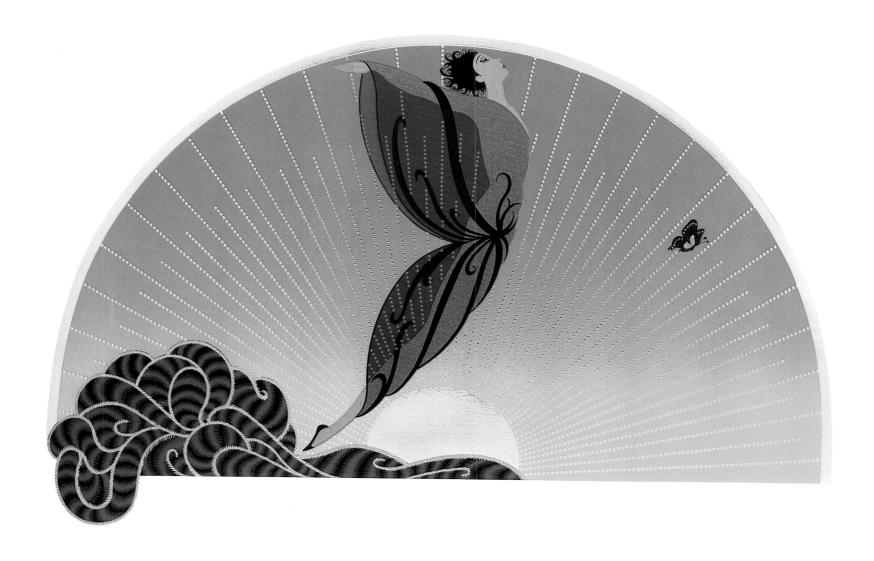

Sunrise
Soleil levant
Sole nascente
Sonnenaufgang

85

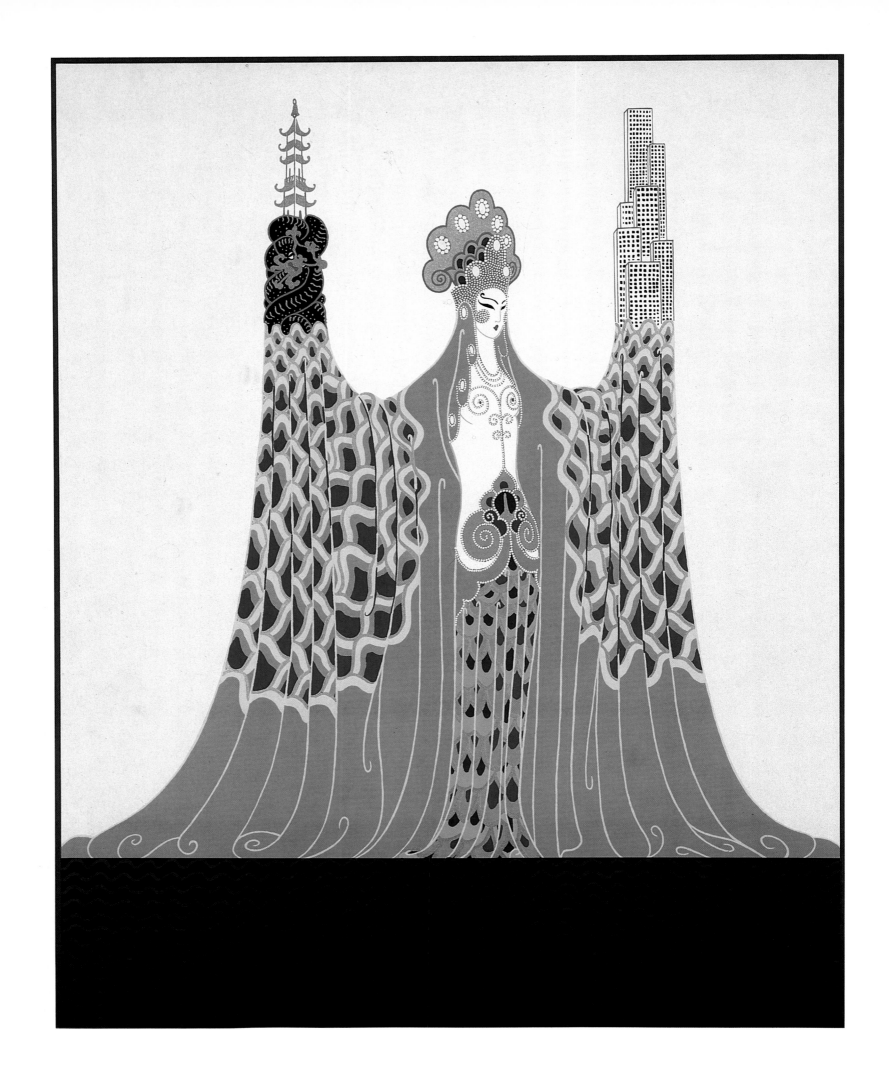

Océan pacifique
Océan pacifique
Oceano Pacifico
Pazifischer Ozean

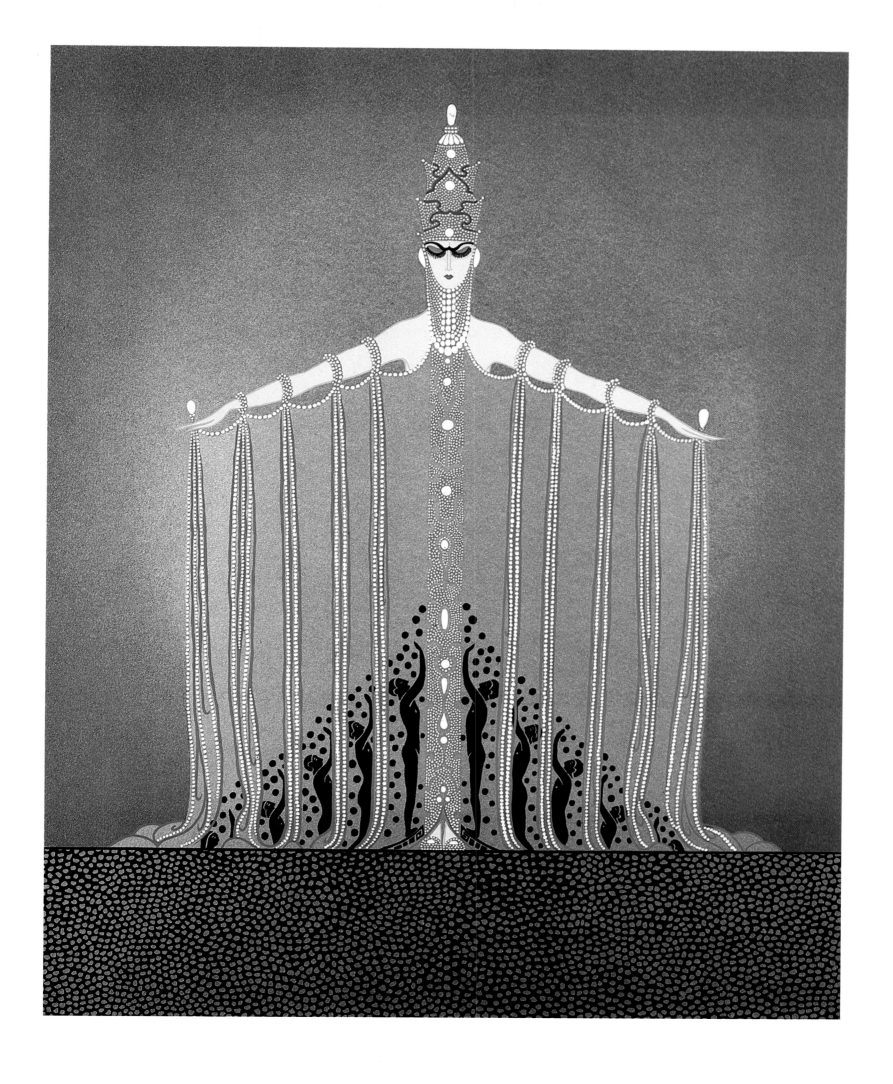

Adoration
Adoration
Adorazione
Anbetung

87

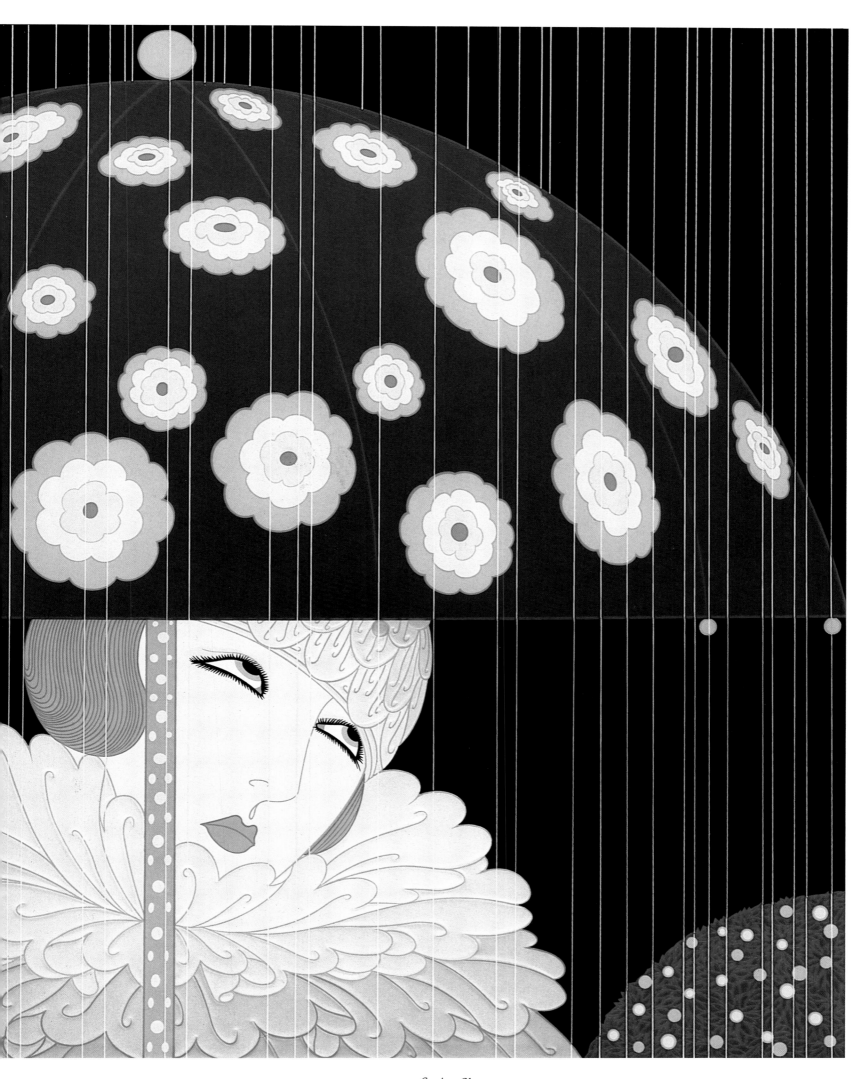

Spring Showers
Giboulées de printemps
Scrosci di primavera
Frühlingsregen

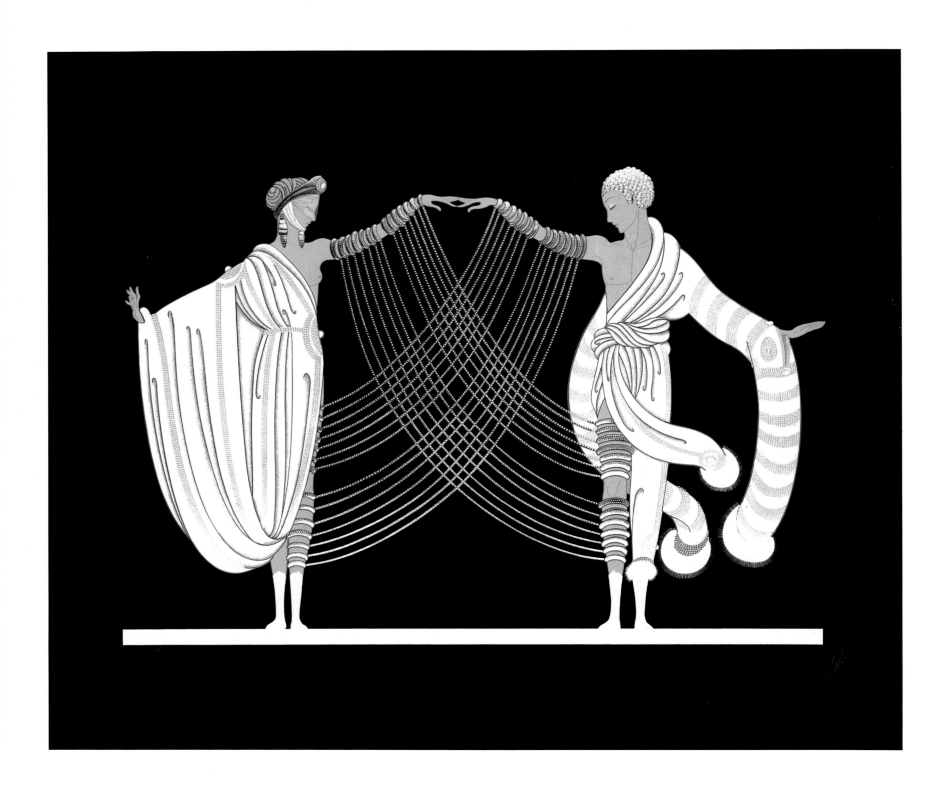

LOVE AND PASSION SUITE *Marriage Dance*
SÉRIE AMOUR ET PASSION *Danse nuptiale*
SUITE AMORE E PASSIONE *Danza nuziale*
LIEBE UND LEIDENSCHAFT *Hochzeitstanz*

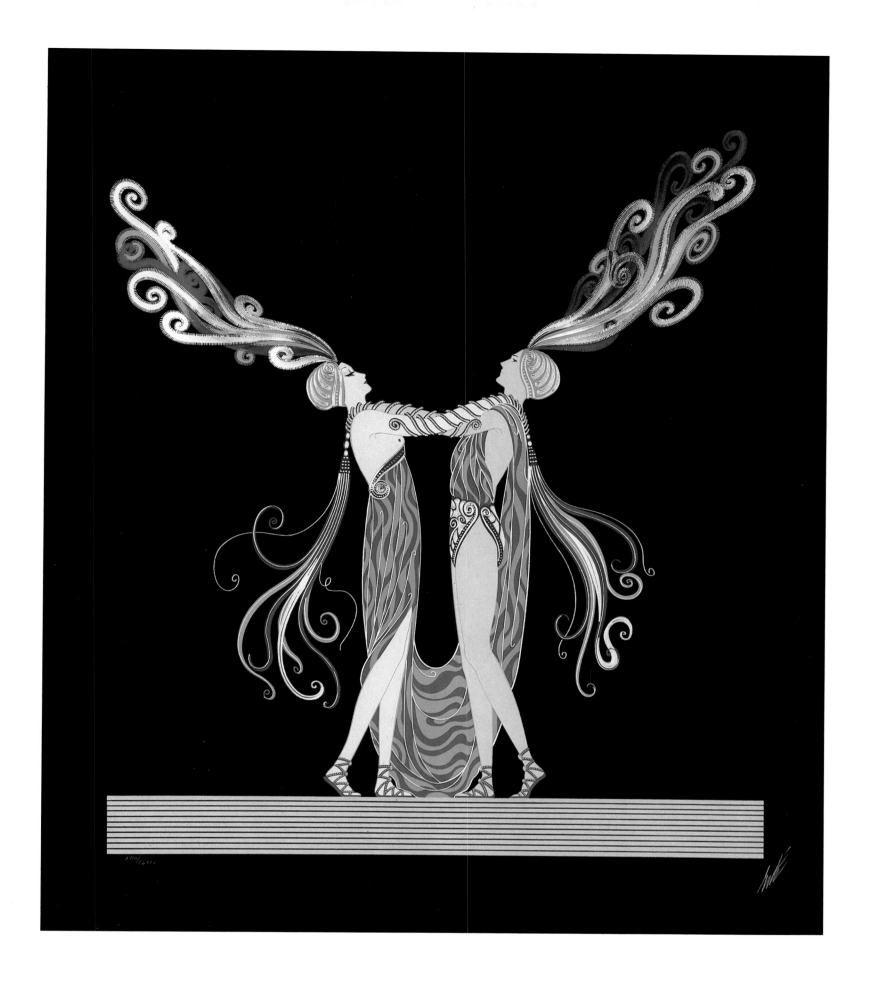

Kiss of Fire
Baiser de feu
Bacio di fuoco
Feuerkuss

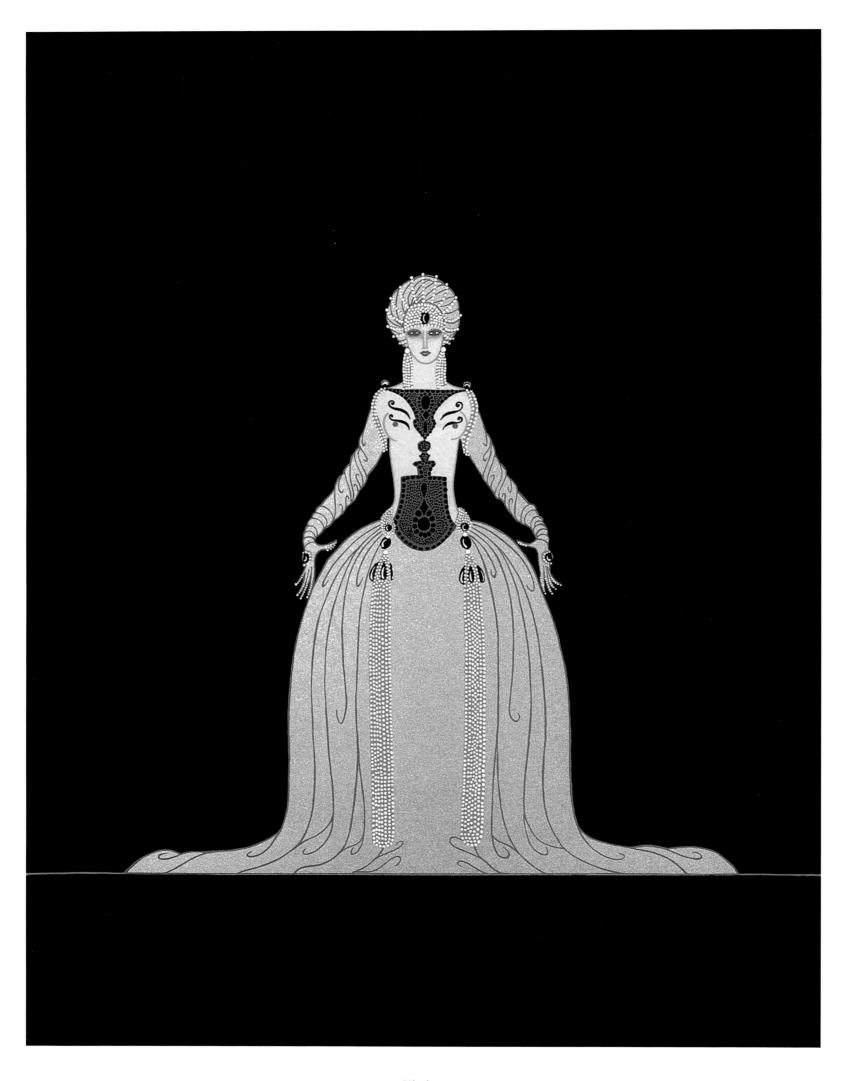

Kissing
Baiser
Il bacio
Das Küssen

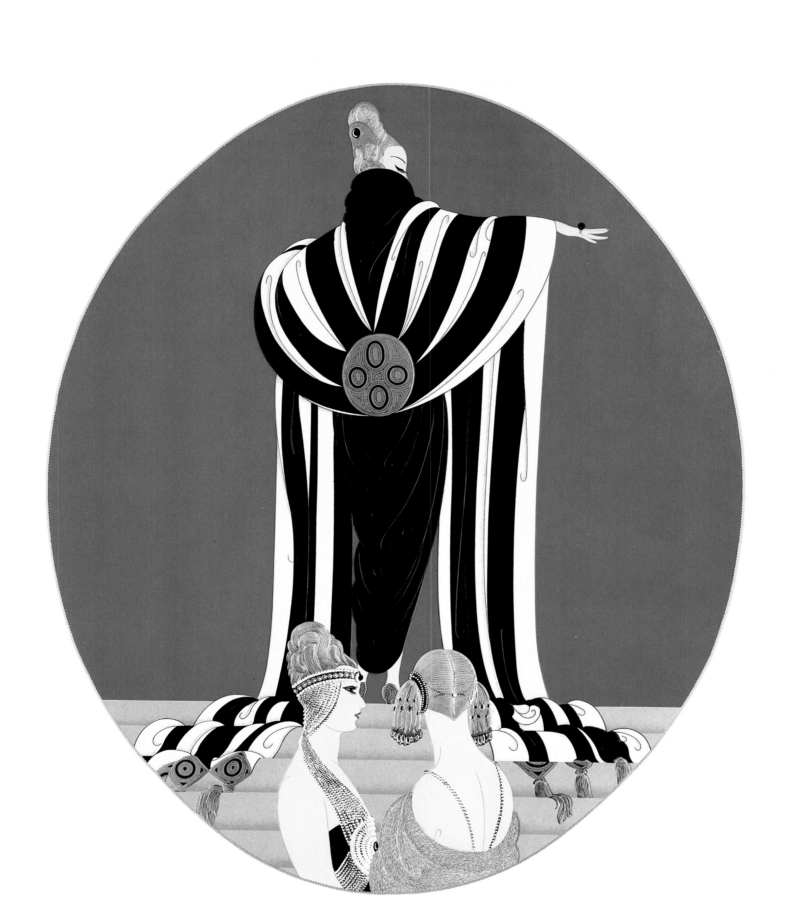

Monaco
Monaco
Monaco
Monaco

93

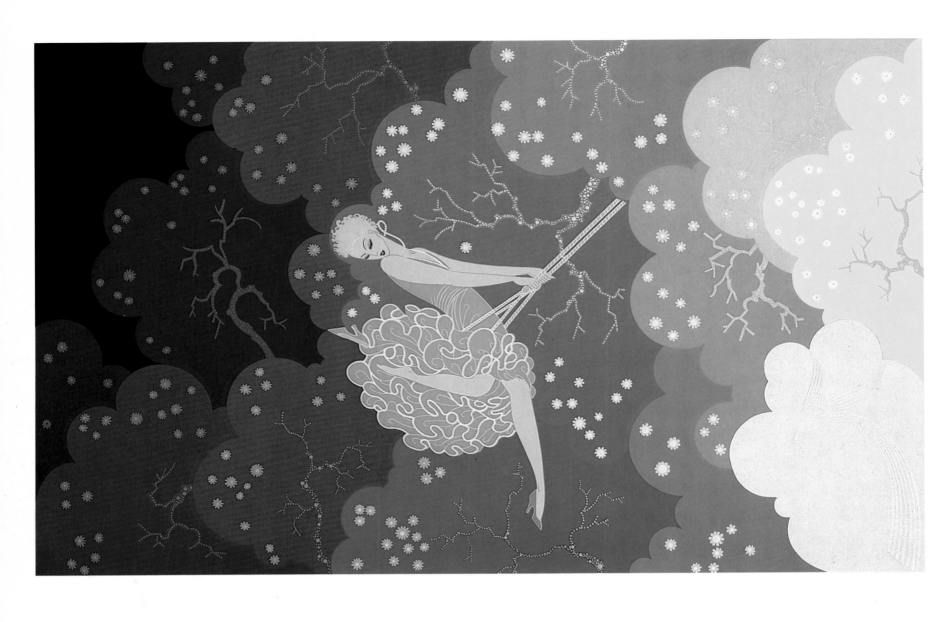

The Swing
La Balançoire
L'altalena
Die Wippe

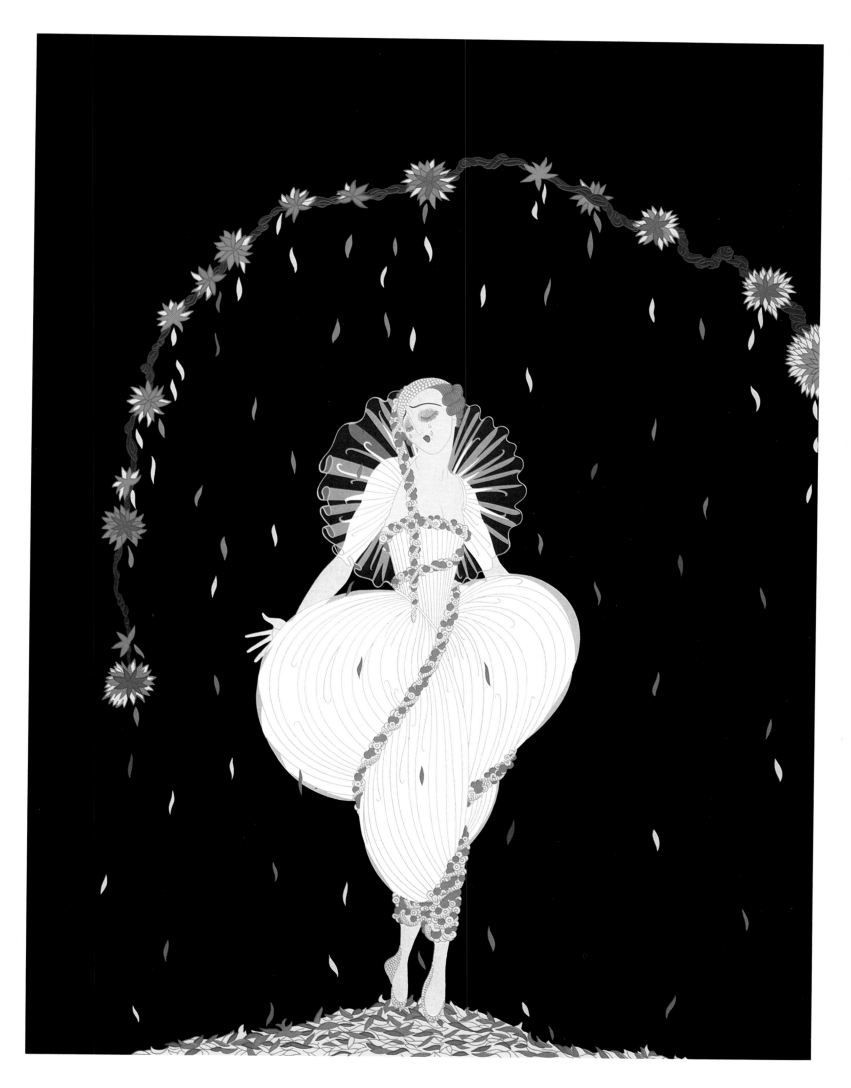

Columbine
Colombine
Colombina
Columbine

95

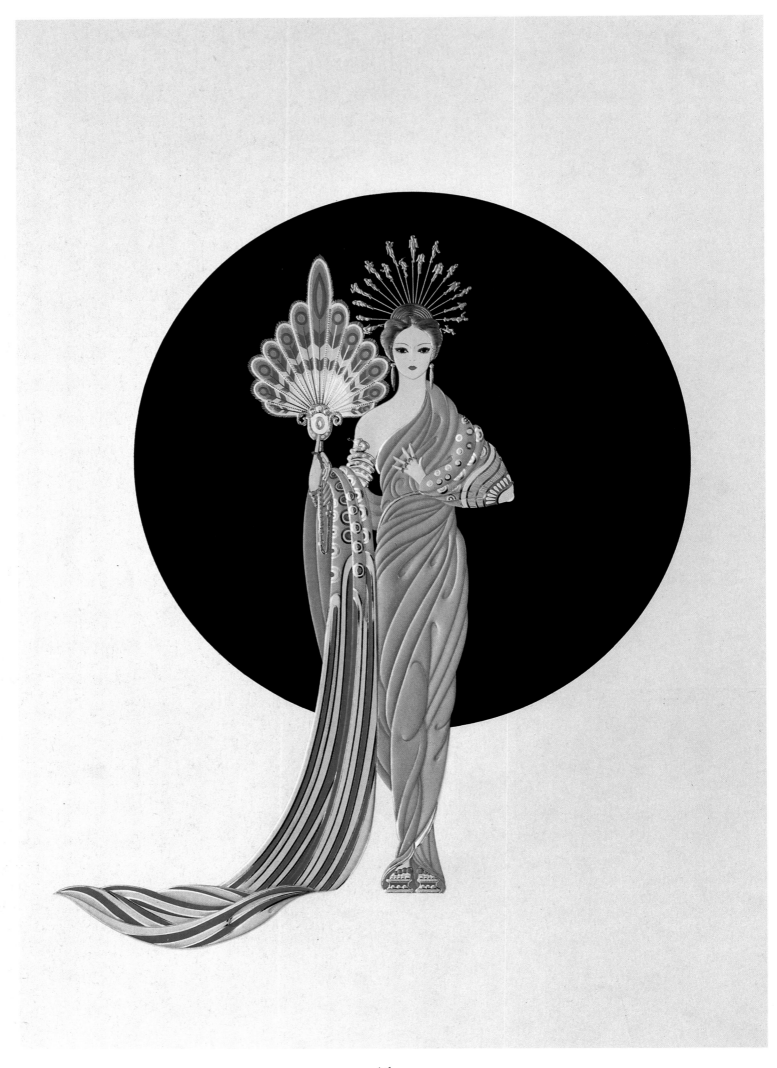

Athena
Athéna
Atena
Athena

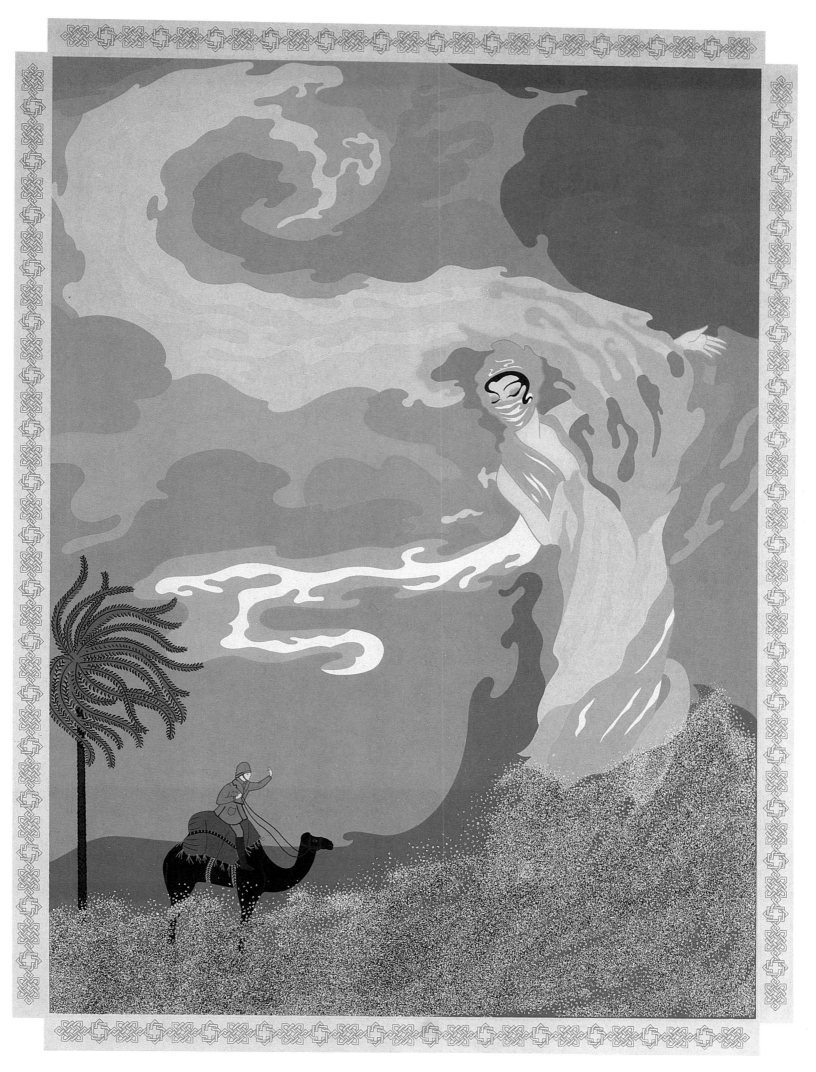

Sandstorm
Tempête de sable
Tempesta di sabbia
Wüstensturm

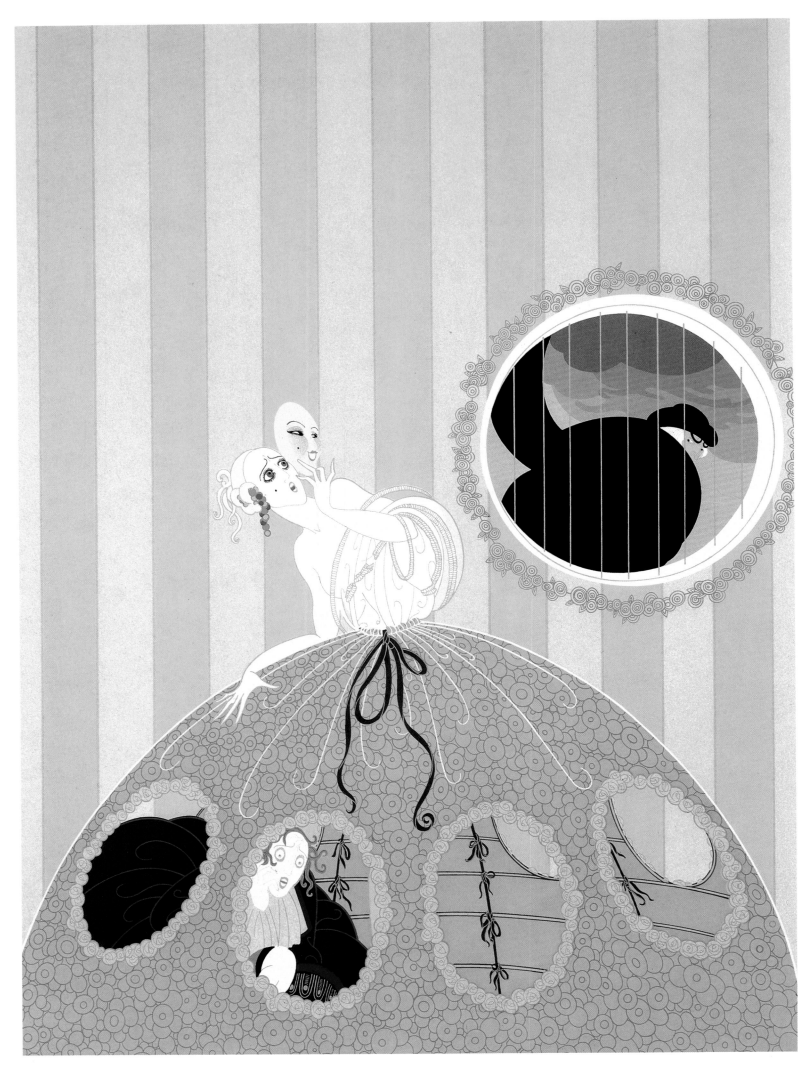

Deception
Trompe-l'œil
Inganno
Die Täuschung

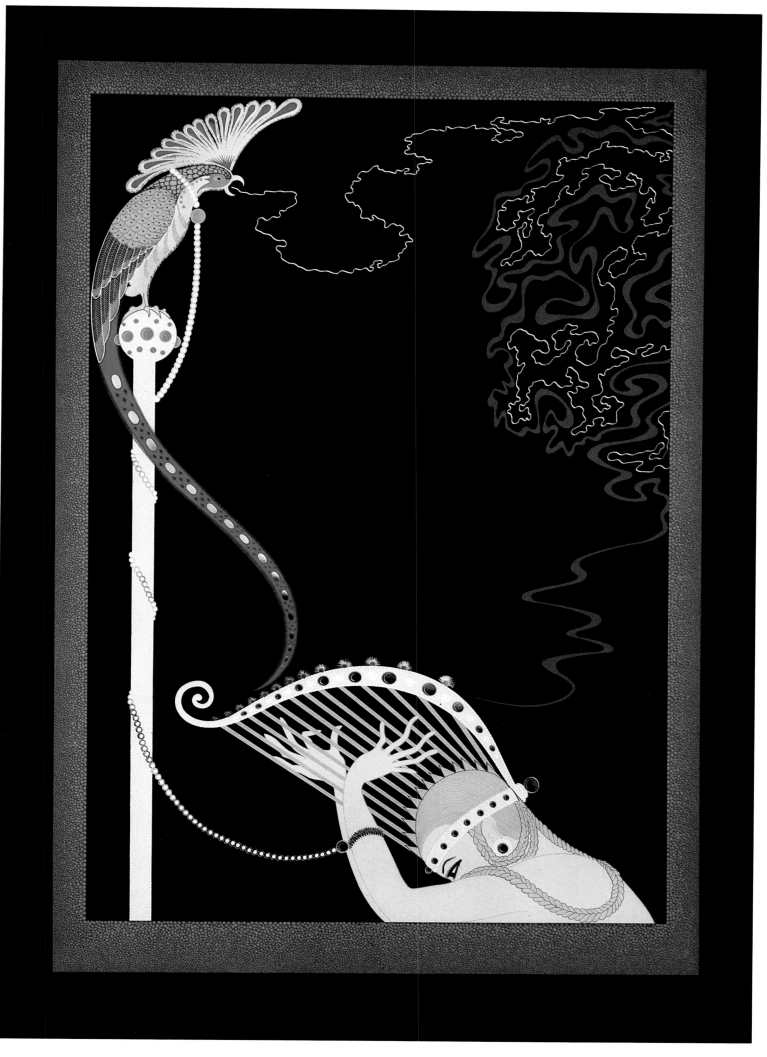

Enchanted Melody
Mélodie ensorcelée
Melodia incantata
Zauberische Melodie

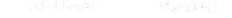

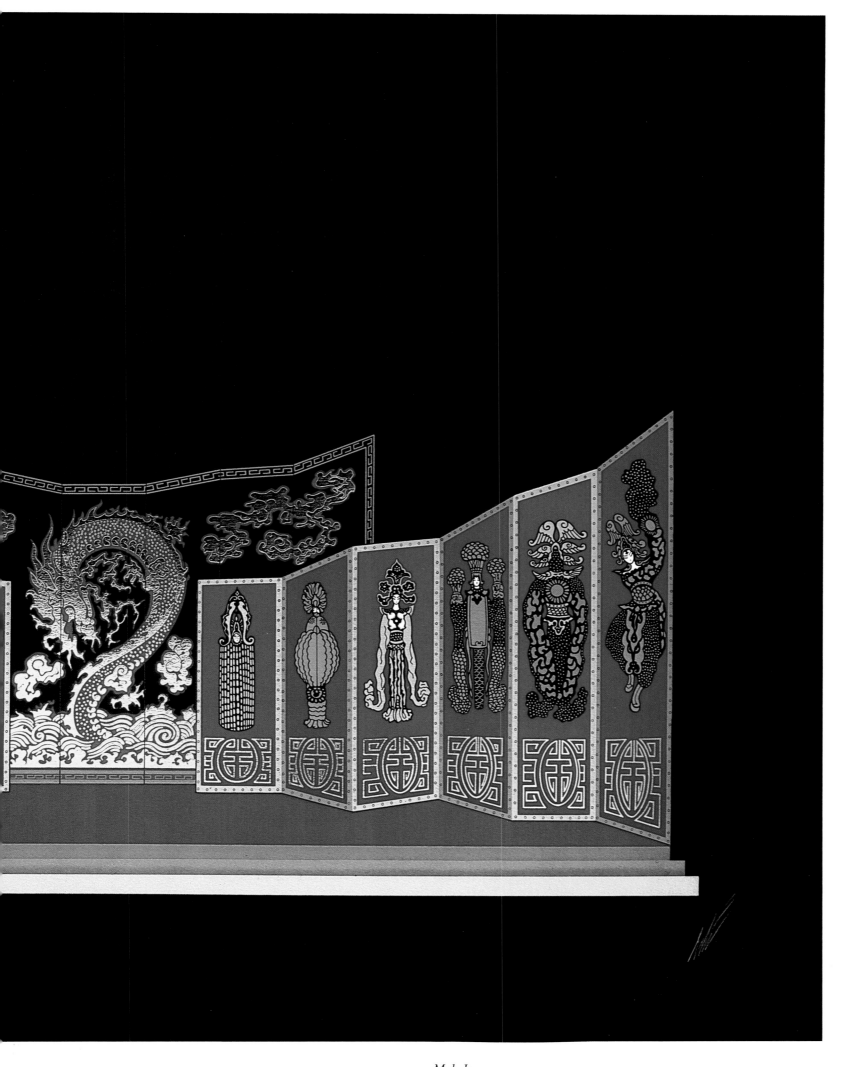

Mah-Jongg
Mah-jong
Mah-Jongg
Mah-Jongg

101

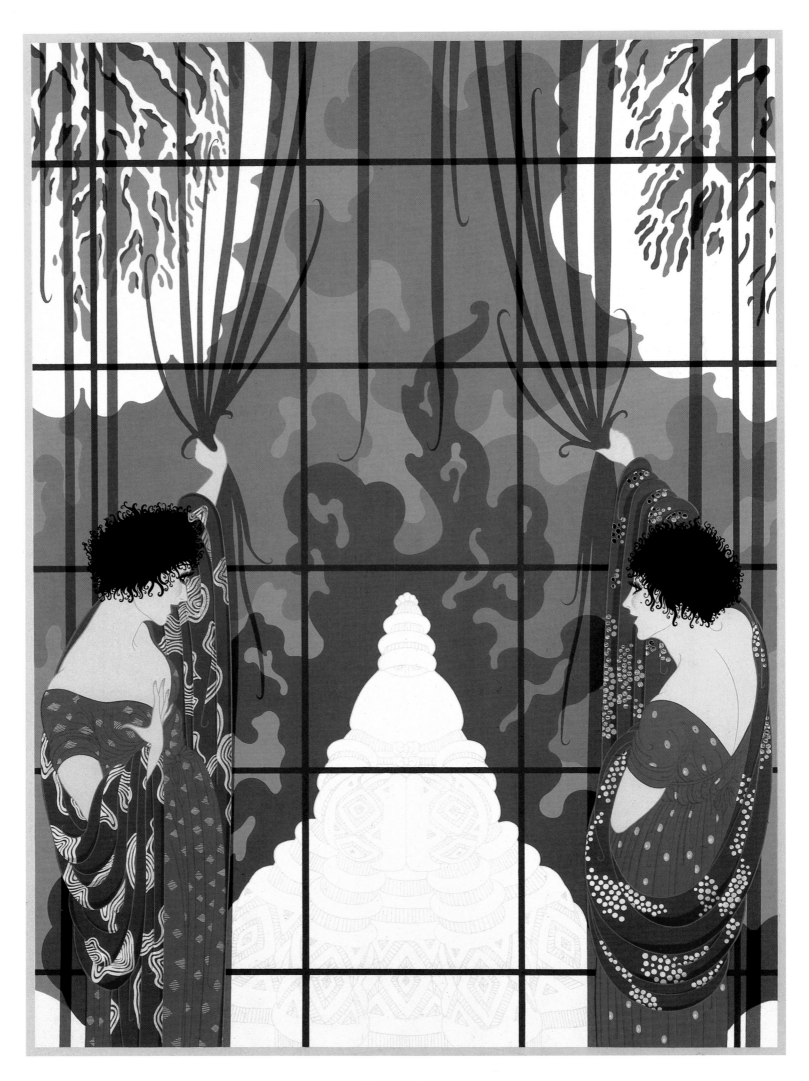

Winter's Arrival
Arrivée de l'hiver
L'arrivo dell'inverno
Der Winter ist da

Moonlight
Clair de lune
Chiaro di luna
Mondlicht

103

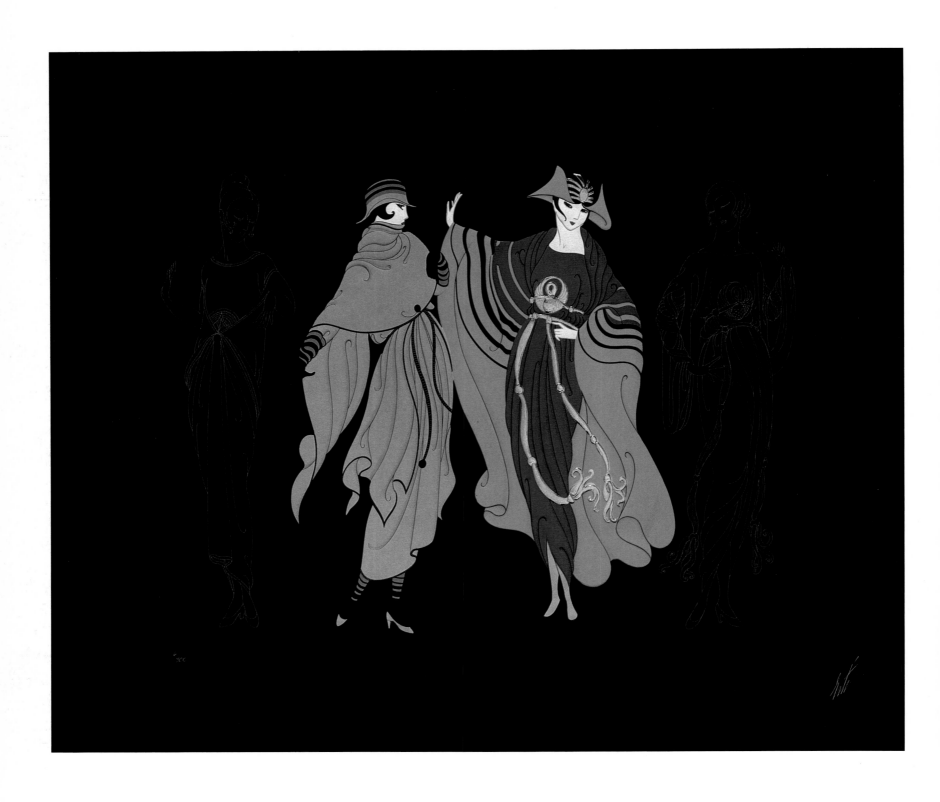

METROPOLIS SUITE *On the Avenue*
SÉRIE METROPOLIS *Sur l'avenue*
SUITE METROPOLIS *Lungo il viale*
METROPOLIS *Promenade*

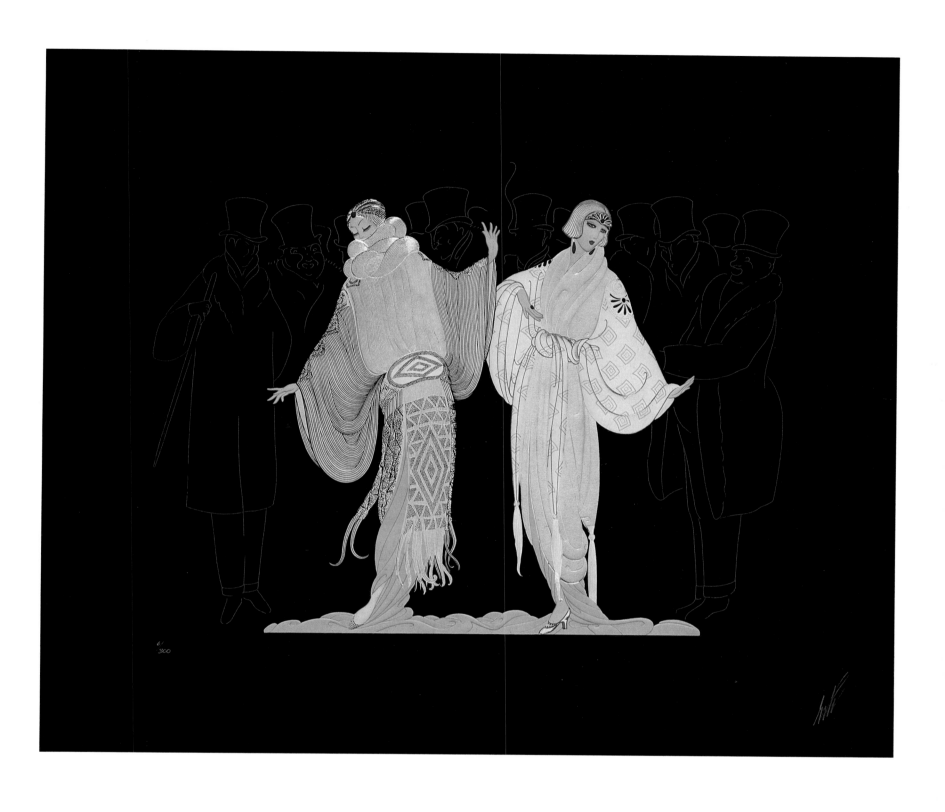

Opening Night
Première de gala
La sera della prima
Premiere

105

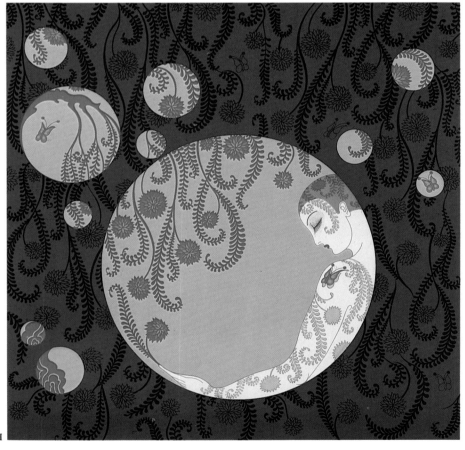

Spring Shadows I
Ombres printanières I
Ombre di Primavera I
Frühlingsschatten I

Spring Shadows III
Ombres printanières III
Ombre di Primavera III
Frühlingsschatten III

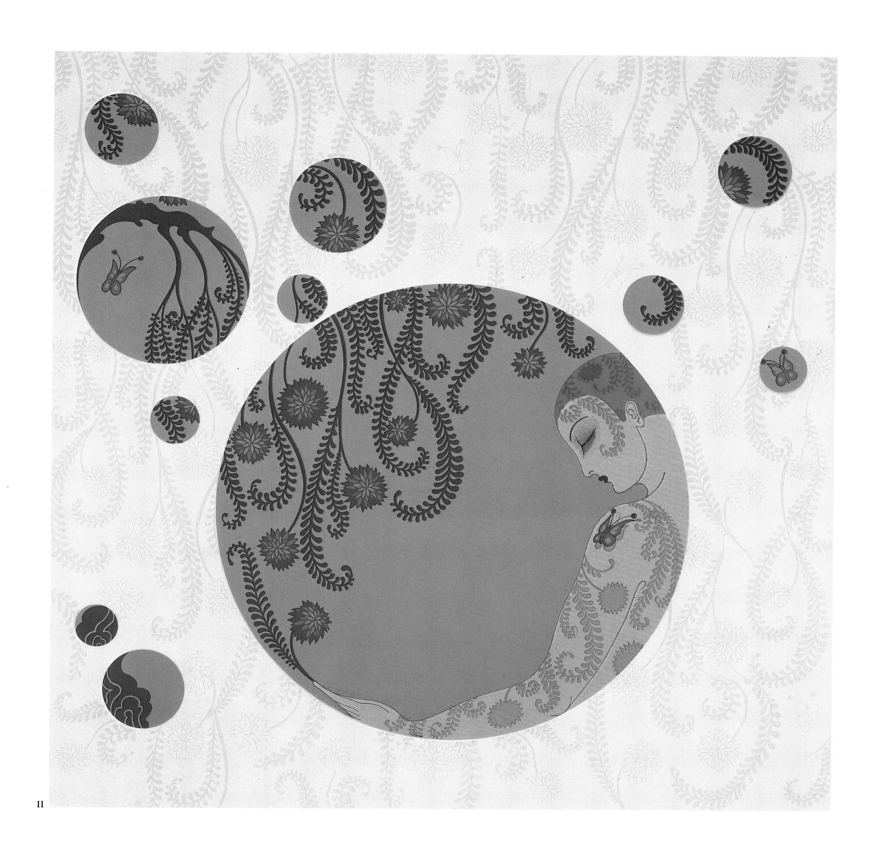

II

Spring Shadows II
Ombres printanières II
Ombre di Primavera II
Frühlingsschatten II

107

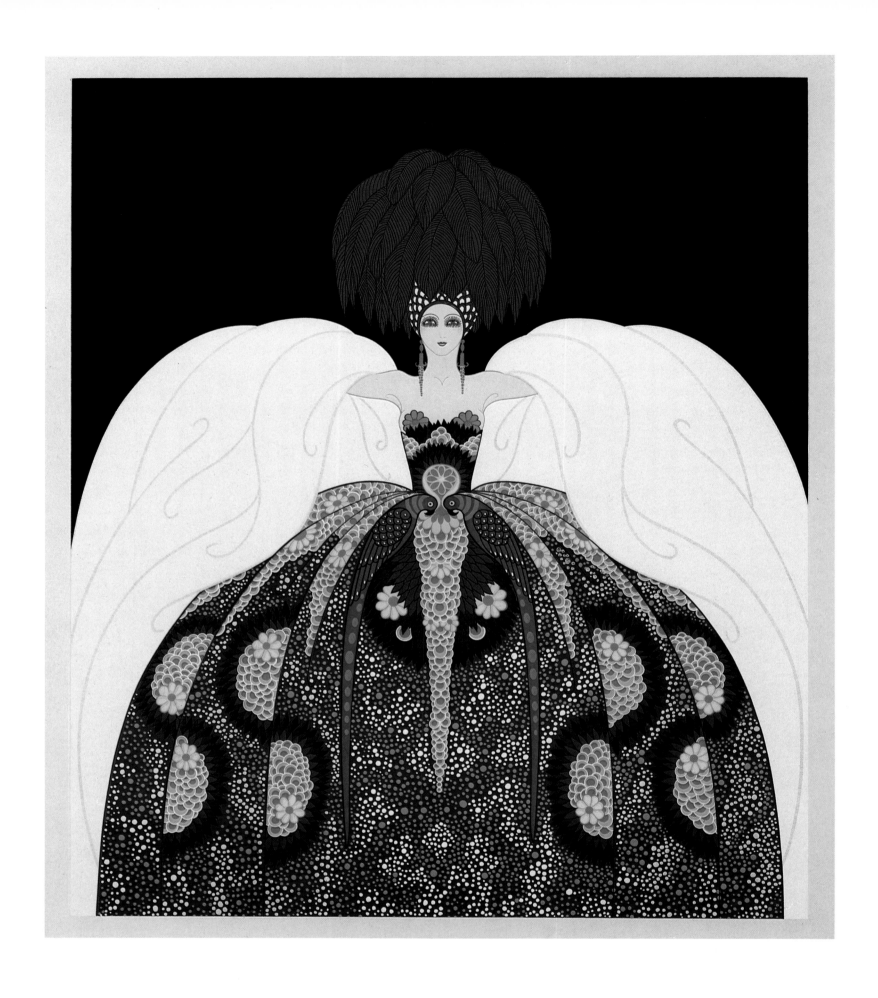

Copacabana
Copacabana
Copacabana
Copacabana

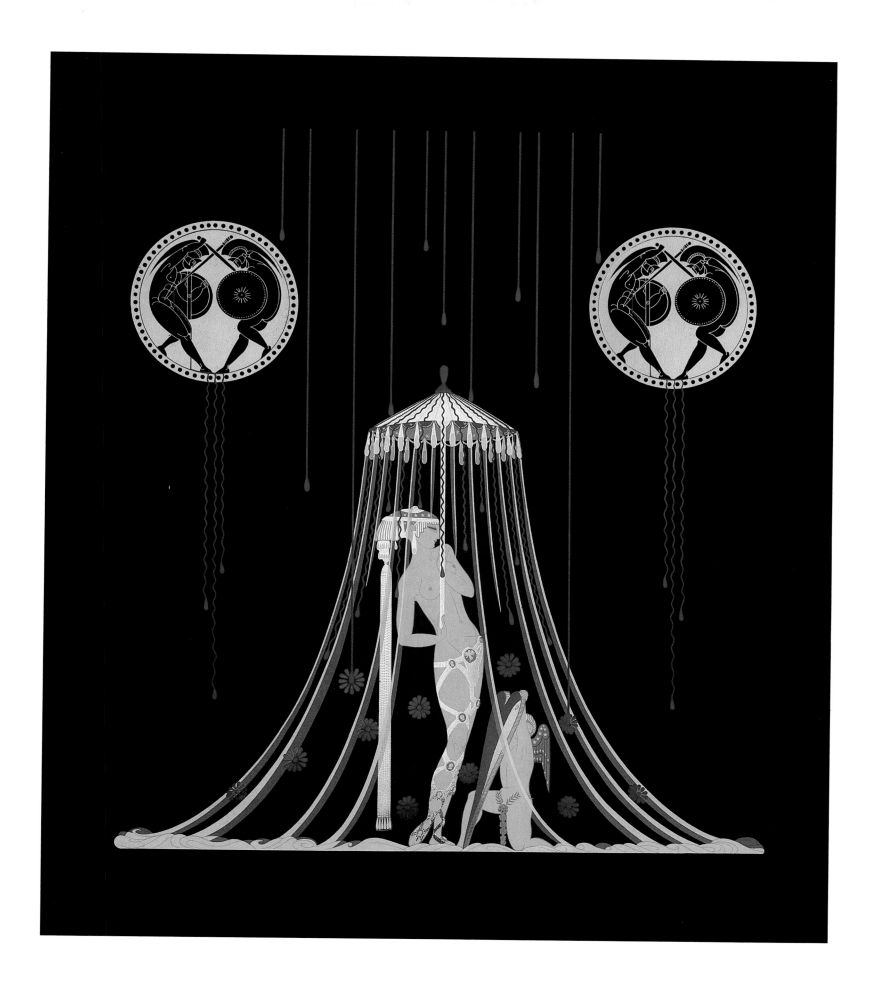

Helen of Troy
Hélène de Troie
Elena di Troia
Die schöne Helena

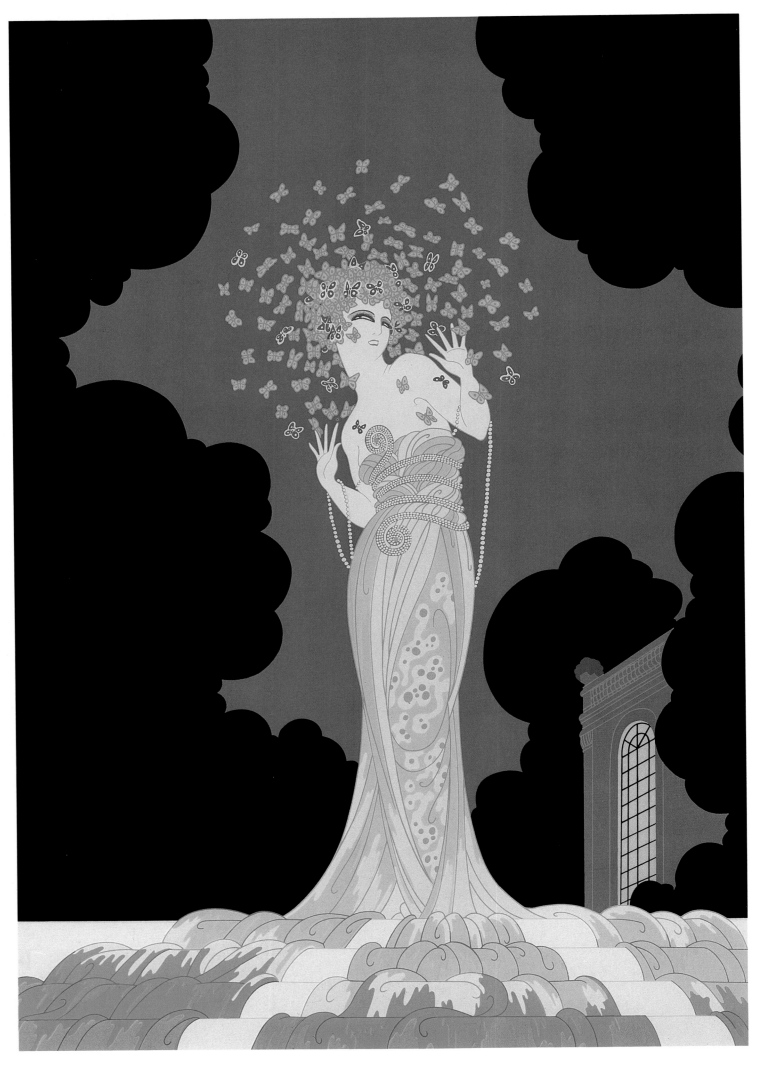

Fantasia
Fantaisie
Fantasia
Phantasie

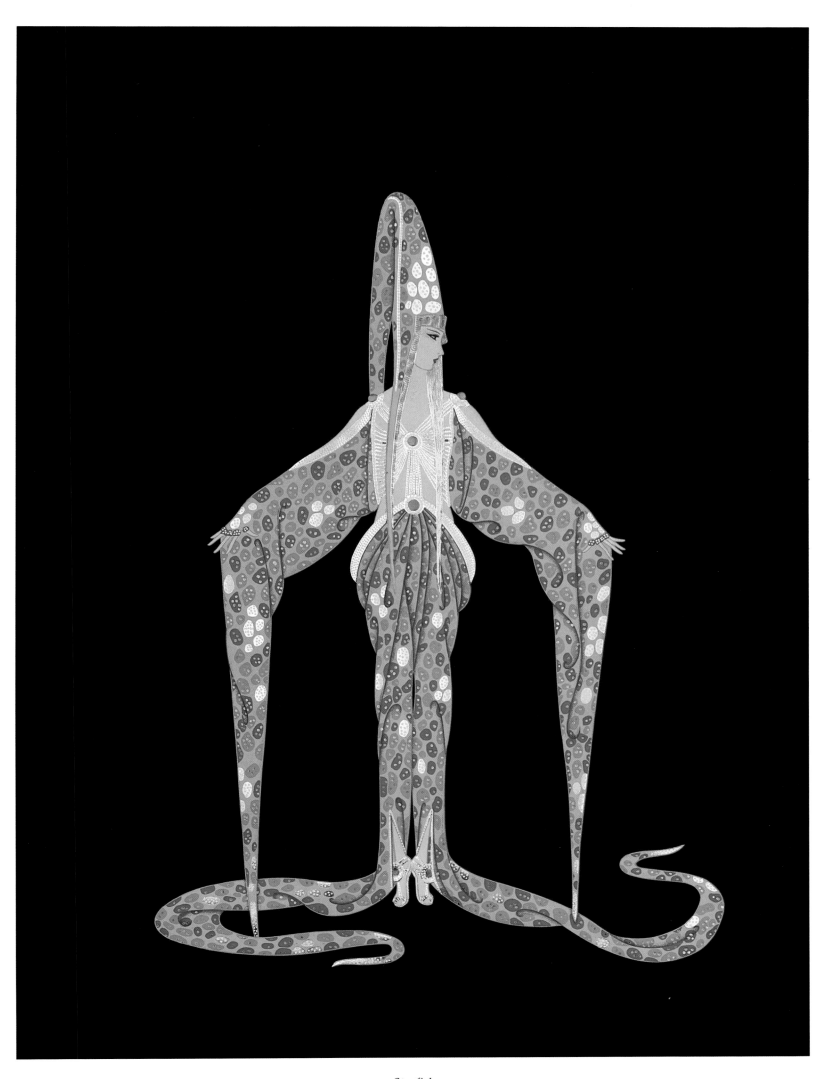

Starfish
Étoile de mer
Stella di mare
Seestern

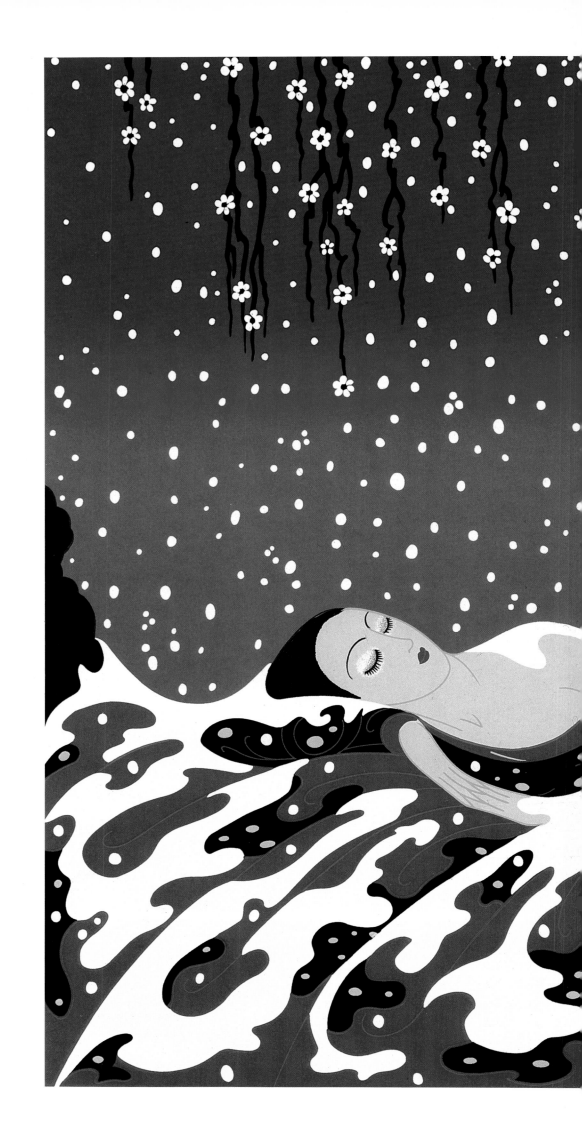

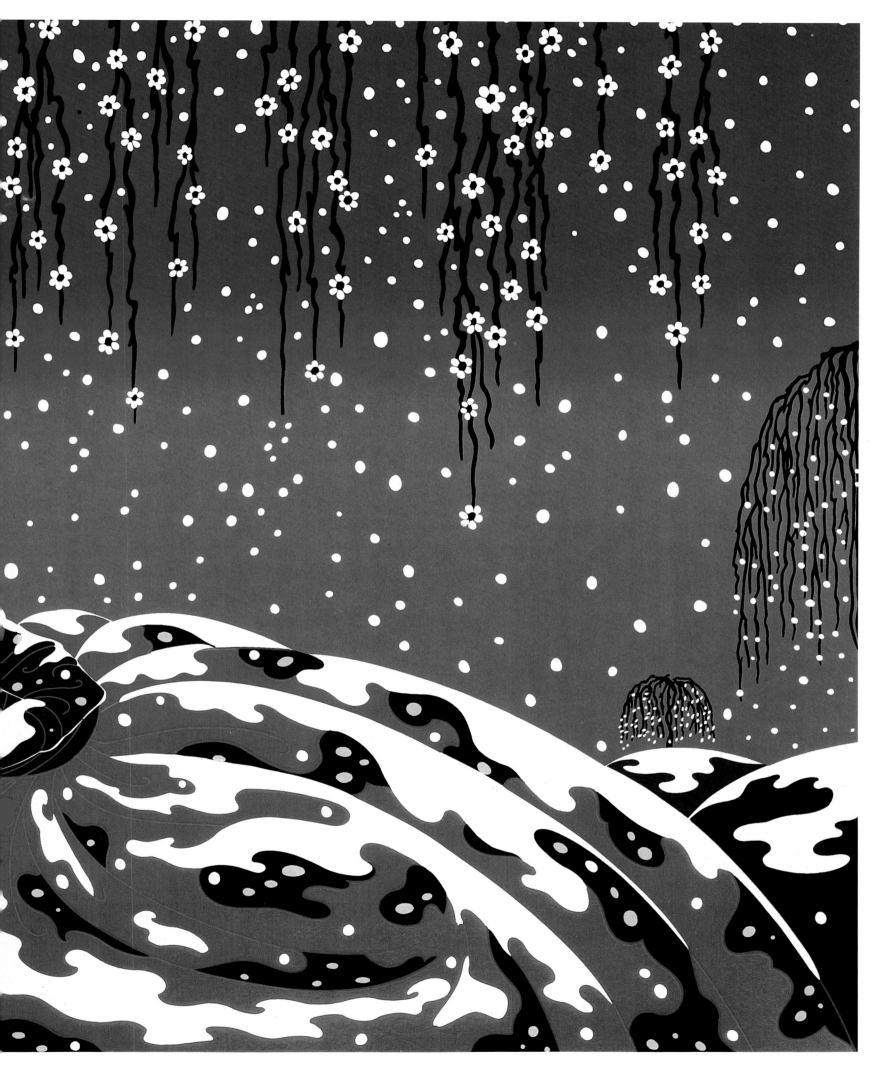

Sleeping Beauty
La Belle au Bois dormant
La bella addormentata
Schlafende Schönheit

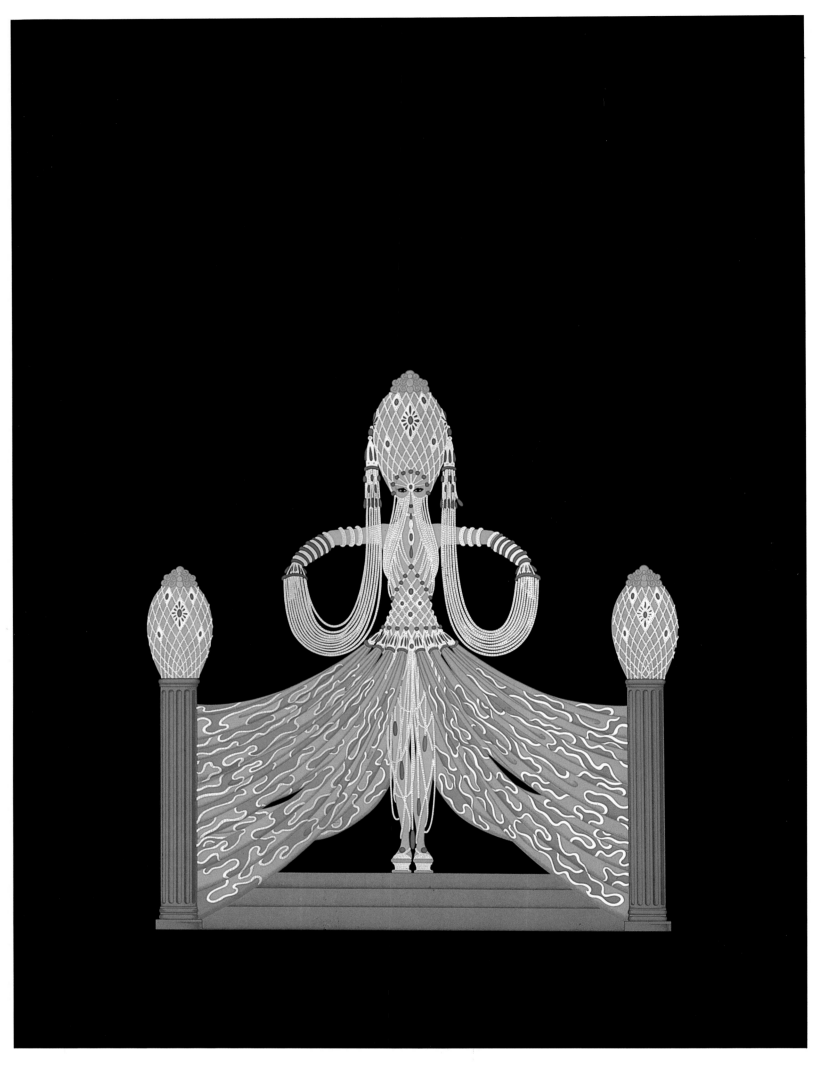

Enchantress
Enchanteresse
Incantatrice
Die Zauberin

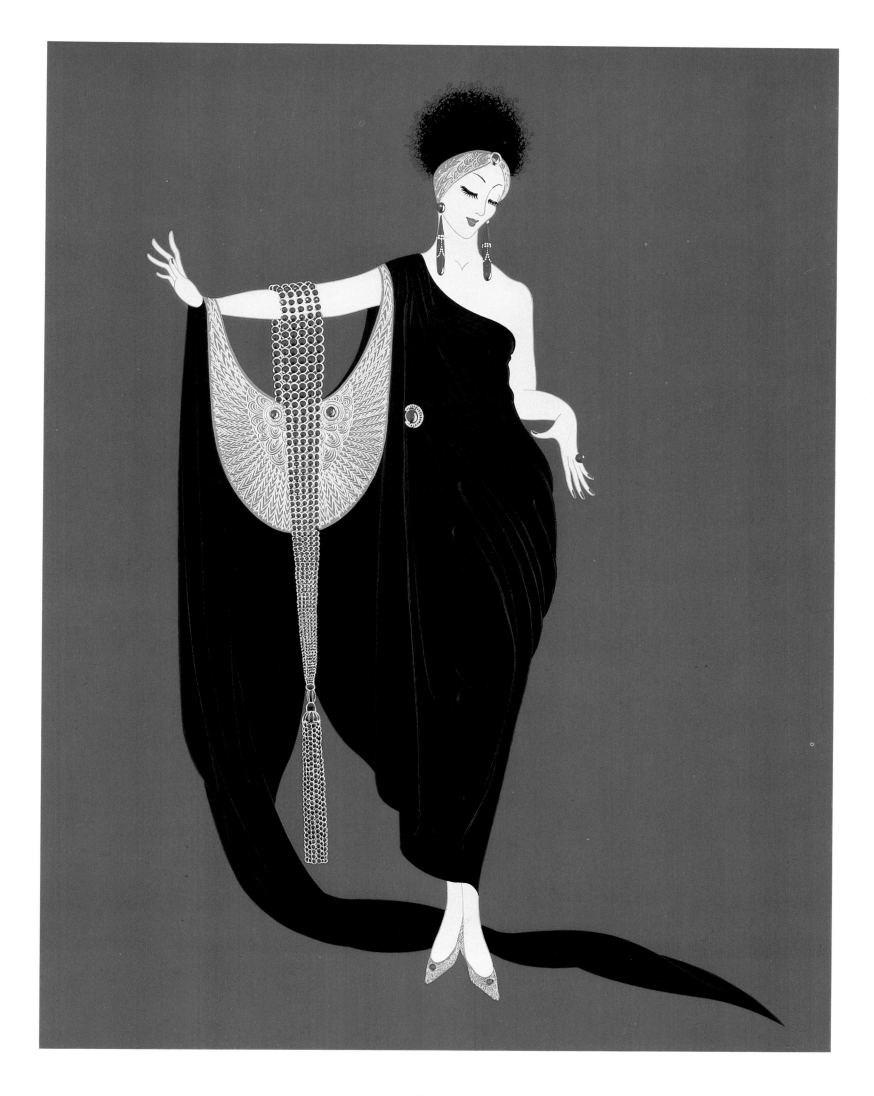

Glamour
Charmeuse
Fascino
Glamour

115

Writer in Landscape
Écrivain dans un paysage
Paesaggio con scrittore
Schreibender in einer Landschaft

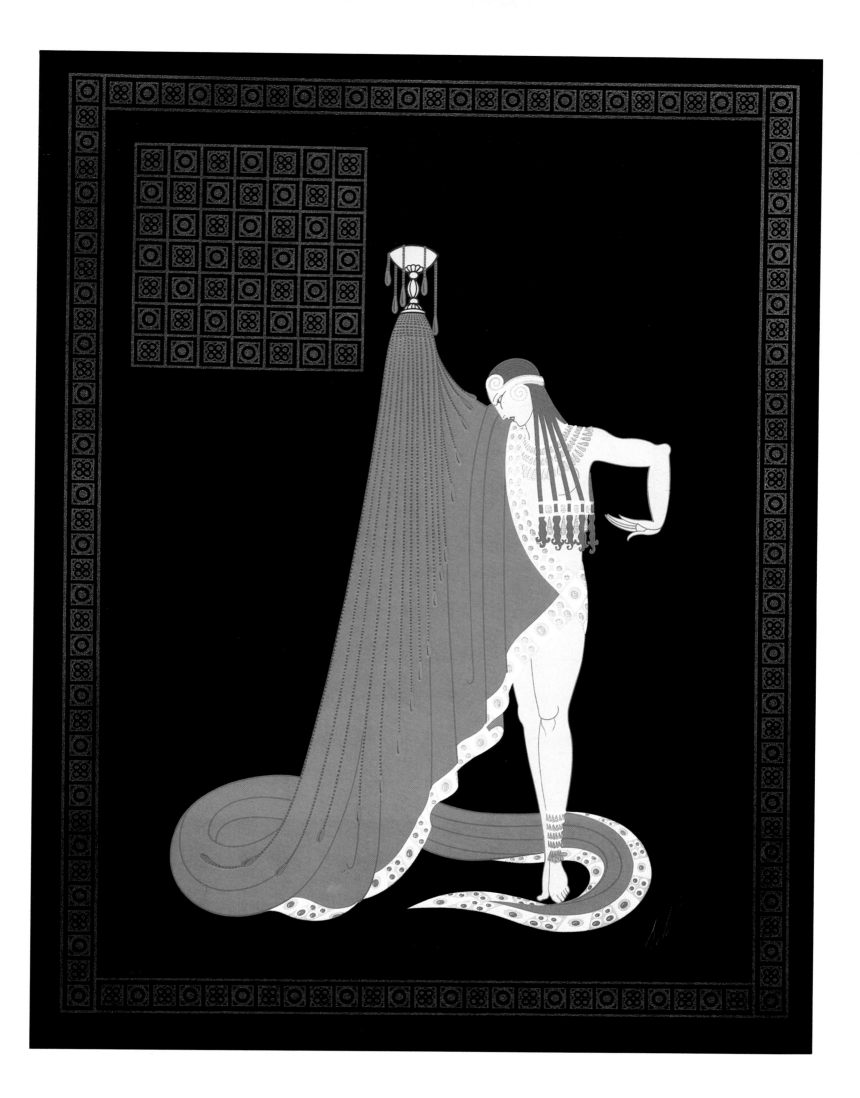

The Slave
L'Esclave
Lo schiavo
Der Sklave

117

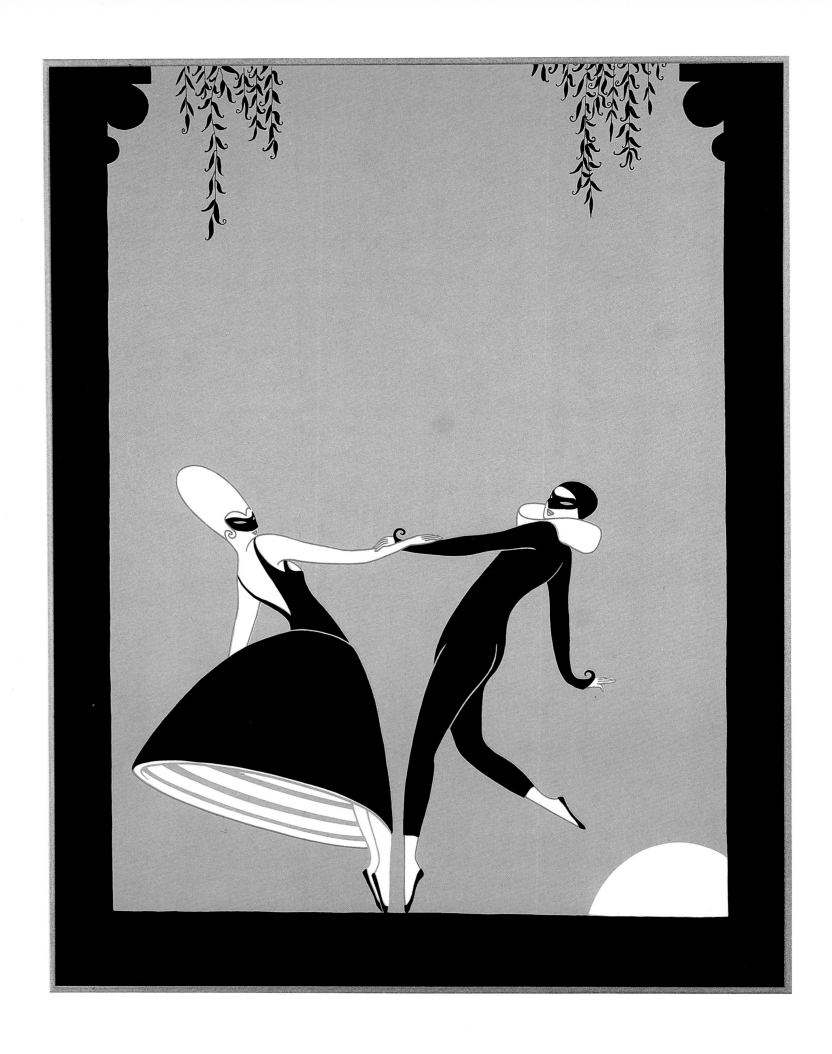

Pas de deux
Pas de deux
Pas de deux
Pas de deux

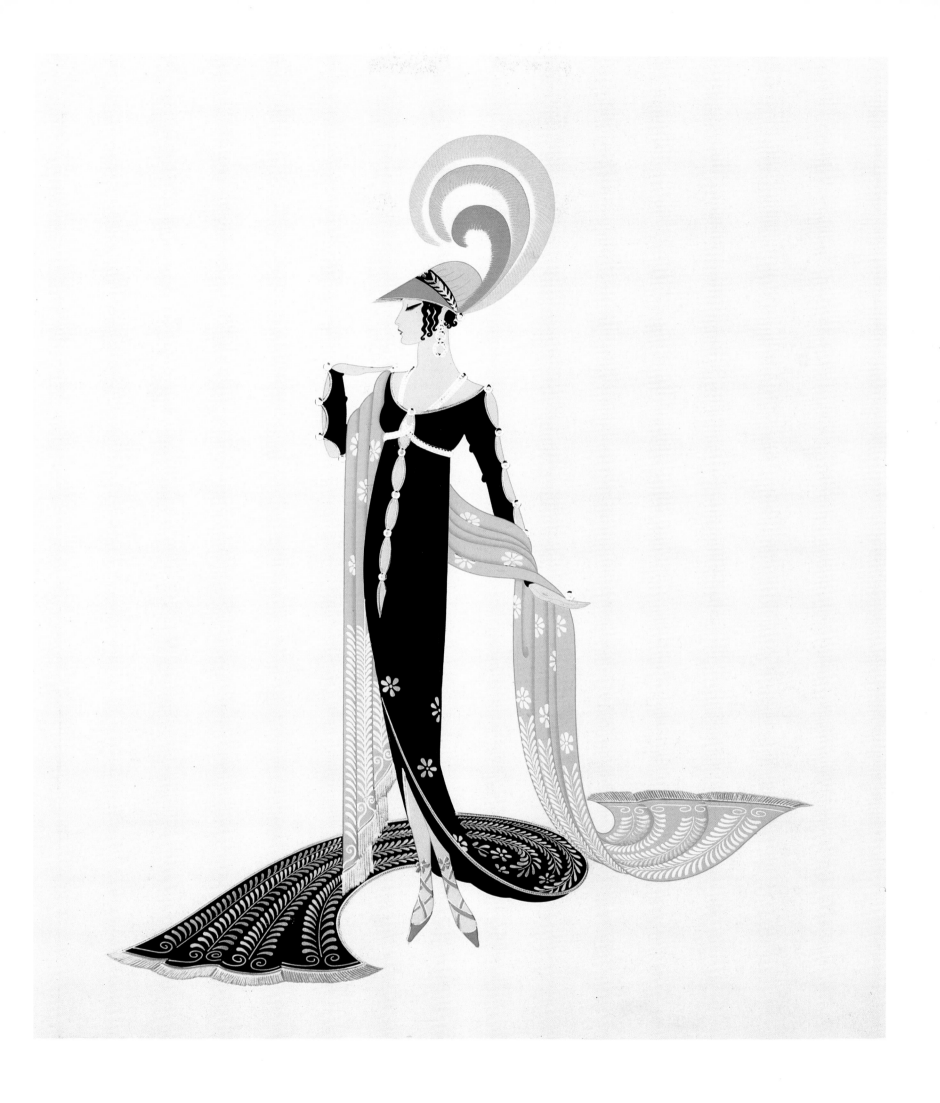

Directoire
Directoire
Direttorio
Directoire

119

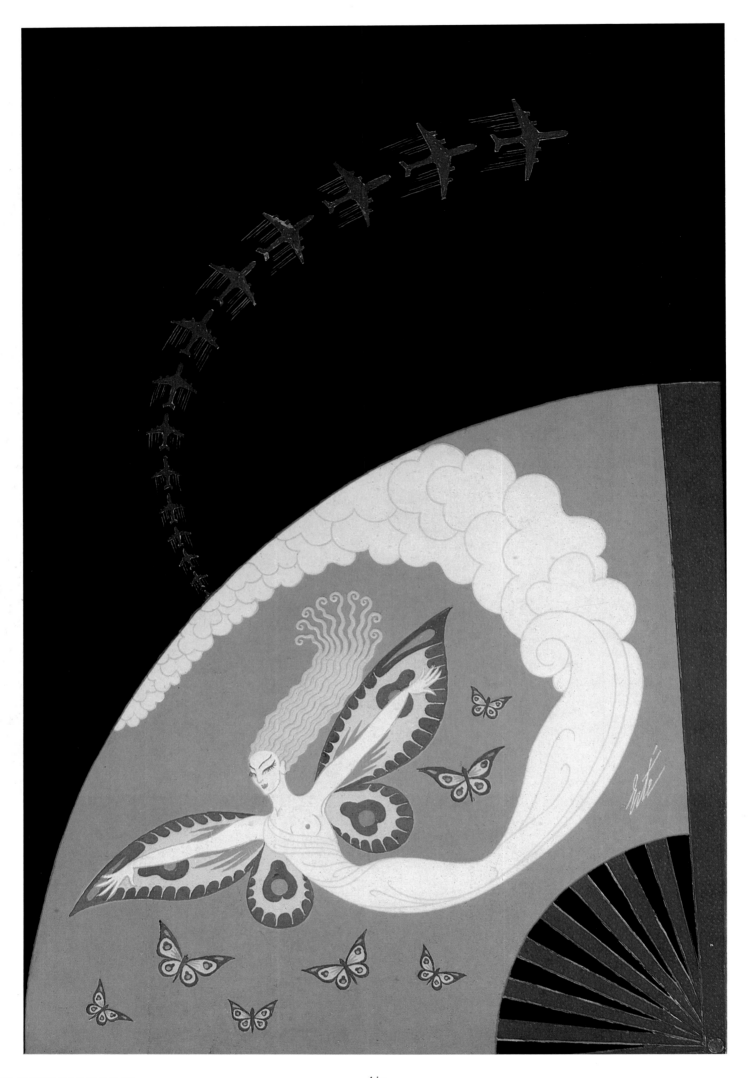

THE FOUR ELEMENTS	*Air*
LES QUATRE ÉLÉMENTS	*L'Air*
I QUATTRO ELEMENTI	*Aria*
DIE VIER ELEMENTE	*Luft*

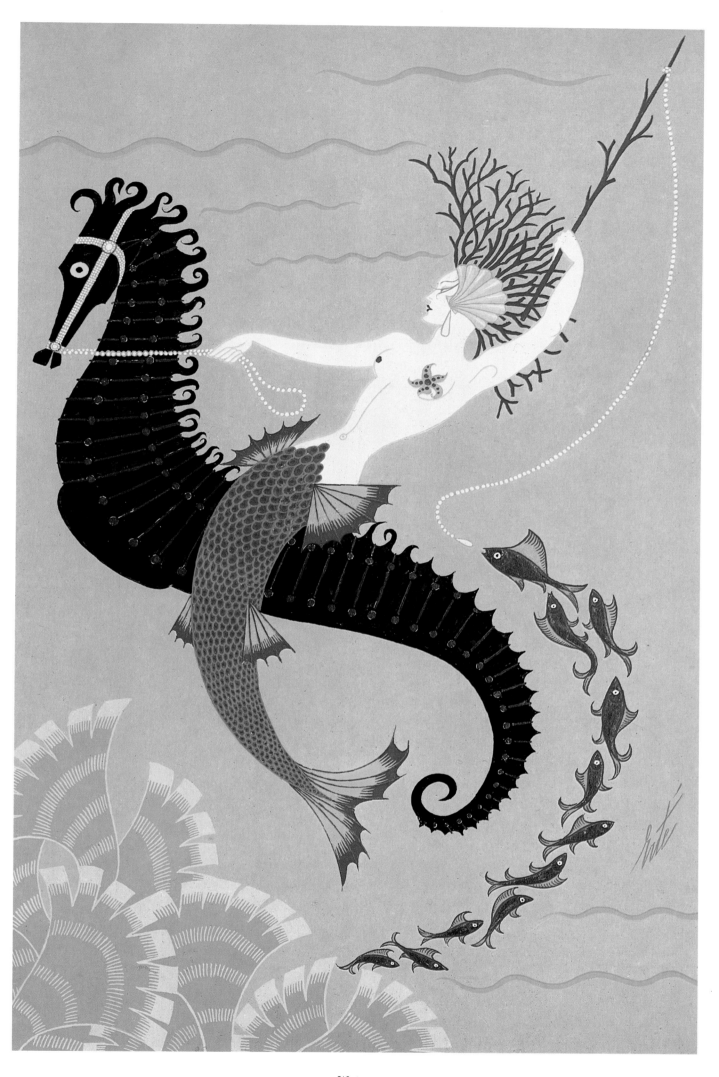

Water
L'Eau
Acqua
Wasser

THE FOUR ELEMENTS
LES QUATRE ÉLÉMENTS
I QUATTRO ELEMENTI
DIE VIER ELEMENTE

121

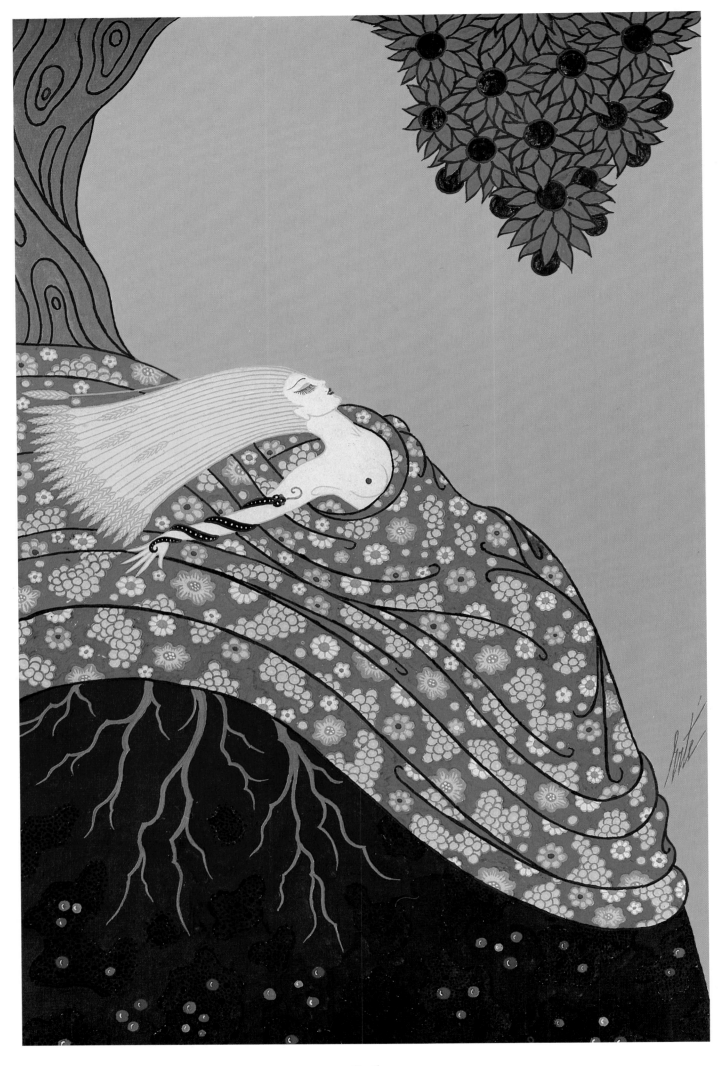

THE FOUR ELEMENTS
LES QUATRE ÉLÉMENTS
I QUATTRO ELEMENTI
DIE VIER ELEMENTE

Earth
La Terre
Terra
Erde

Fire
Le Feu
Fuoco
Feuer

THE FOUR ELEMENTS
LES QUATRE ÉLÉMENTS
I QUATTRO ELEMENTI
DIE VIER ELEMENTE

123

Aladdin and His Bride
Aladin et son épouse
Aladino e la sua sposa
Aladdin und seine Braut

Byzantine
Byzantine
Bizantina
Die Byzantinerin

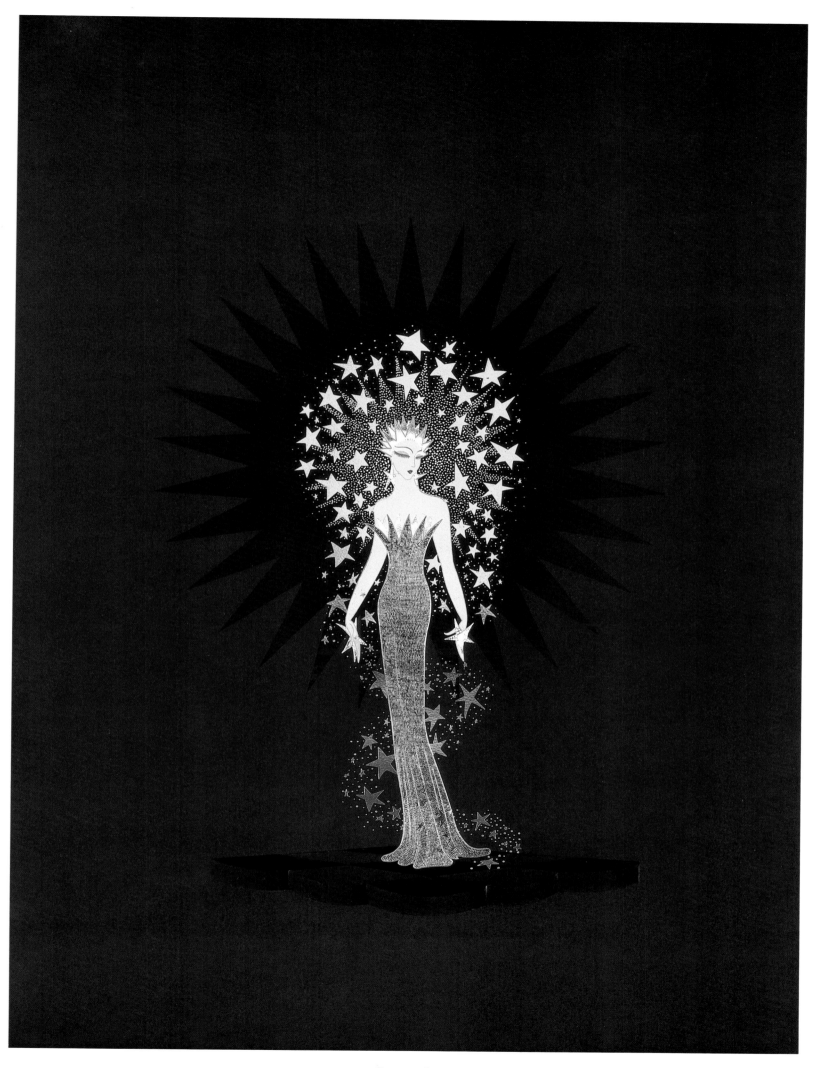

Starstruck
Bouquet d'étoiles
In un turbine di stelle
Von Sternen getroffen

127

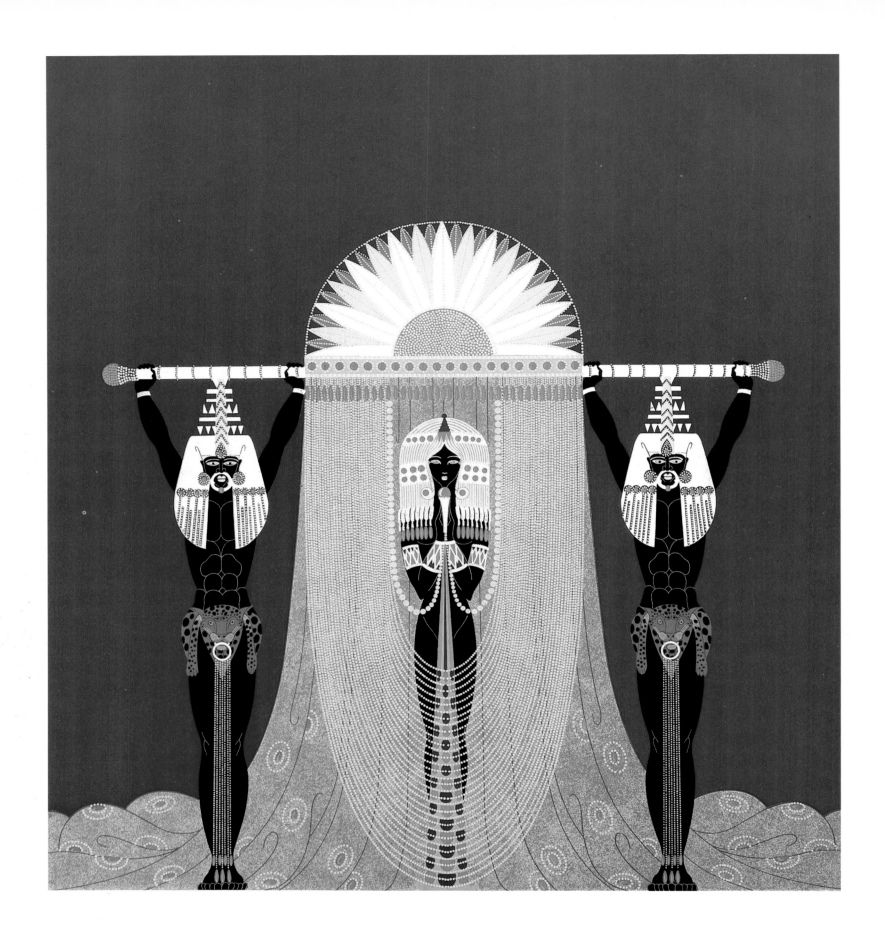

The Egyptian
L'Égyptienne
L'egiziana
Die Ägypterin

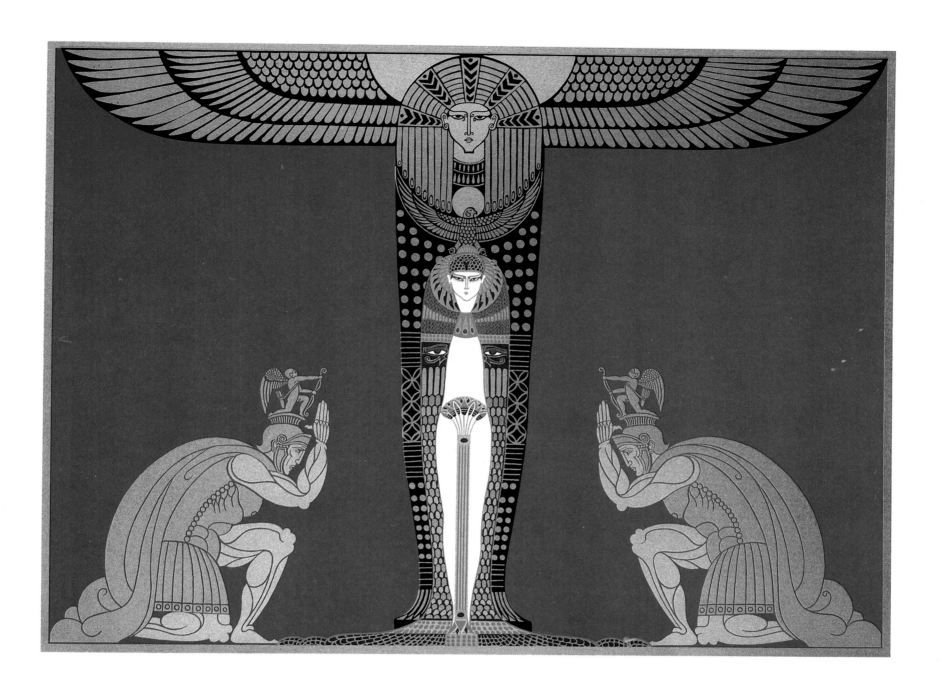

Cléopâtre
Cléopâtre
Cleopatra
Kleopatra

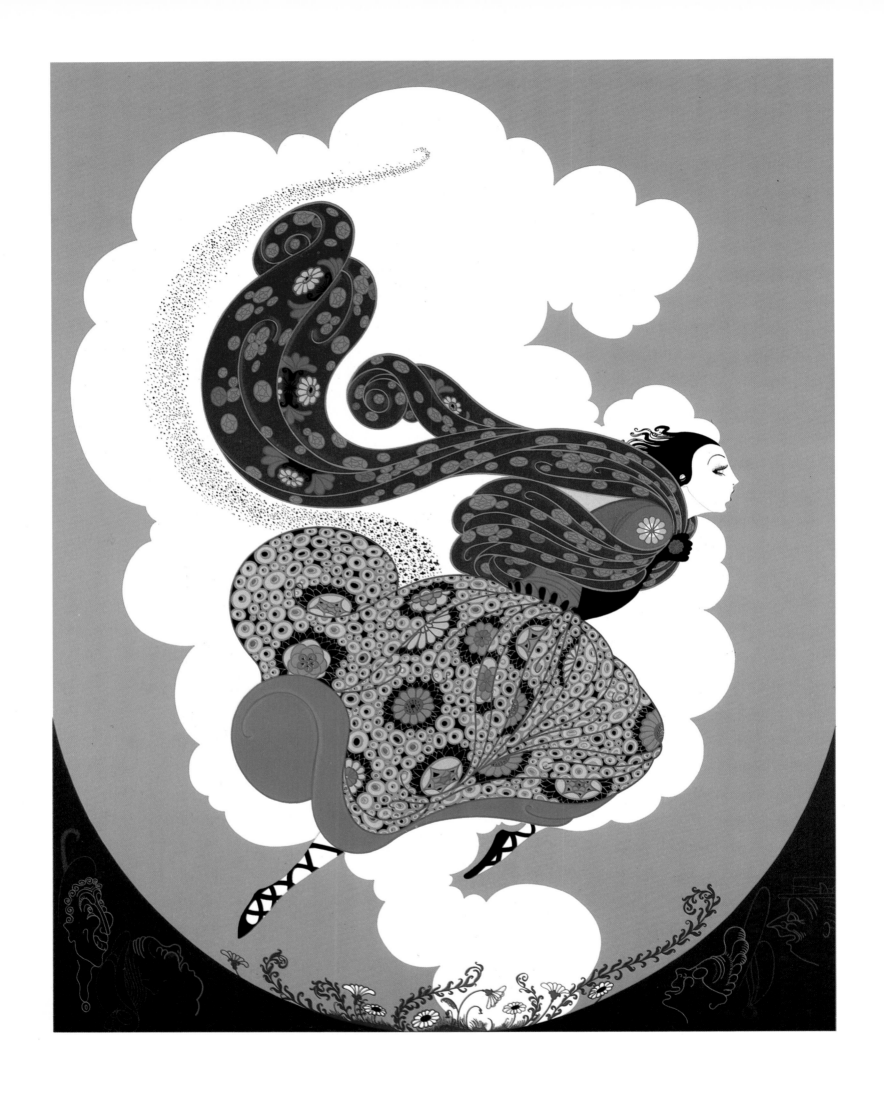

The Pursuit of Flore
Flore poursuivie
L'inseguimento di Flora
Die Verfolgung der Flora

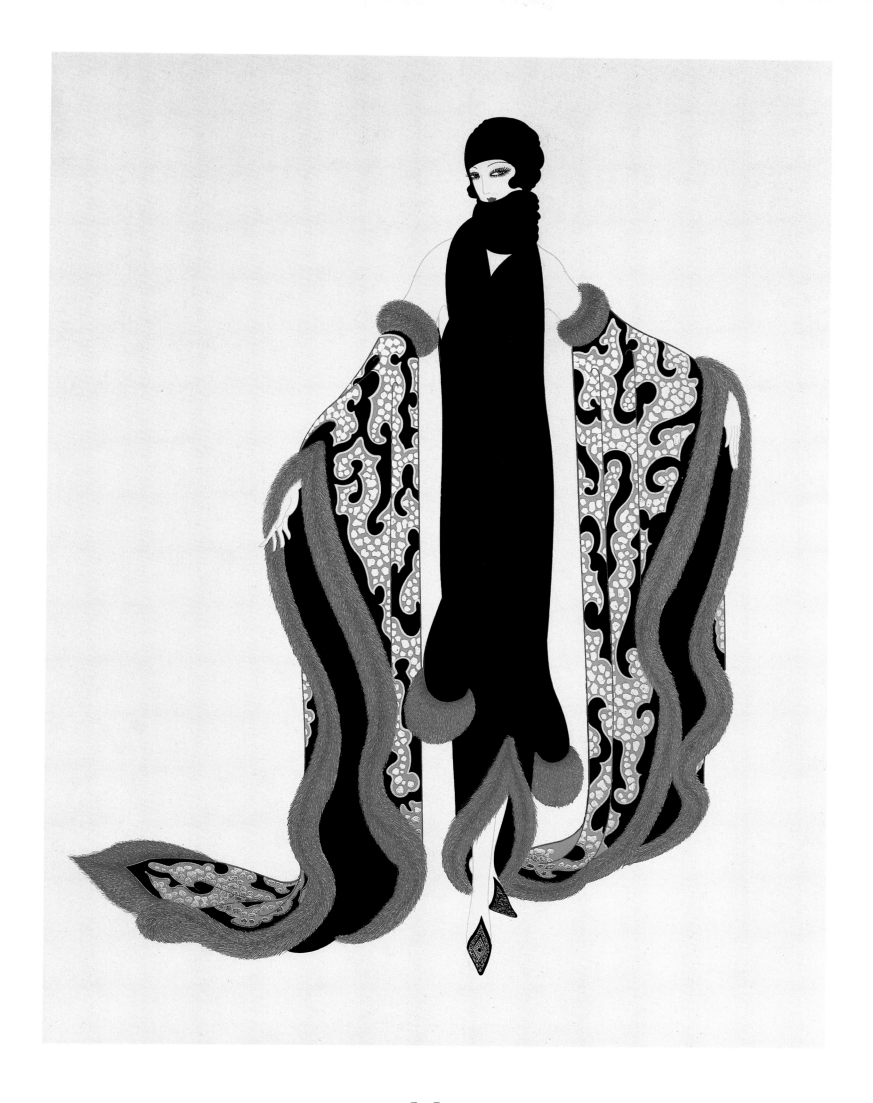

Fox Fur
Renard
Volpe
Fuchspelz

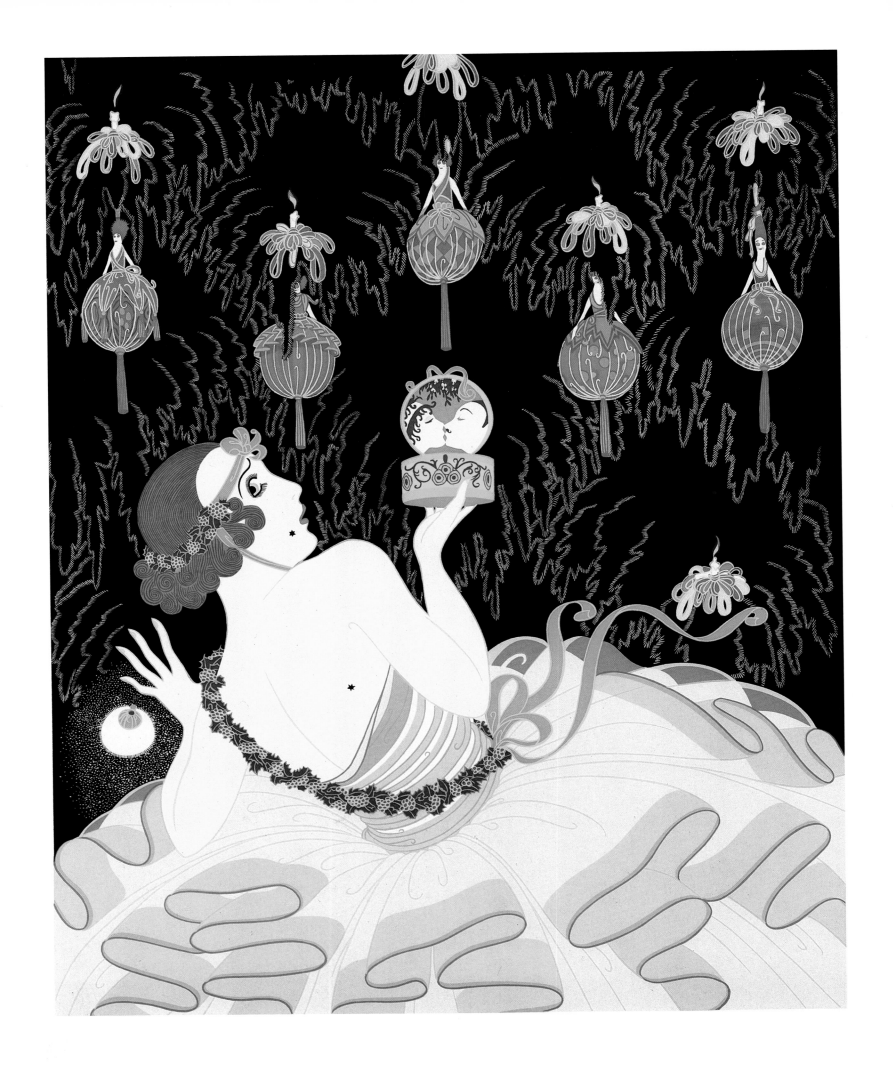

Stolen Kisses
Baisers volés
Baci rubati
Geraubte Küsse

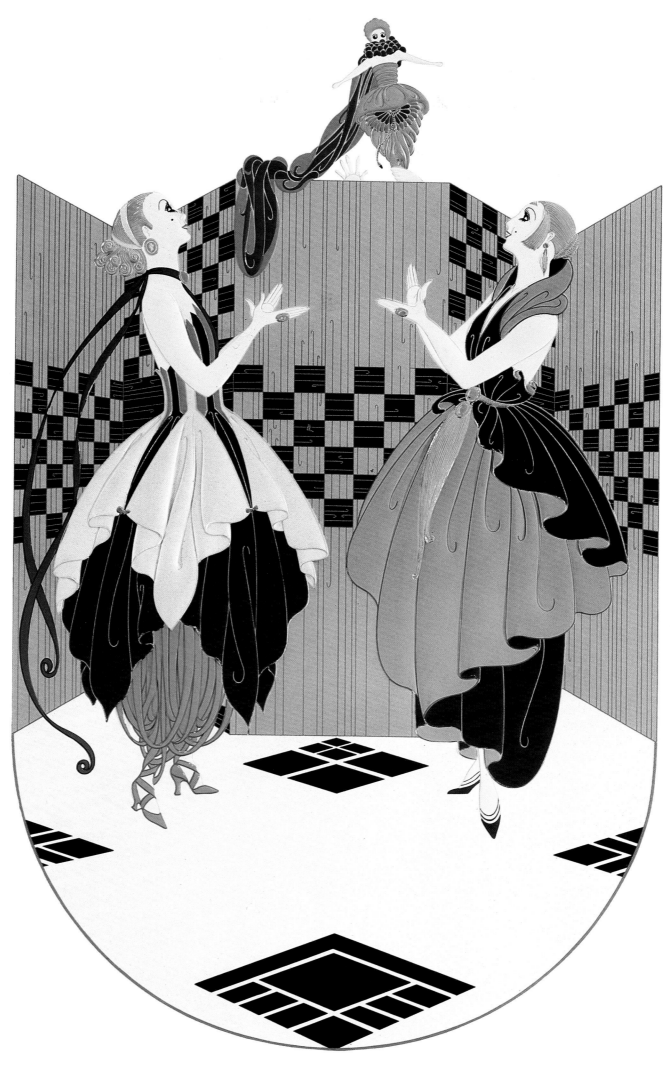

The Puppet Show
Théâtre de marionnettes
Il teatrino delle marionette
Puppentheater

133

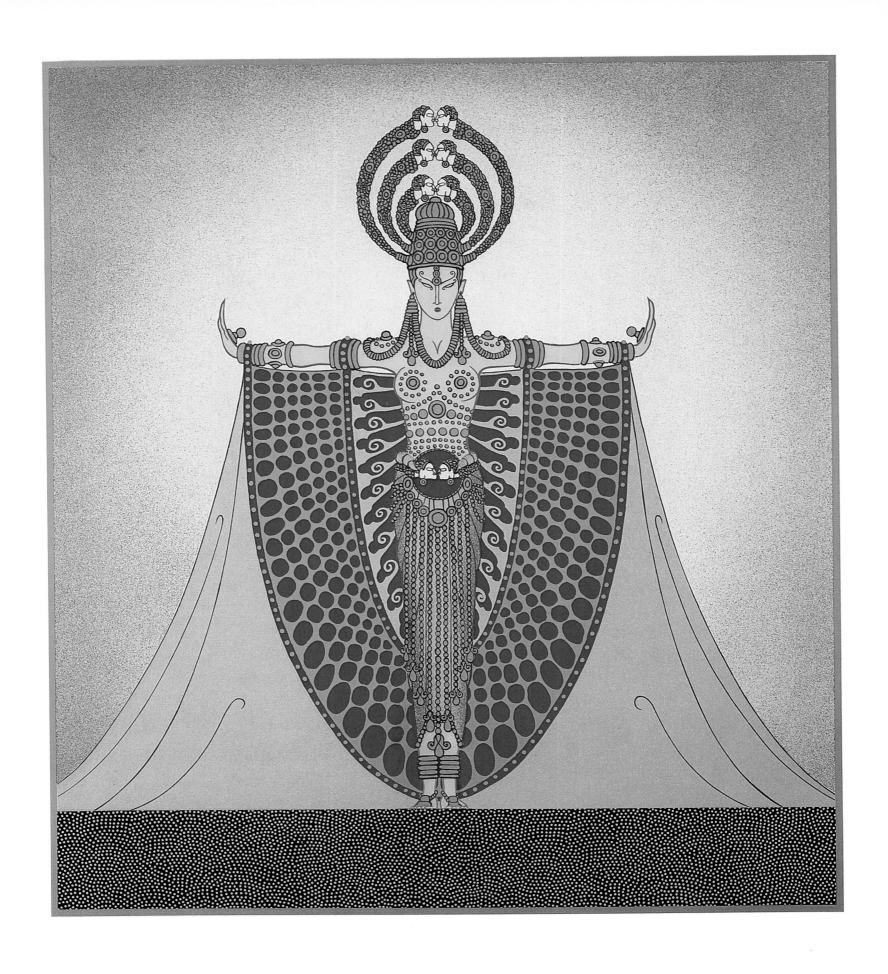

Indochina
Indochine
Indocina
Indochina

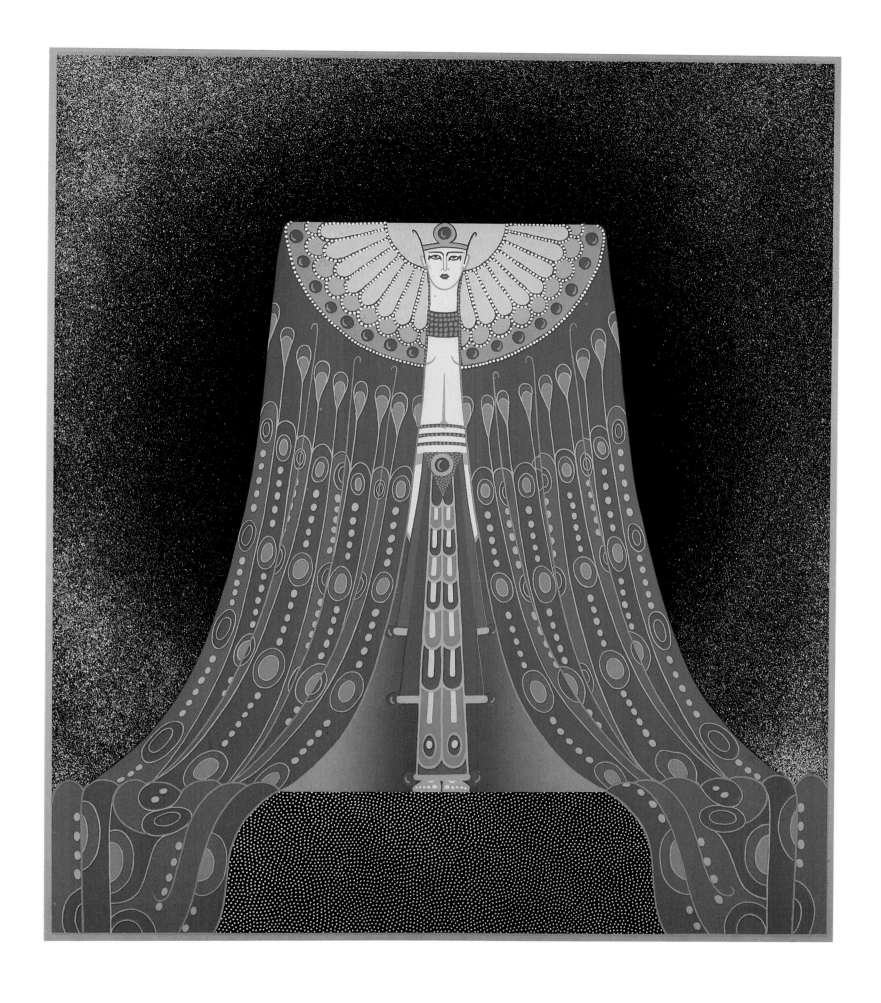

Red Sea
Mer Rouge
Mar Rosso
Das Rote Meer

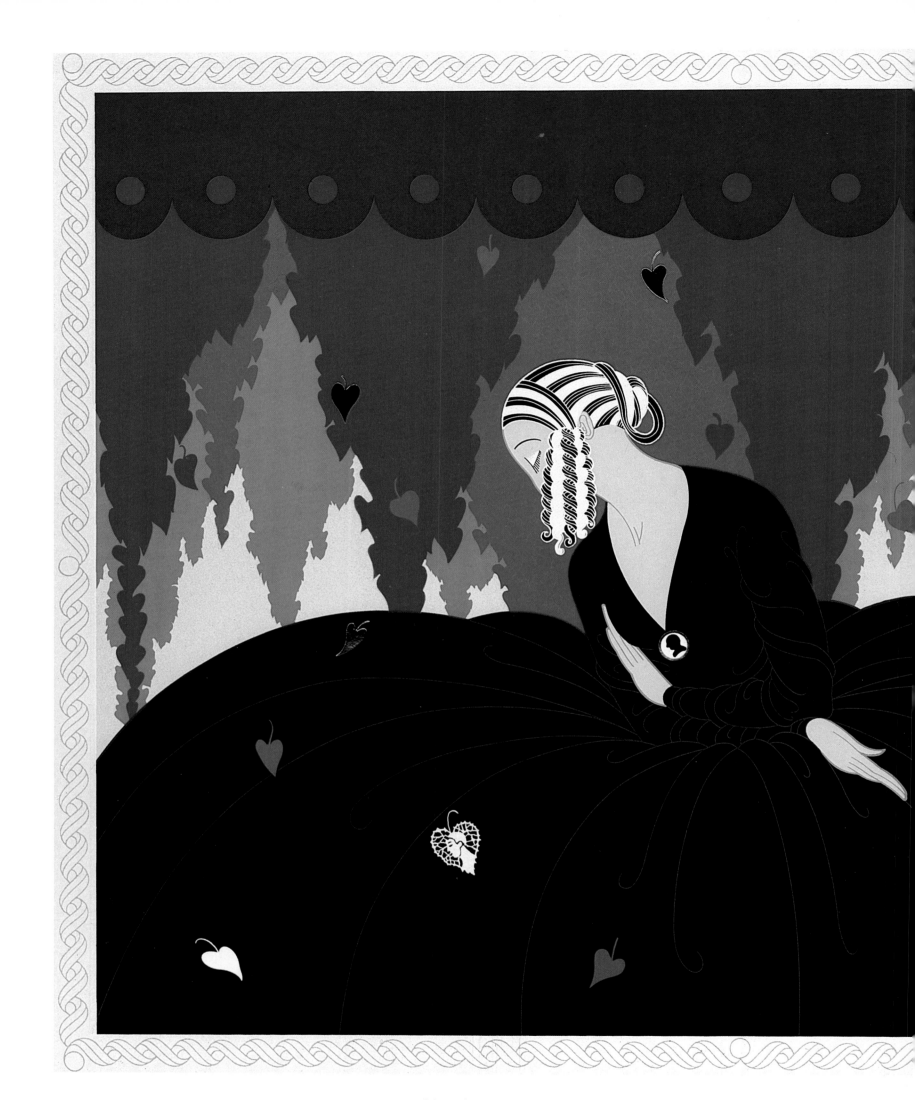

Memories
Souvenirs
Ricordi
Erinnerungen

136

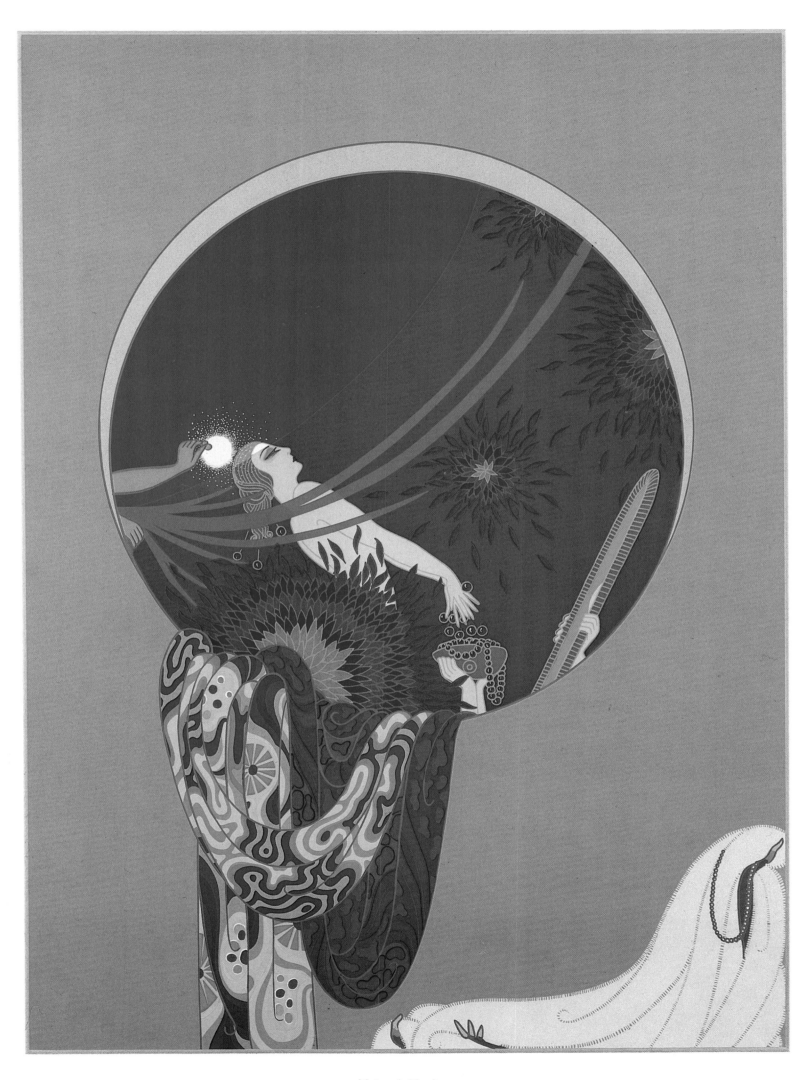

Nature's Vanity
Vanité de la nature
La vanità della natura
Die Eitelkeit der Natur

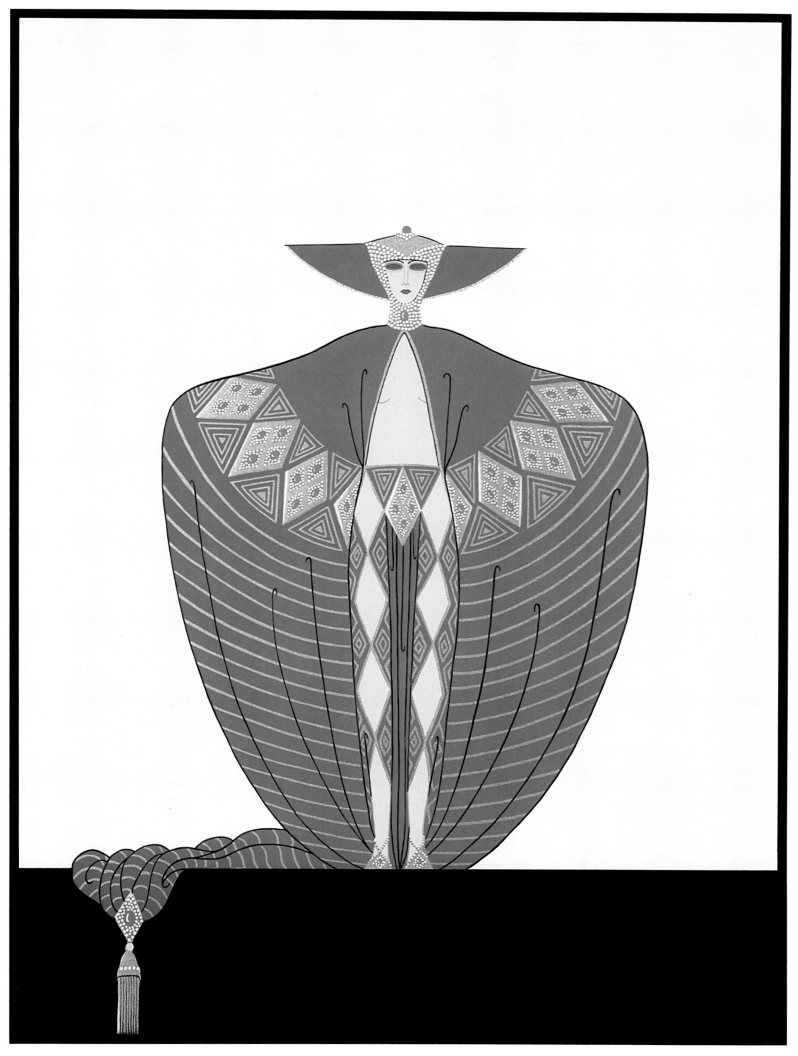

La Somptueuse
La Somptueuse
La sontuosa
Die Prächtige

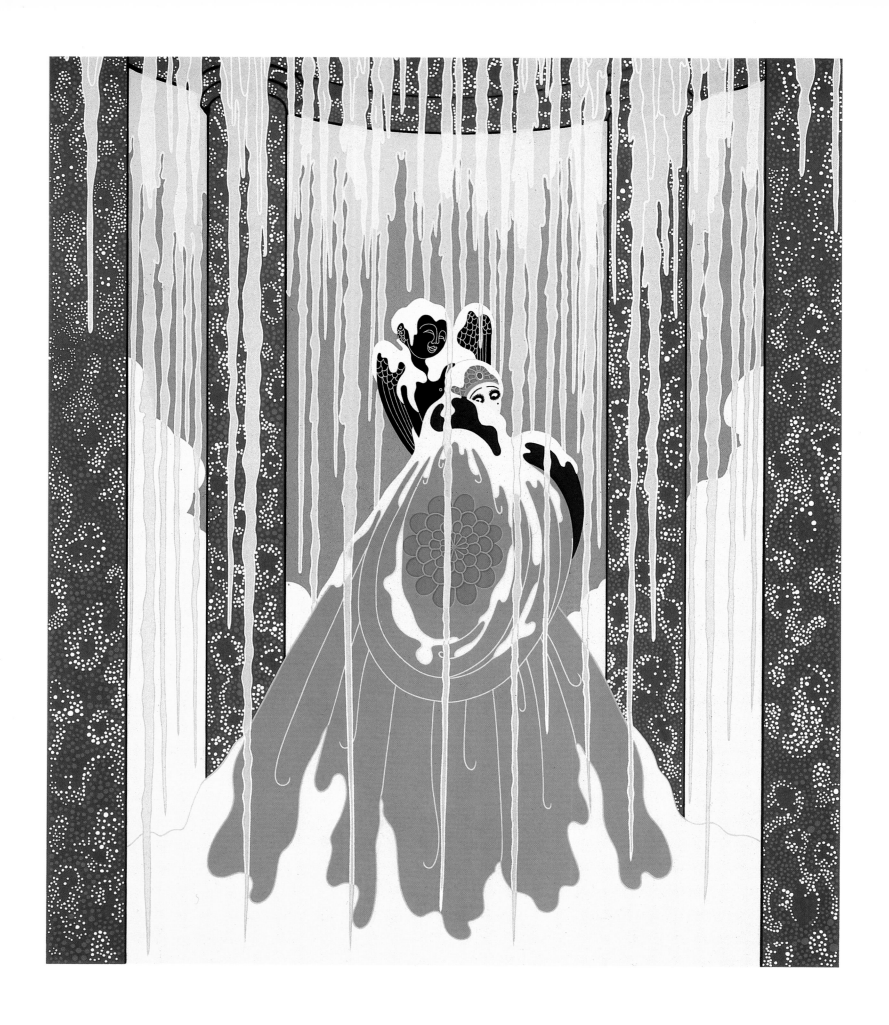

Love's Captive
Captive de l'amour
Schiava d'amore
Die Gefangene der Liebe

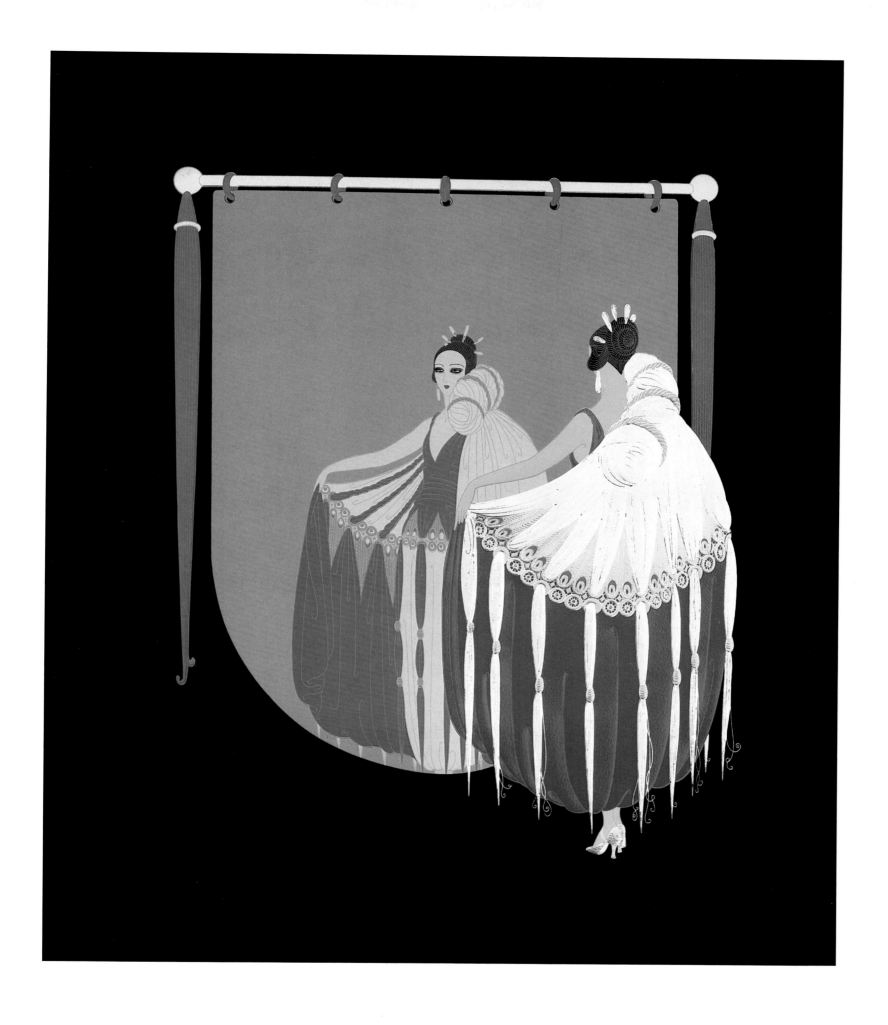

The Mirror
Le Miroir
Lo specchio
Der Spiegel

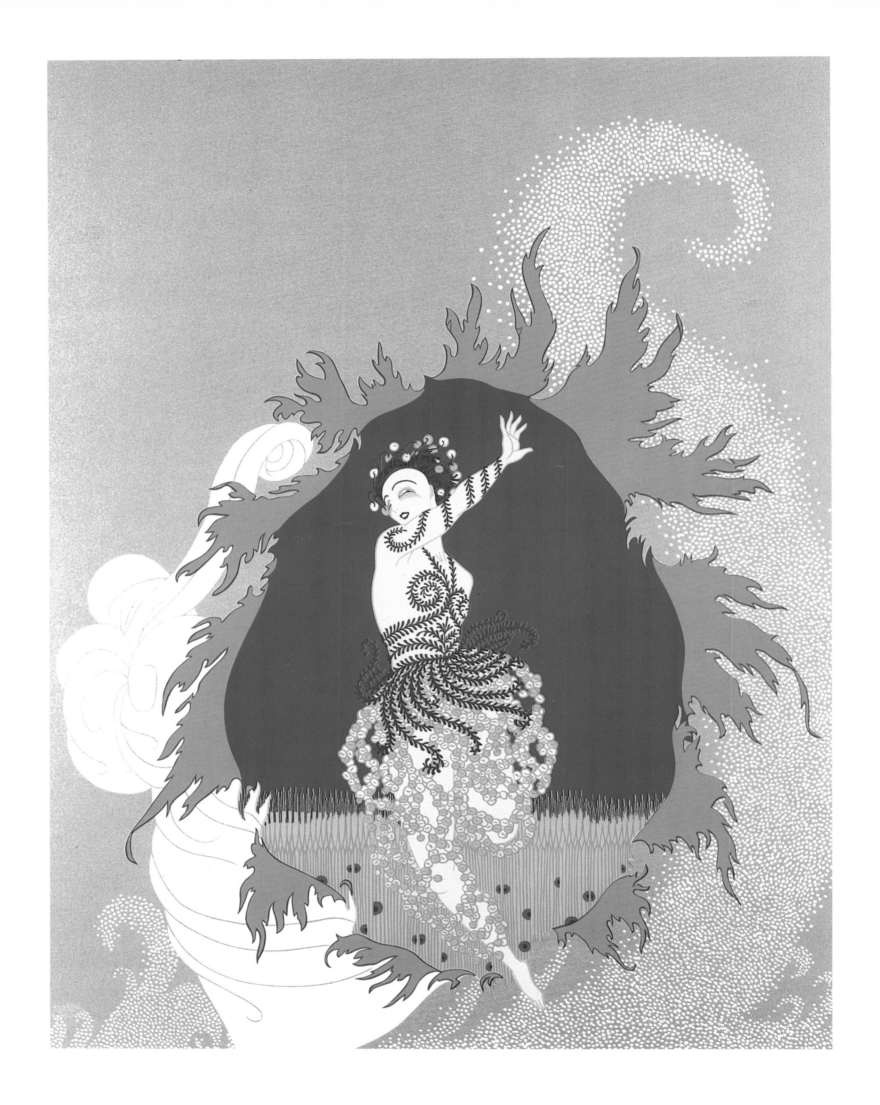

The Coming of Spring
L'Éveil du printemps
L'arrivo della Primavera
Der Frühling kommt

142

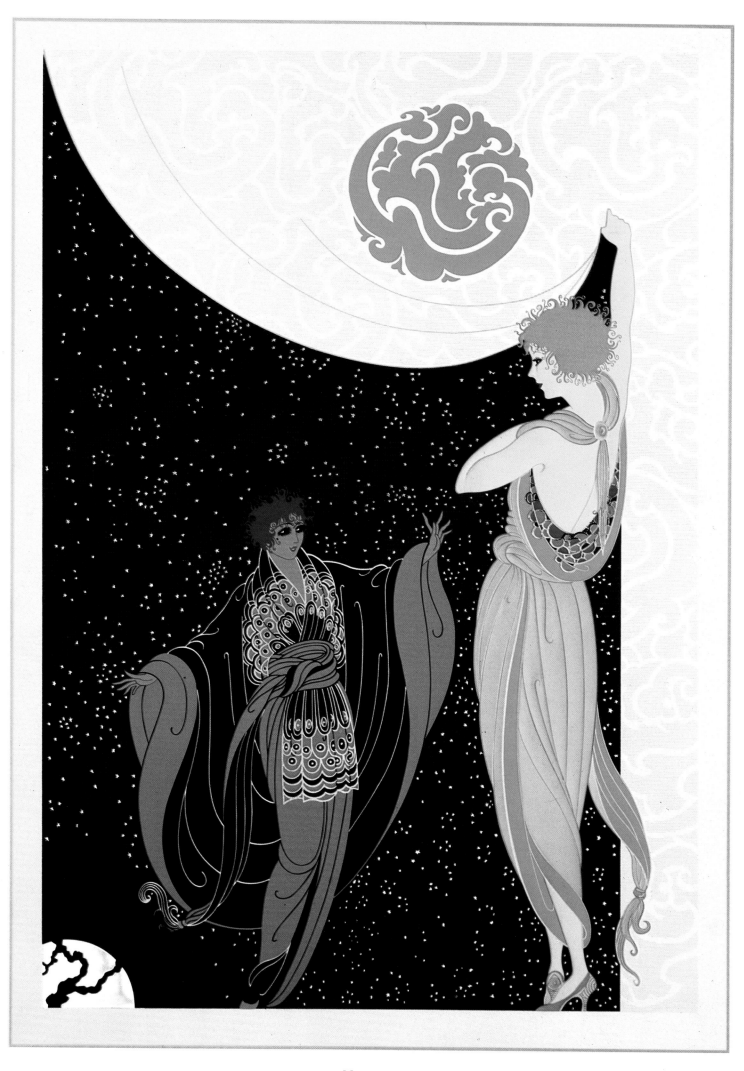

Nocturne
Nocturne
Notturno
Nachtstück

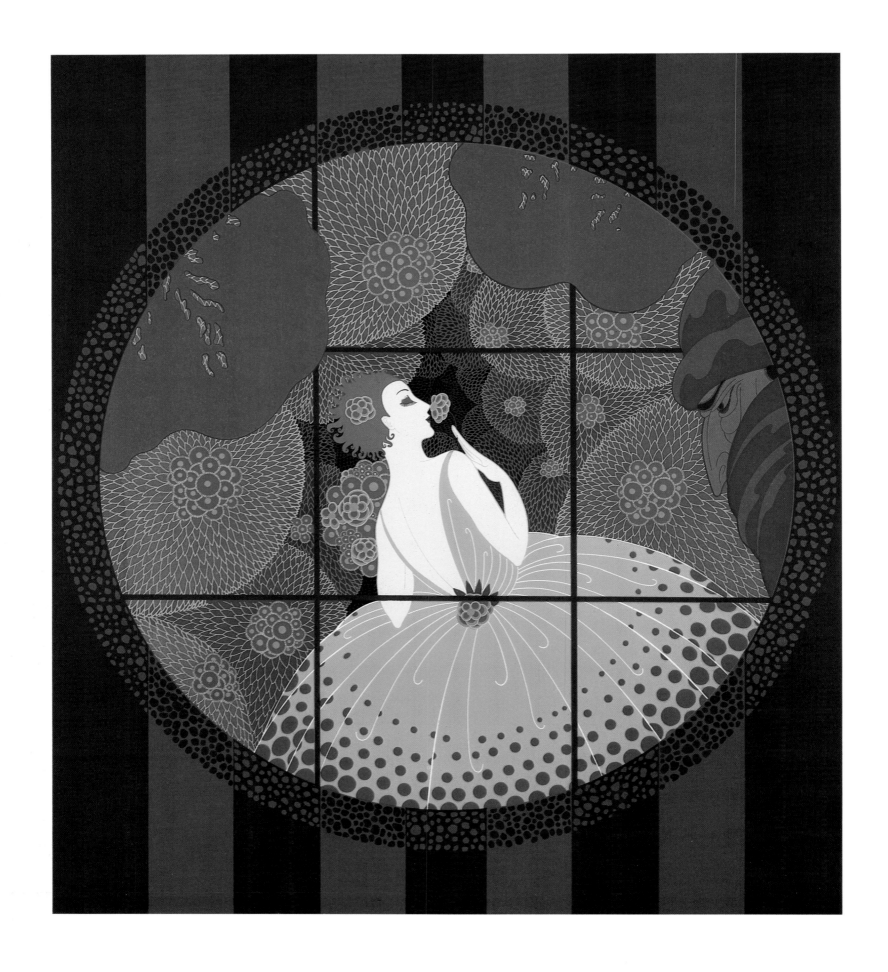

Winter Flowers
Fleurs d'hiver
Fiori d'inverno
Winterblumen

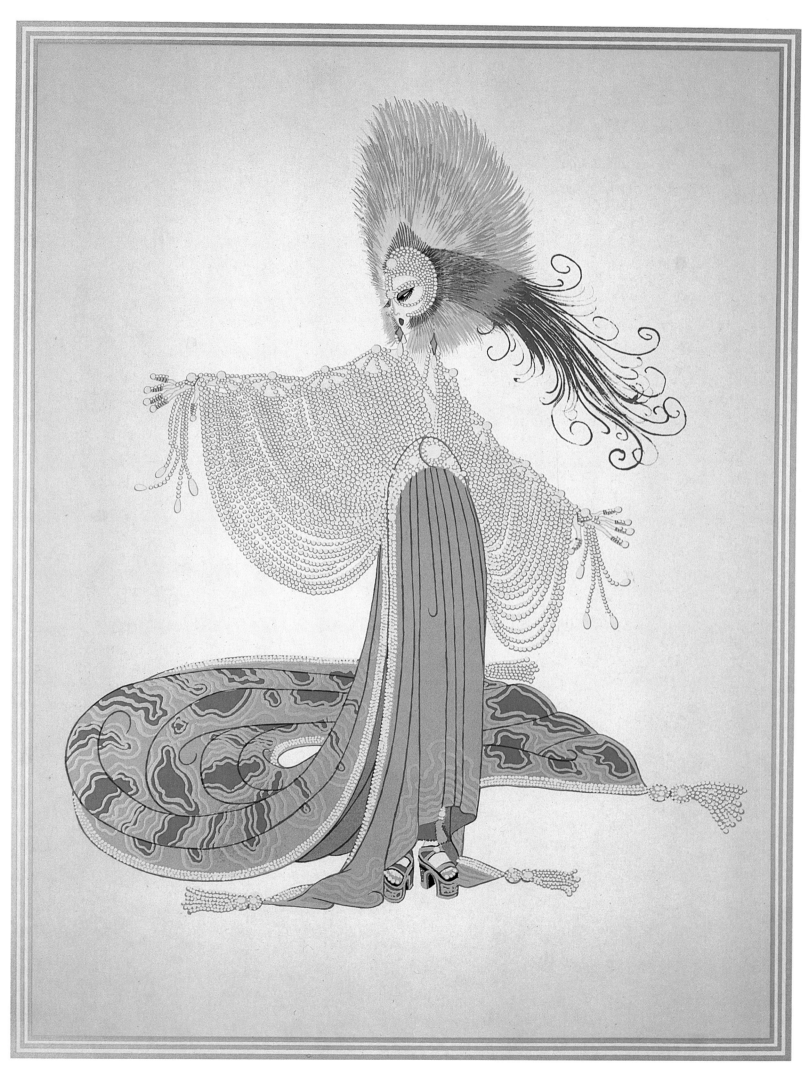

L'Orientale
L'Orientale
L'orientale
Die Orientalin

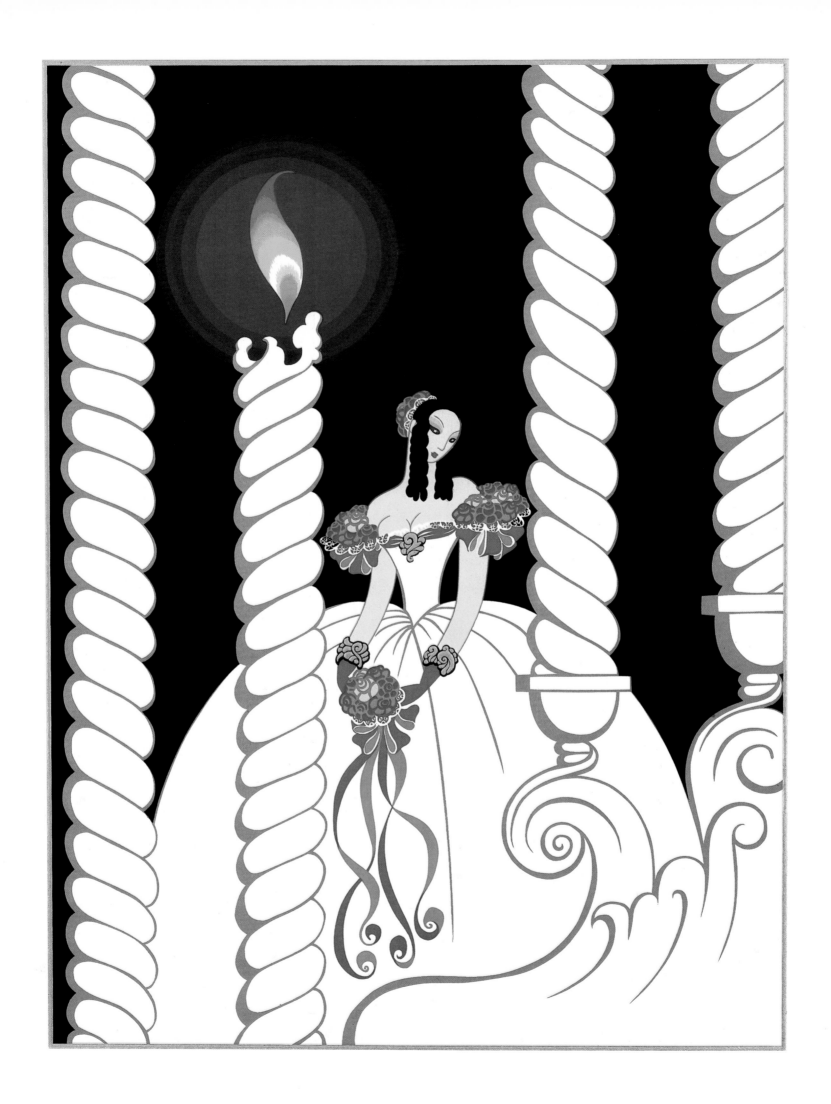

La Traviata
La Traviata
La Traviata
La Traviata

146

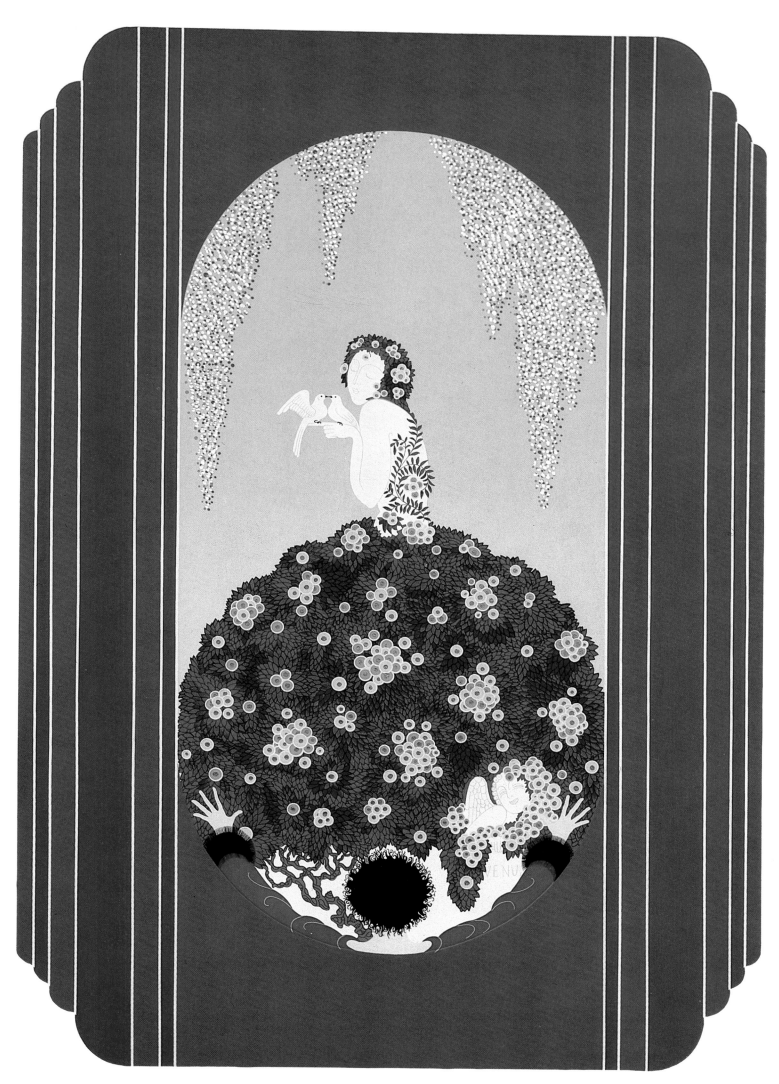

The Spring Dress of Venus
La Robe de printemps de Vénus
L'abito primaverile di Venere
Das Frühlingskleid der Venus

147

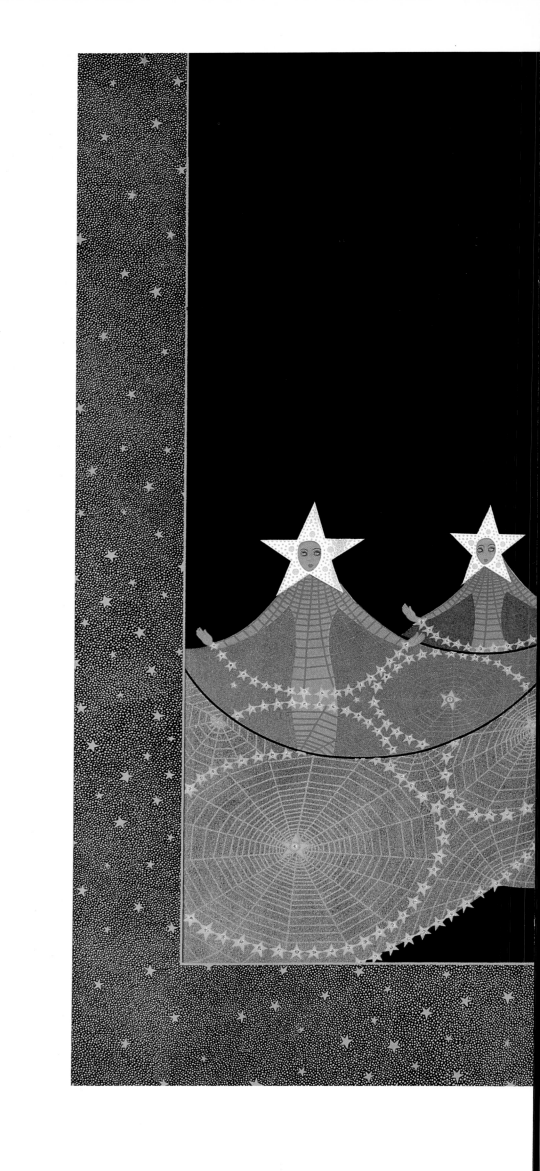

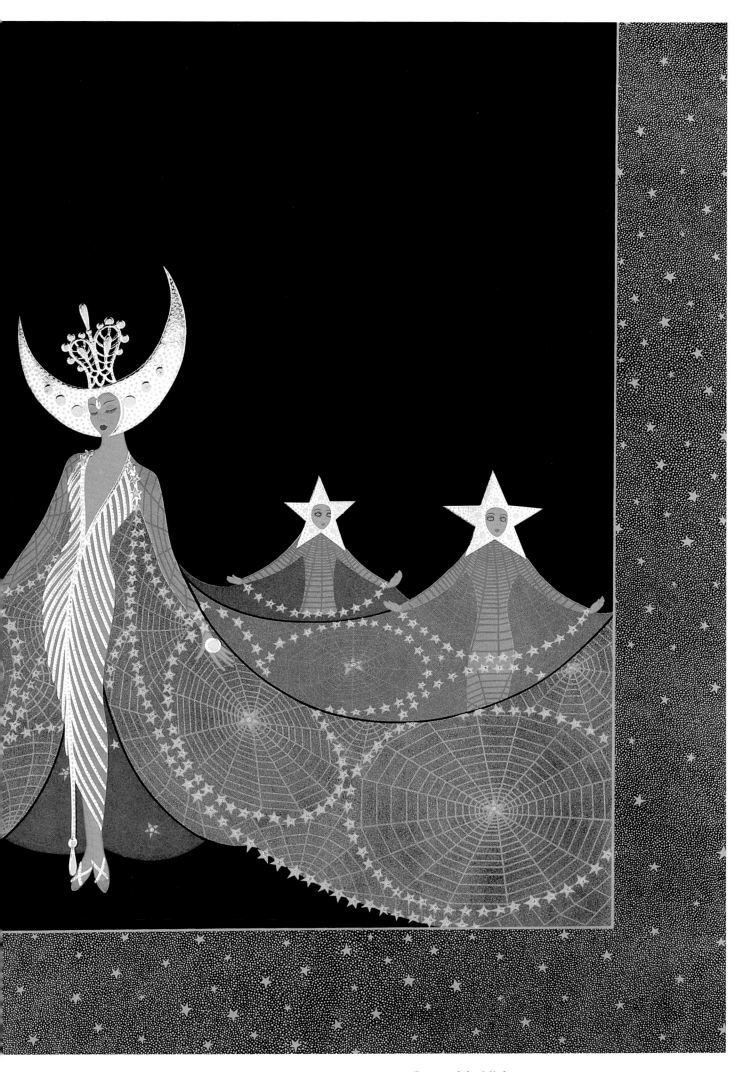

Queen of the Night
Reine de la nuit
La Regina della Notte
Die Königin der Nacht

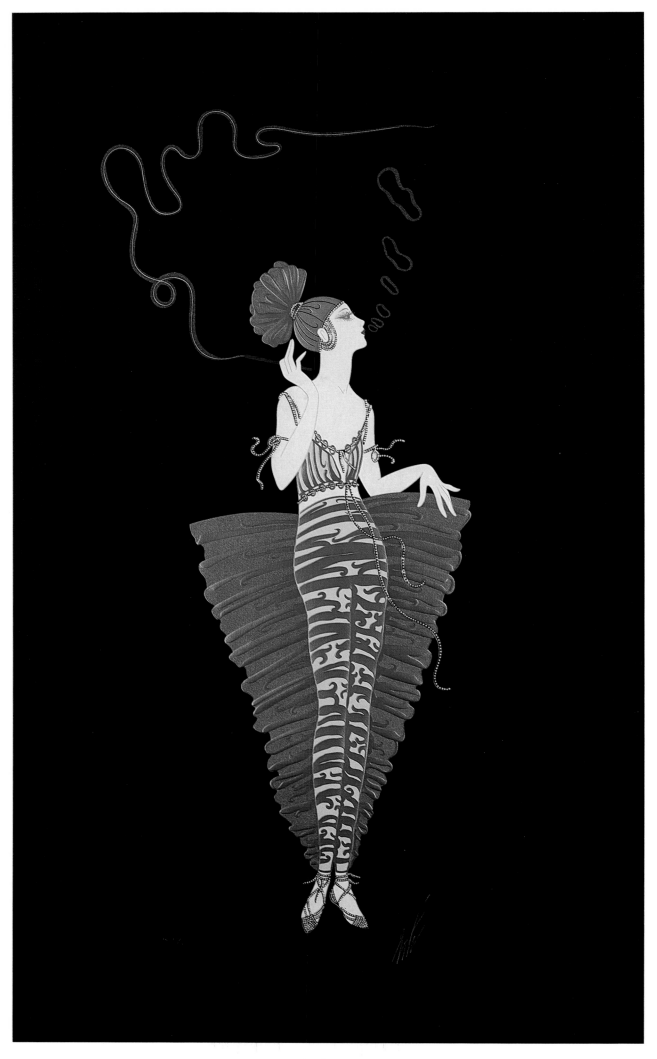

The Contessa
La Comtesse
La contessa
Die Komtess

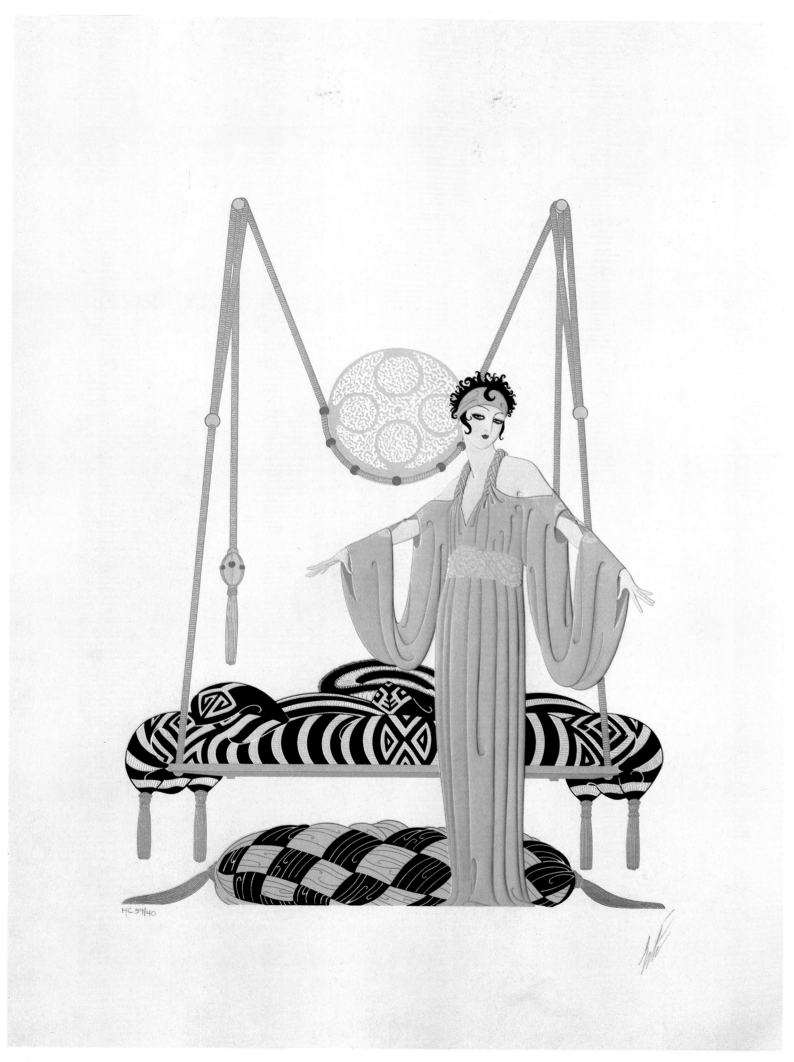

Pillow Swing
Escarpolette à coussins
Dondolo di cuscini
Die Liegeschaukel

151

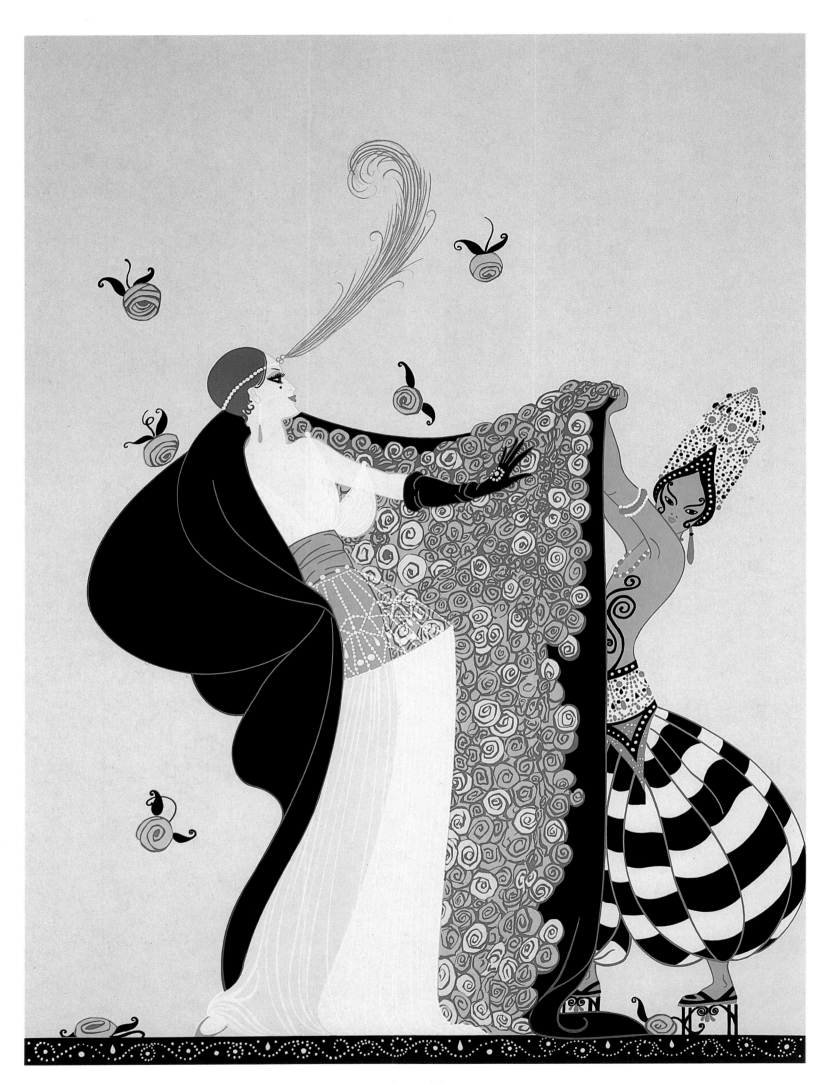

The Flowered Cape
La Cape fleurie
La cappa fiorita
Das geblümte Cape

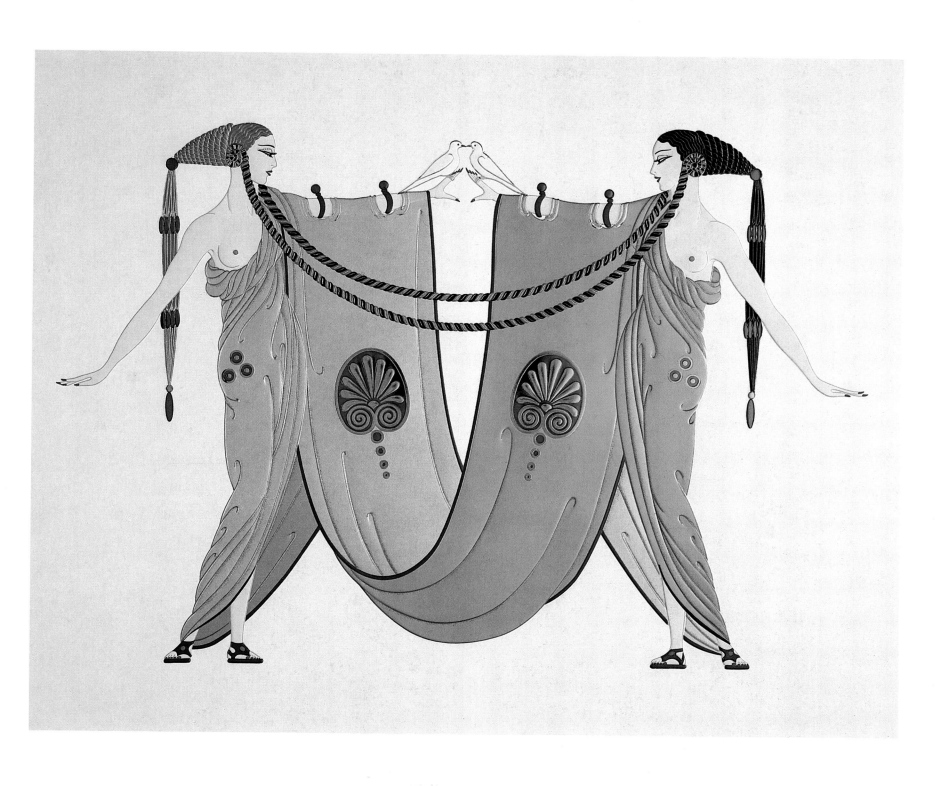

Sisters
Sœurs
Sorelle
Schwestern

153

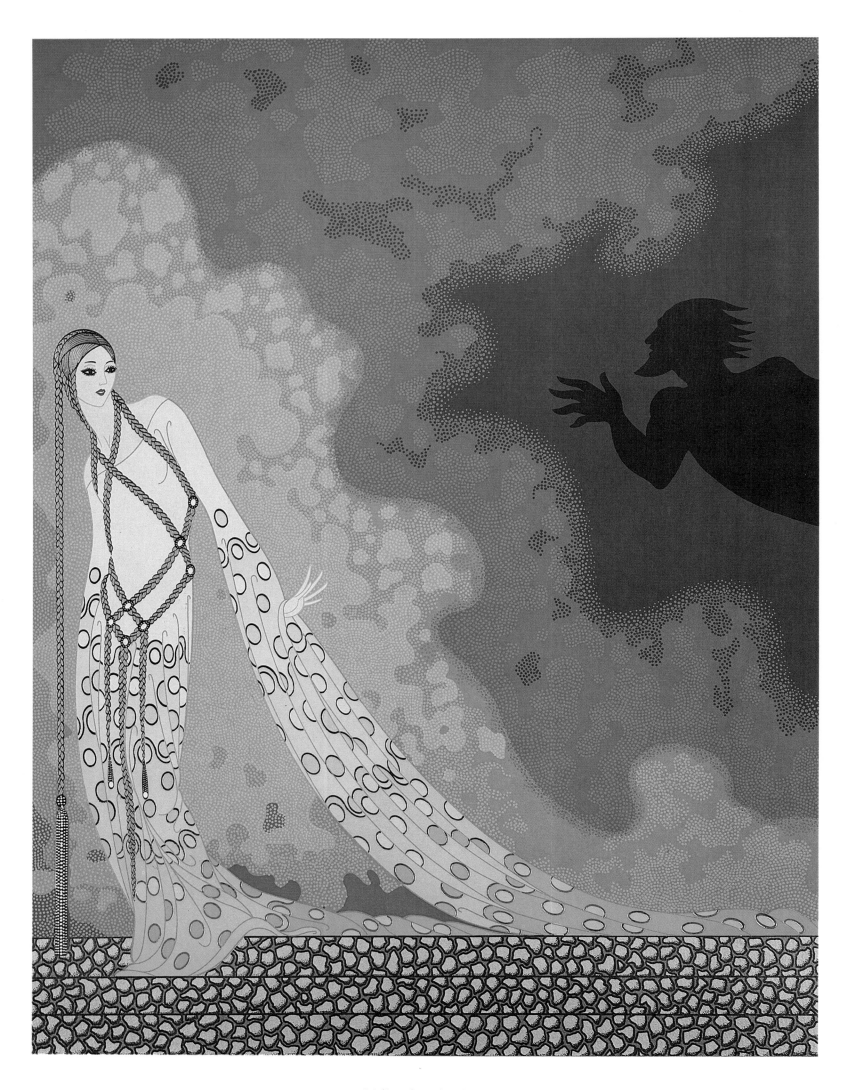

Melisande and Golaud
Mélisande et Golaud
Mélisande e Golaud
Melisande und Golaud

154

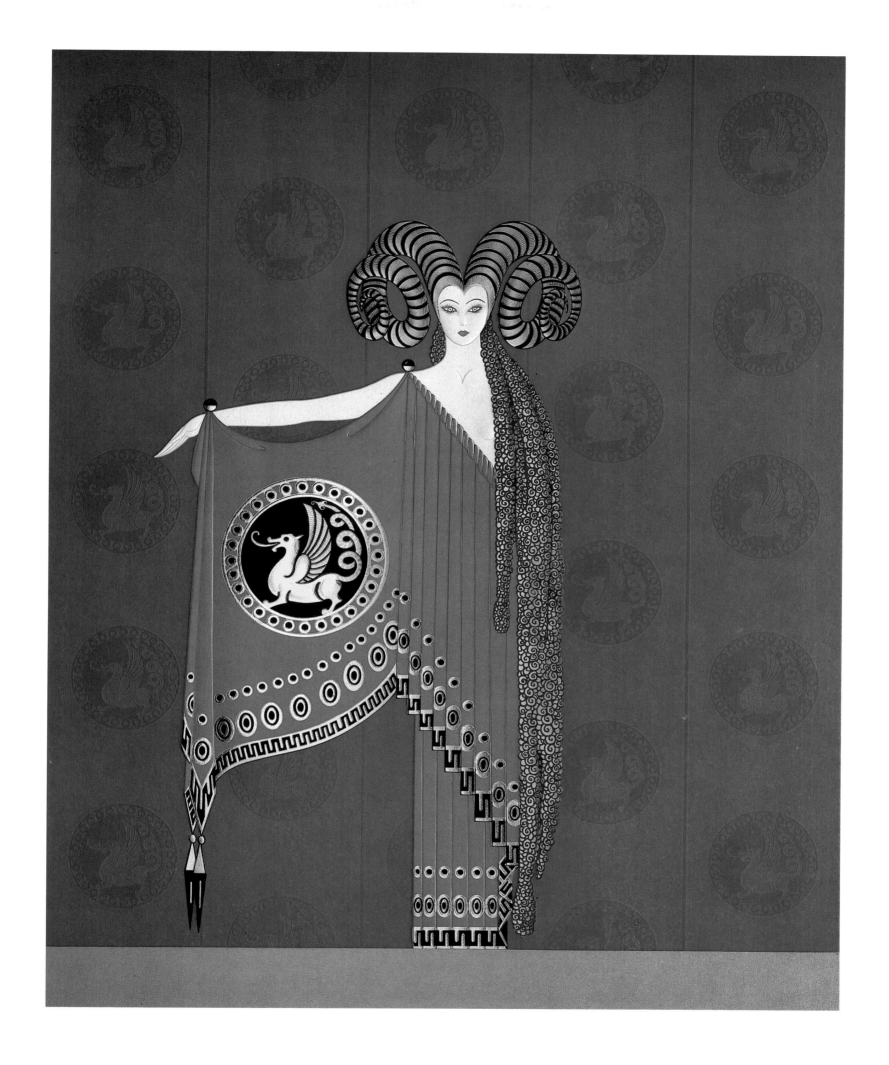

The Golden Fleece
La Toison d'or
Il vello d'oro
Das goldene Vlies

155

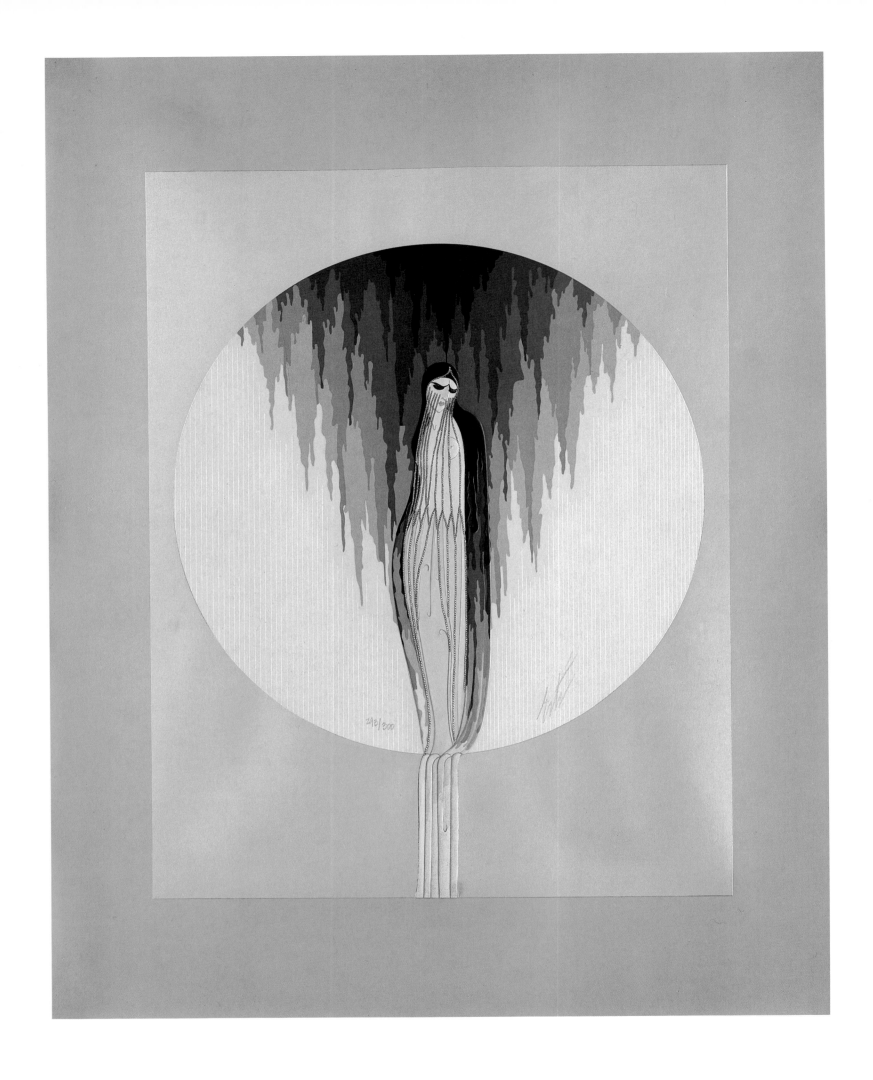

THE FOUR EMOTIONS
LES QUATRE ÉMOTIONS
I QUATTRO SENTIMENTI
VIER GEMÜTSZUSTÄNDE

La Tristesse
La Tristesse
La tristezza
Traurigkeit

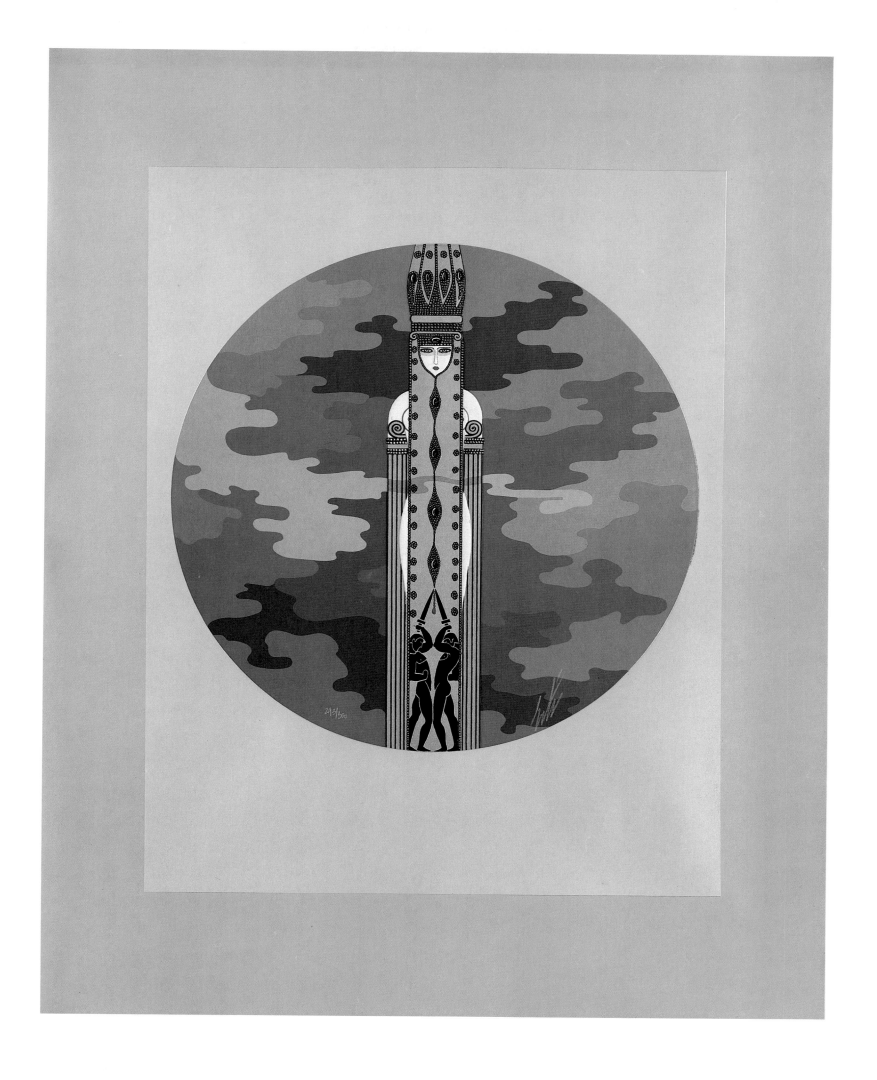

L'Indifférence
L'Indifférence
L'indifferenza
Gleichgültigkeit

157

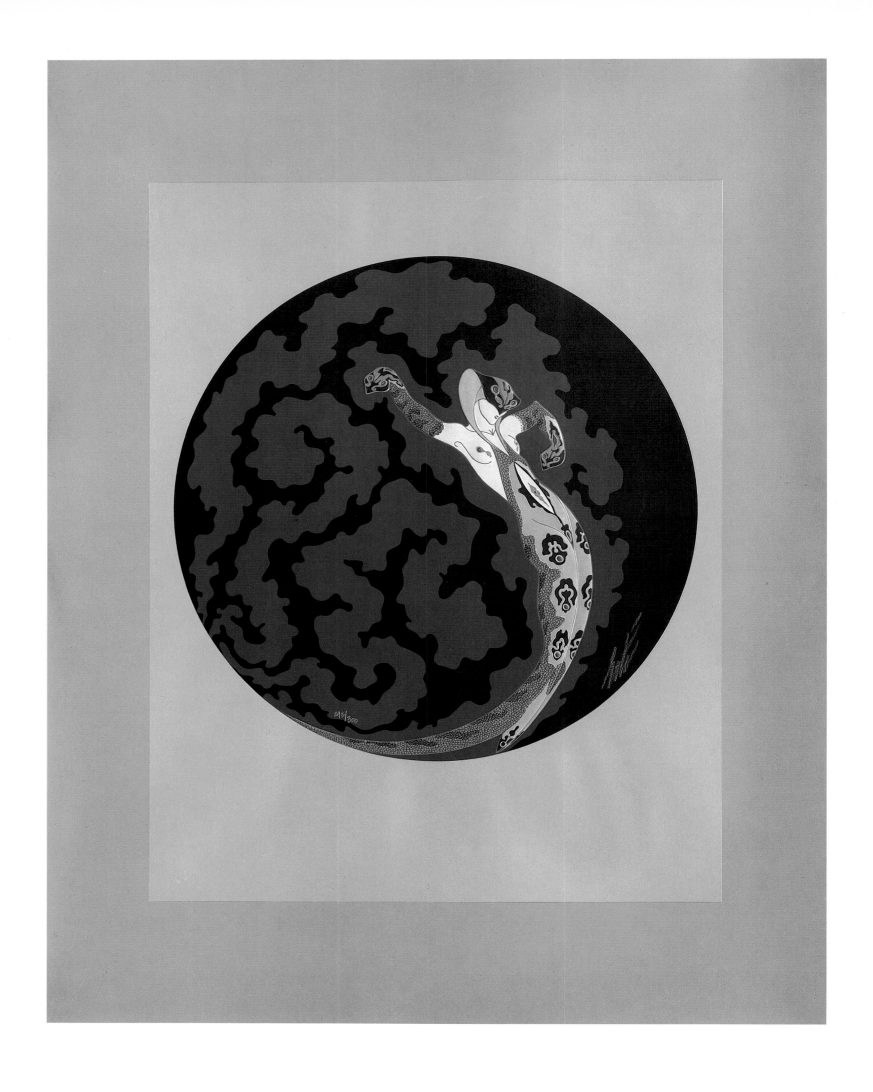

THE FOUR EMOTIONS
LES QUATRE ÉMOTIONS
I QUATTRO SENTIMENTI
VIER GEMÜTSZUSTÄNDE

La Jalousie
La Jalousie
La gelosia
Eifersucht

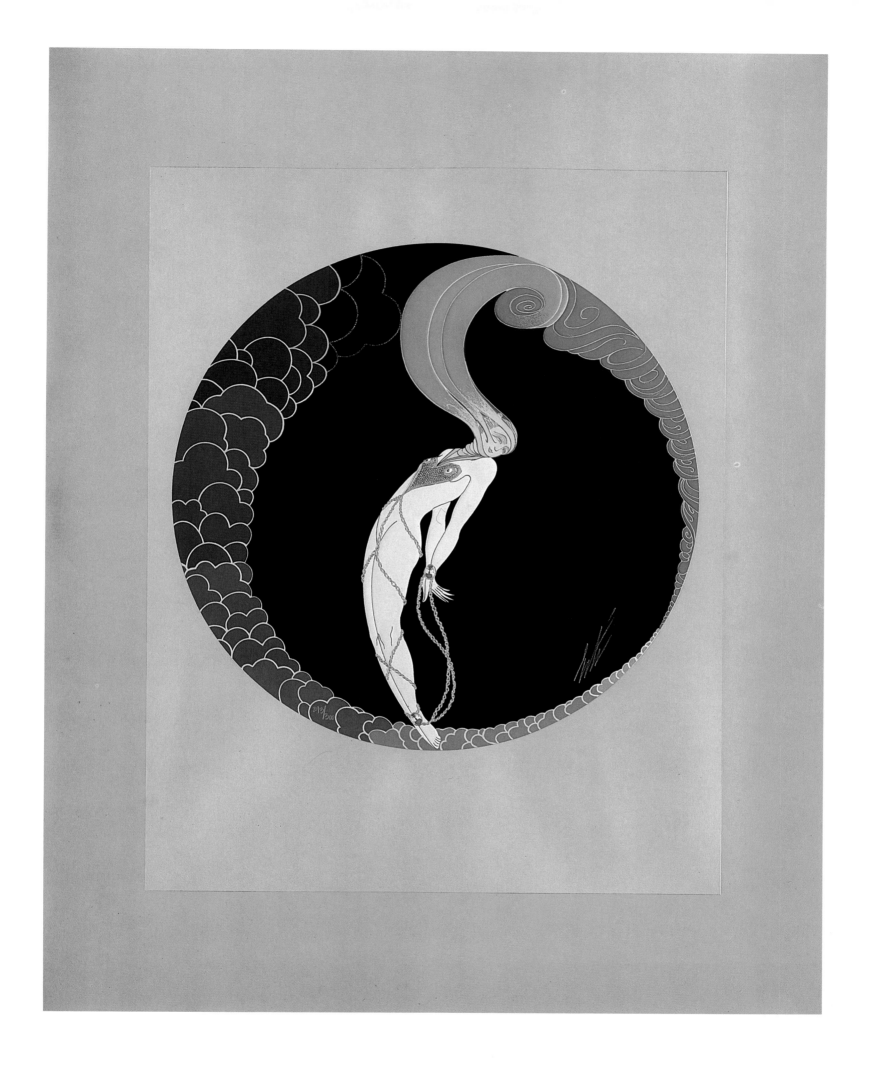

L'Amour
L'Amour
L'amore
Liebe

THE FOUR EMOTIONS
LES QUATRE ÉMOTIONS
I QUATTRO SENTIMENTI
VIER GEMÜTSZUSTÄNDE

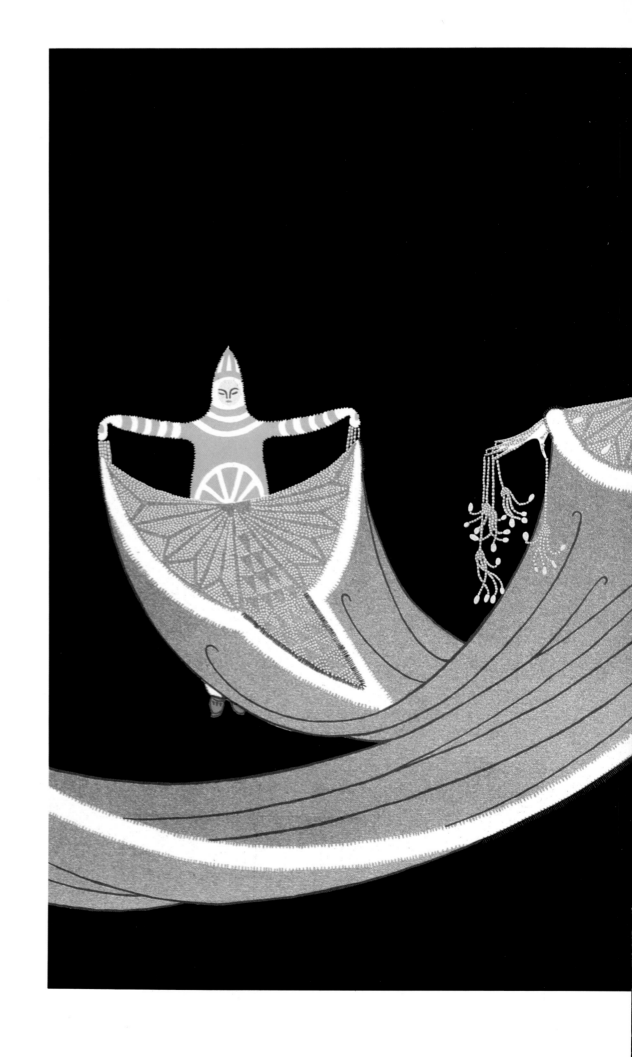

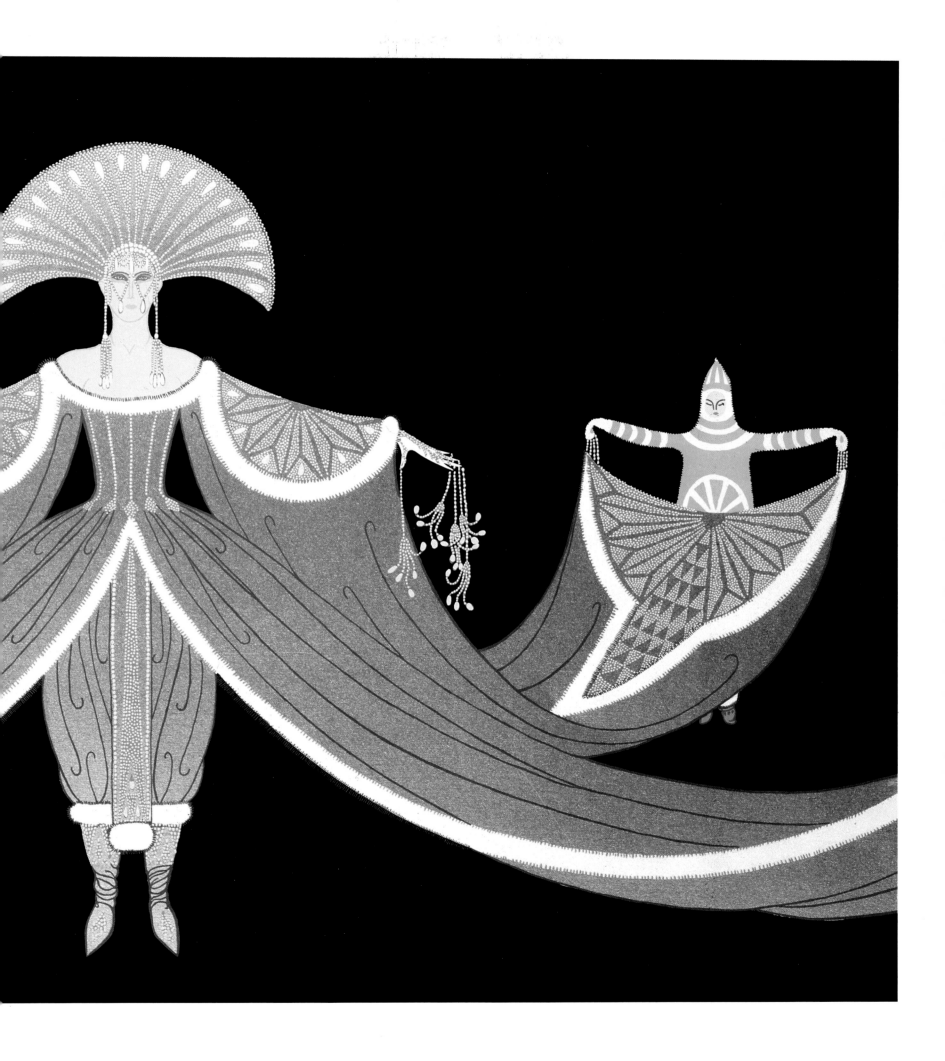

La Mer blanche
La Mer blanche
Il mar bianco
Das weisse Meer

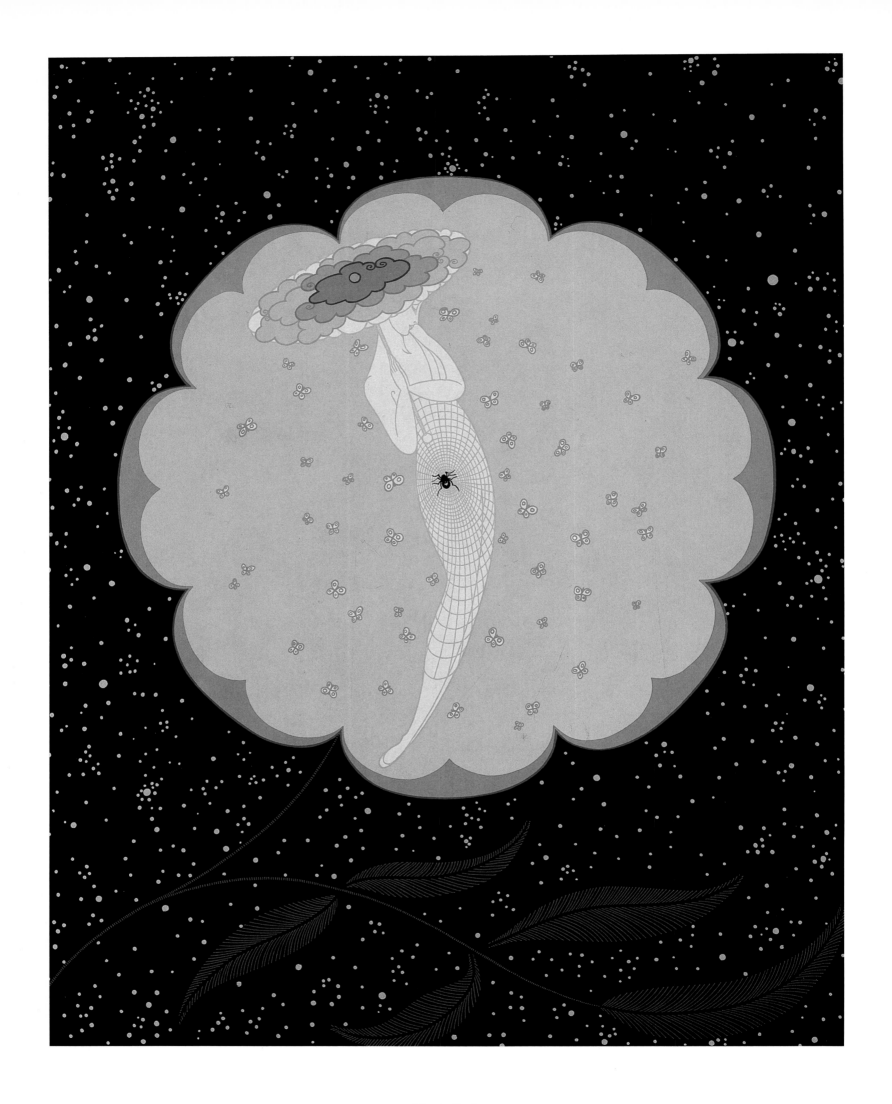

Monte Carlo
Monte-Carlo
Montecarlo
Monte Carlo

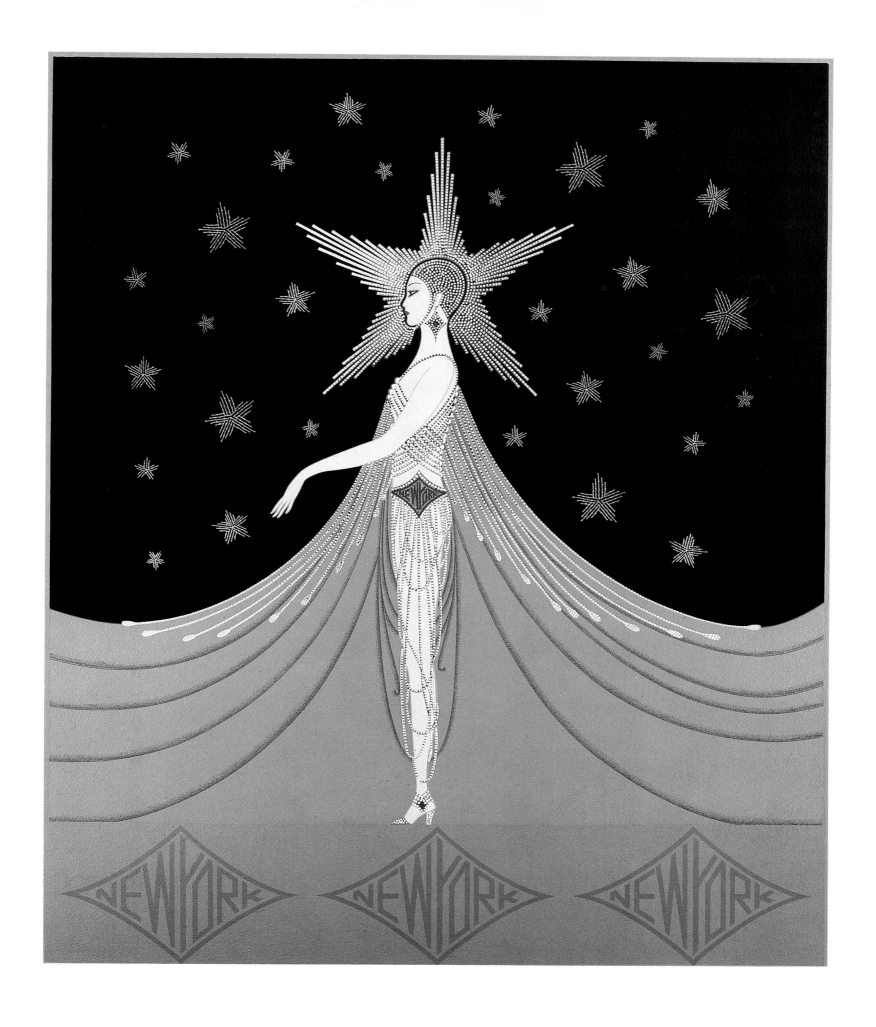

New York, New York
New York, New York
New York, New York
New York, New York

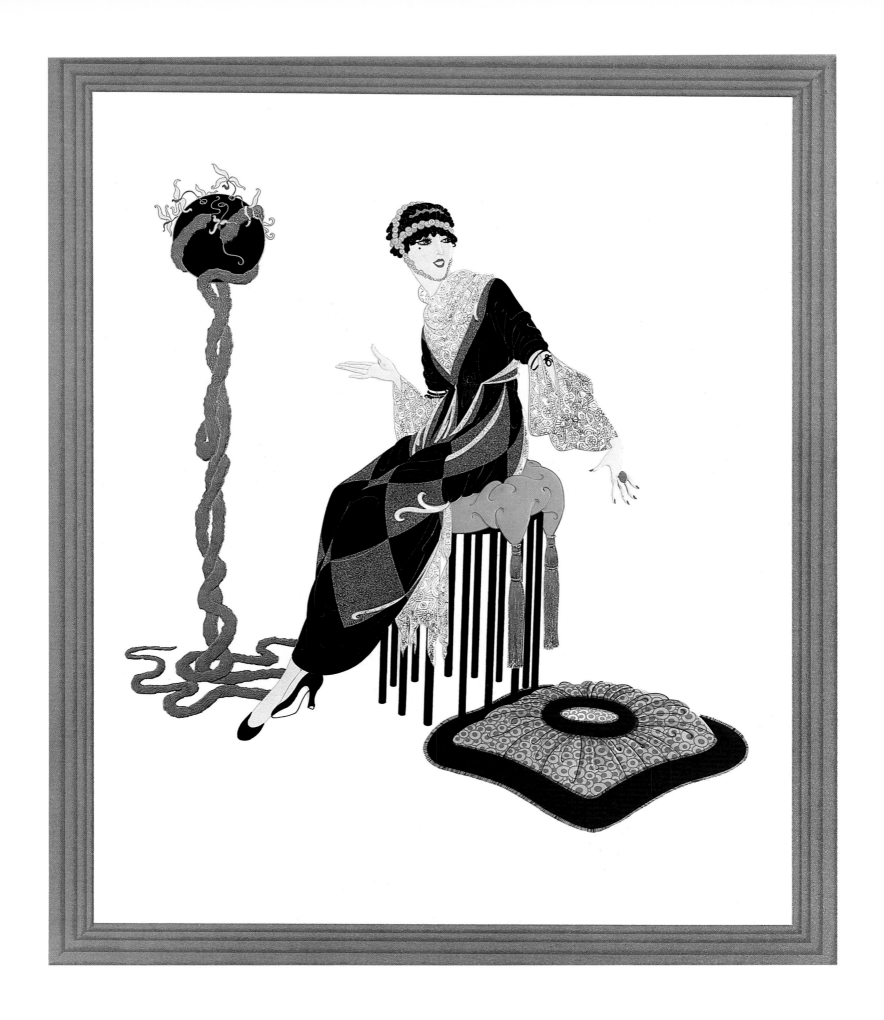

Harmony
Harmonie
Armonia
Harmonie

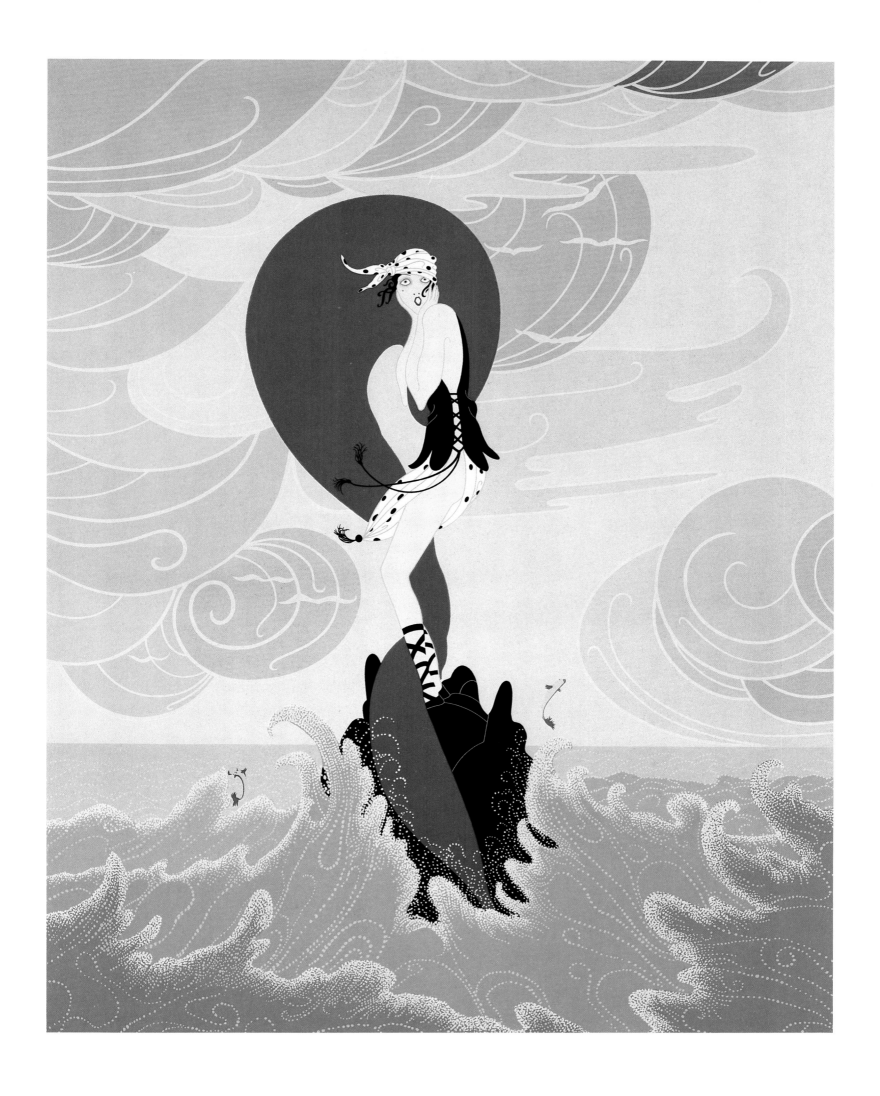

Stranded
Échouée
Incagliata
Gestrandet

165

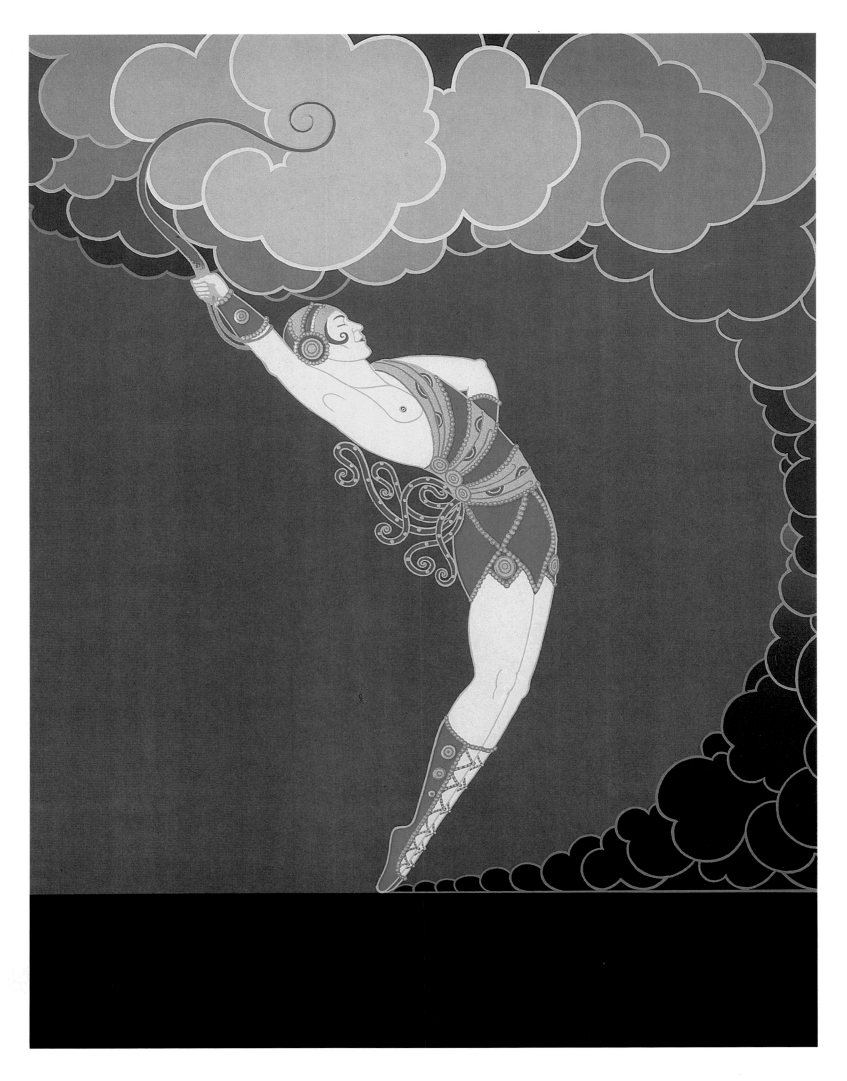

AT THE THEATER SUITE
SÉRIE AU THÉÂTRE
SUITE A TEATRO
SUITE IM THEATER

The Dancer
Le Danseur
Il ballerino
Der Tänzer

166

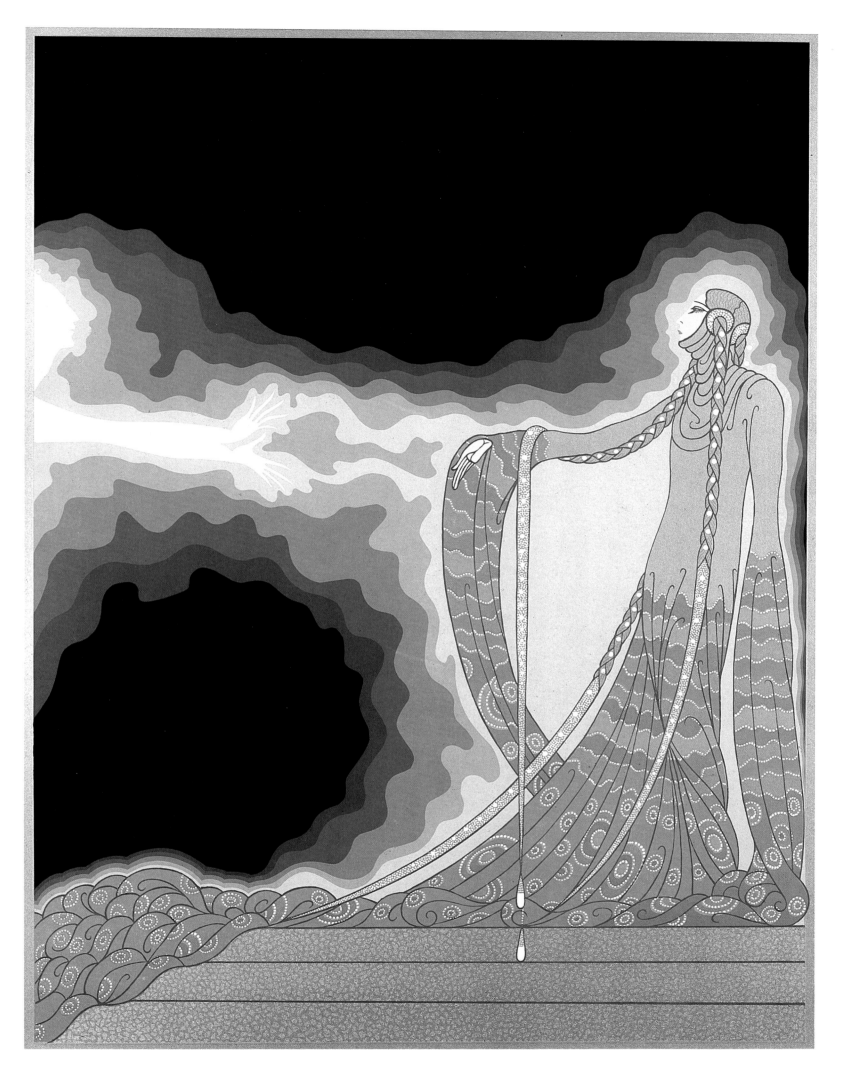

Melisande
Mélisande
Mélisande
Melisande

AT THE THEATER SUITE
SÉRIE AU THÉÂTRE
SUITE A TEATRO
SUITE IM THEATER

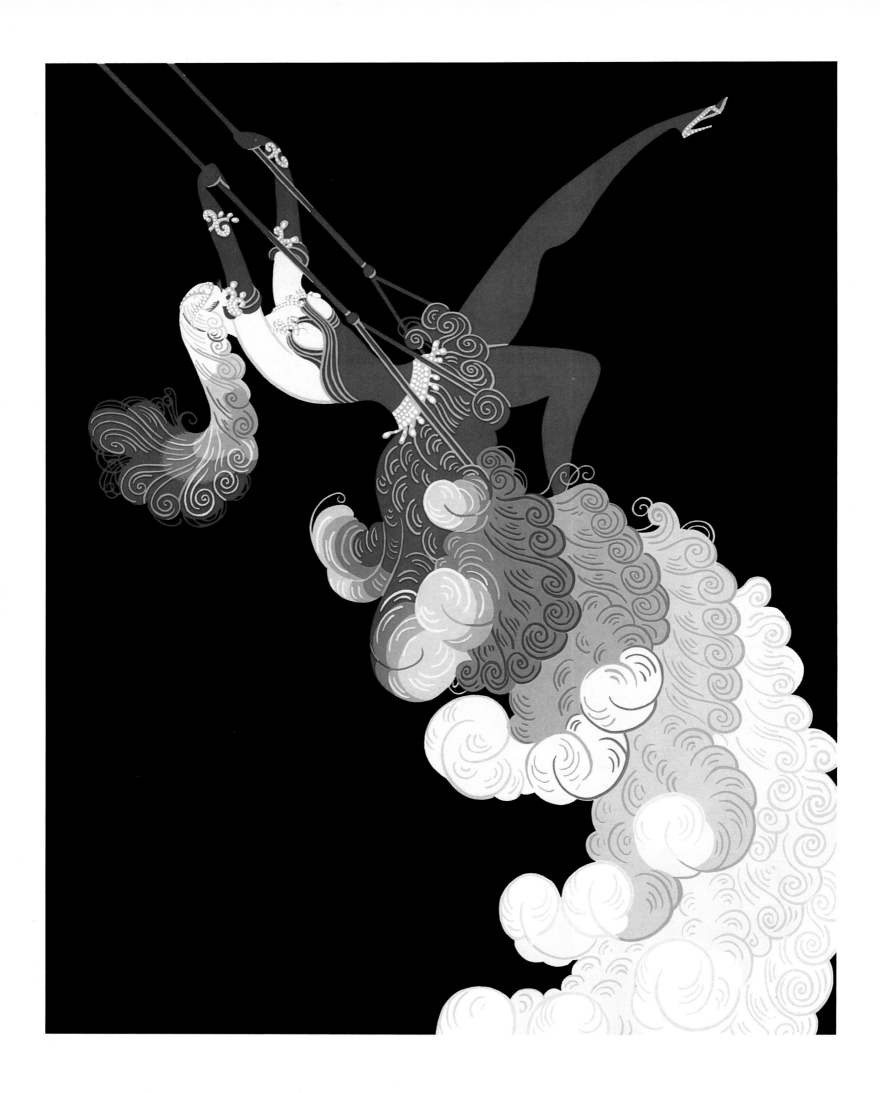

AT THE THEATER SUITE *The Trapeze*
SÉRIE AU THÉÂTRE *Le Trapèze*
SUITE A TEATRO *Il trapezista*
SUITE IM THEATER *Am Trapez*

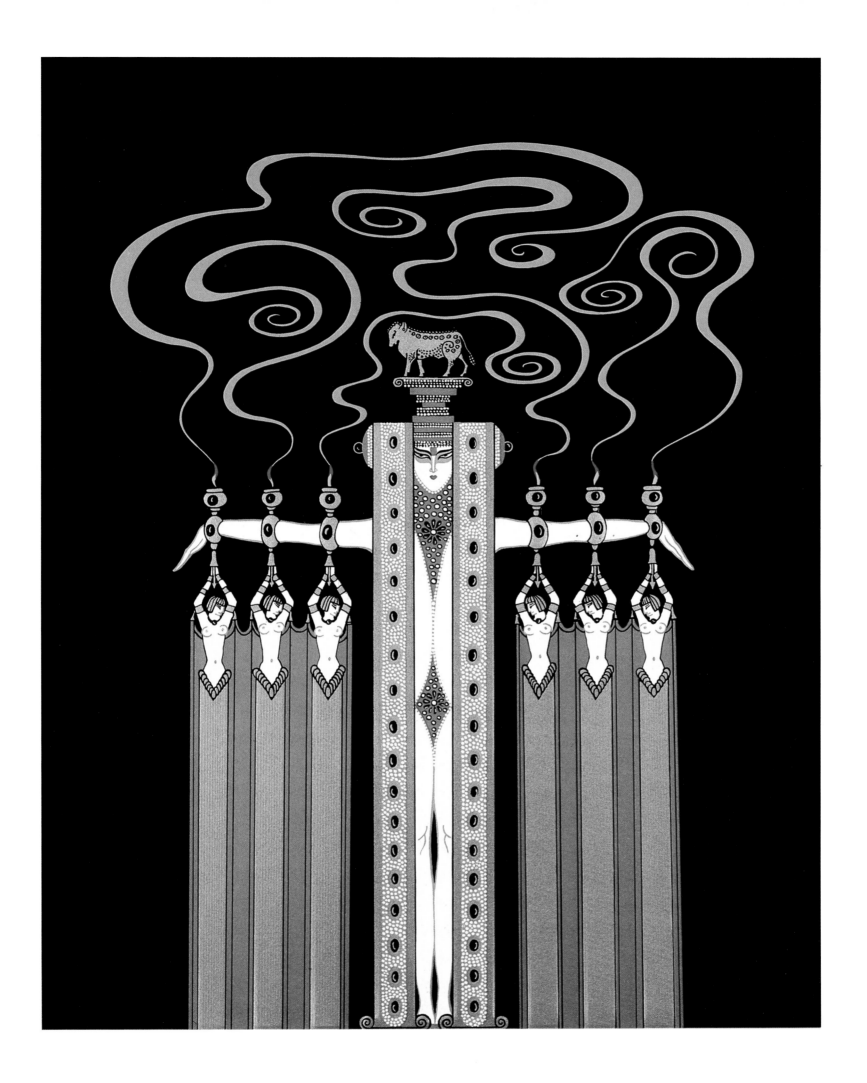

The Golden Calf
Le Veau d'or
Il vitello d'oro
Das goldene Kalb

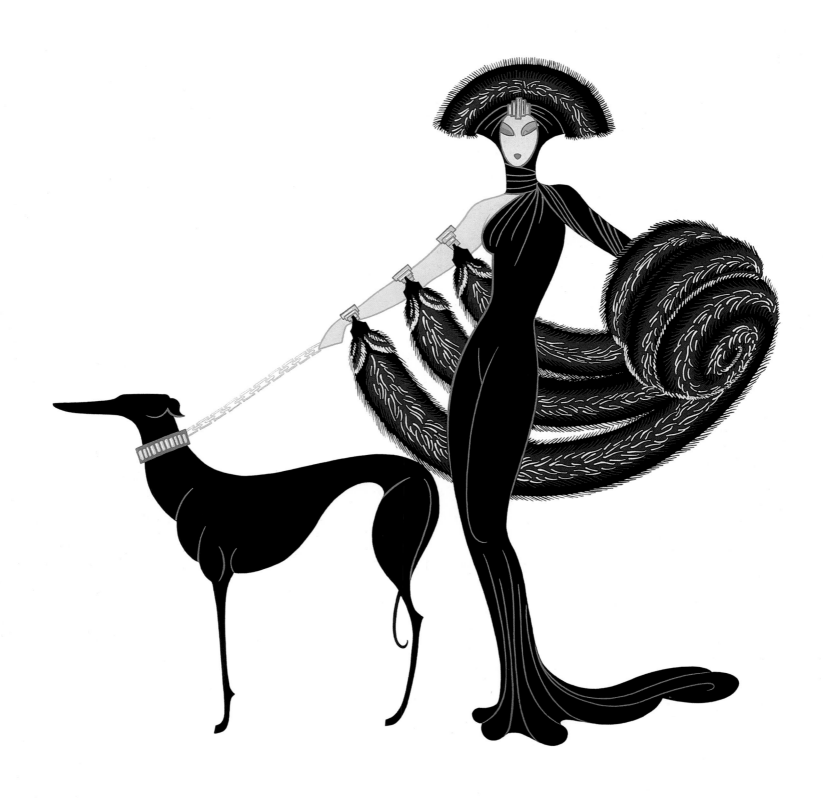

AT THE THEATER SUITE
SÉRIE AU THÉÂTRE
SUITE A TEATRO
SUITE IM THEATER

Symphony in Black
Symphonie en noir
Sinfonia in nero
Symphonie in Schwarz

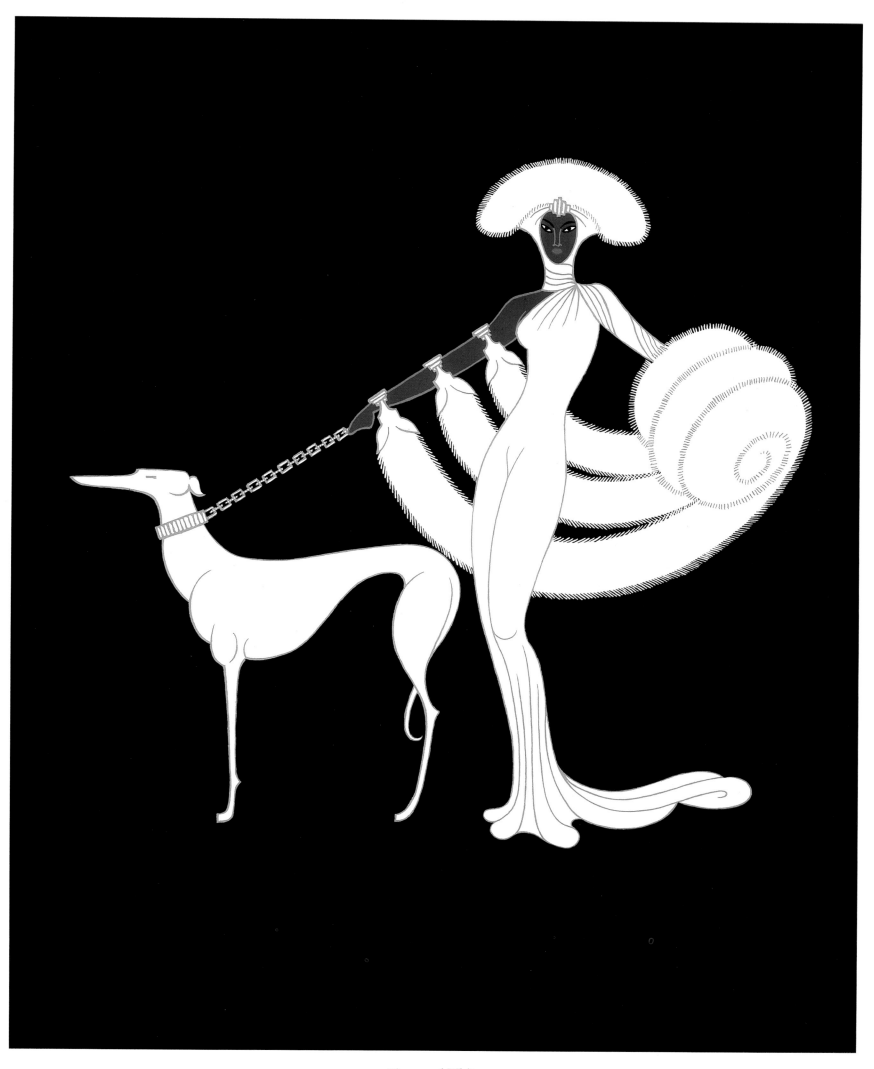

Ebony and White
Ébène et blanc
Nero e bianco
Schwarz und Weiss

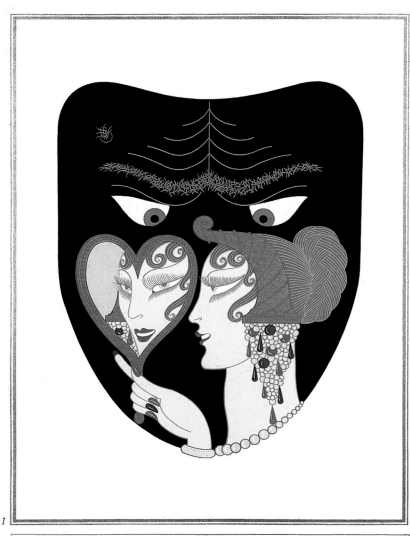

1

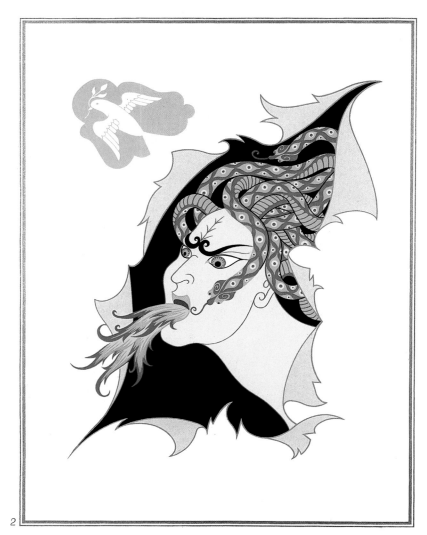

2

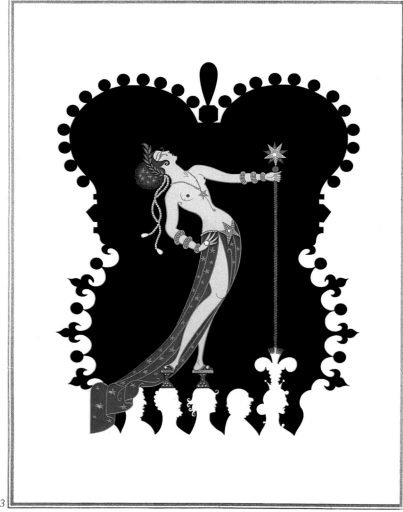

3

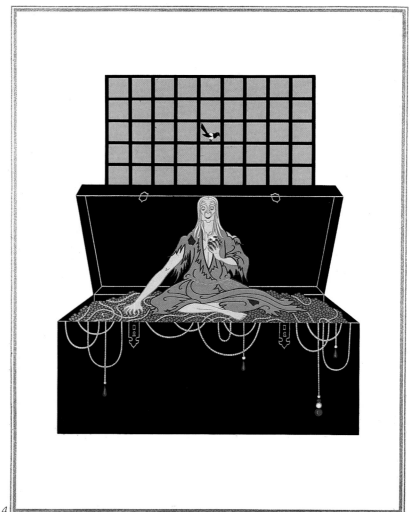

4

THE SEVEN DEADLY SINS	Envy	Anger	Pride	Avarice
LES SEPT PÉCHÉS CAPITAUX	L'Envie	La Colère	L'Orgueil	L'Avarice
I SETTE PECCATI CAPITALI	Invidia	Ira	Superbia	Avarizia
DIE SIEBEN TODSÜNDEN	Neid	Zorn	Stolz	Geiz
	1	2	3	4

172

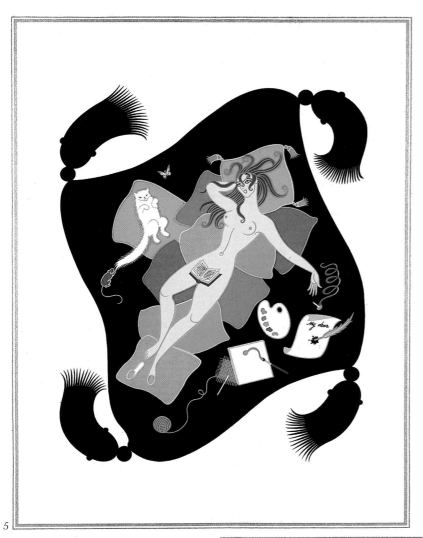

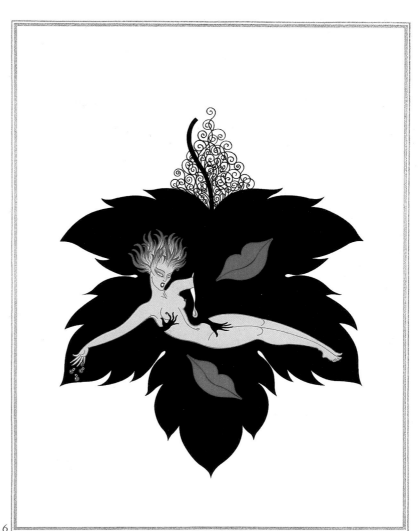

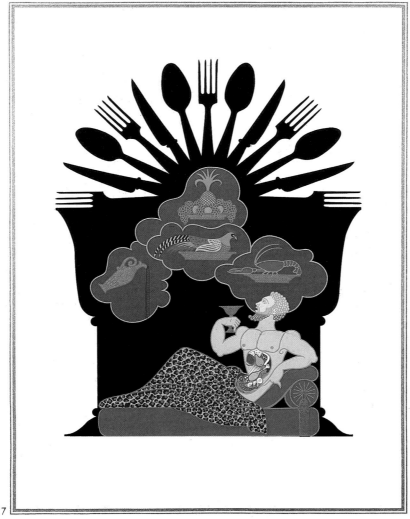

Sloth	*Lust*	*Gluttony*	THE SEVEN DEADLY SINS
La Paresse	*La Luxure*	*La Gourmandise*	LES SEPT PÉCHÉS CAPITAUX
Pigrizia	*Lussuria*	*Gola*	I SETTE PECCATI CAPITALI
Trägheit	*Wollust*	*Völlerei*	DIE SIEBEN TODSÜNDEN
5	6	7	

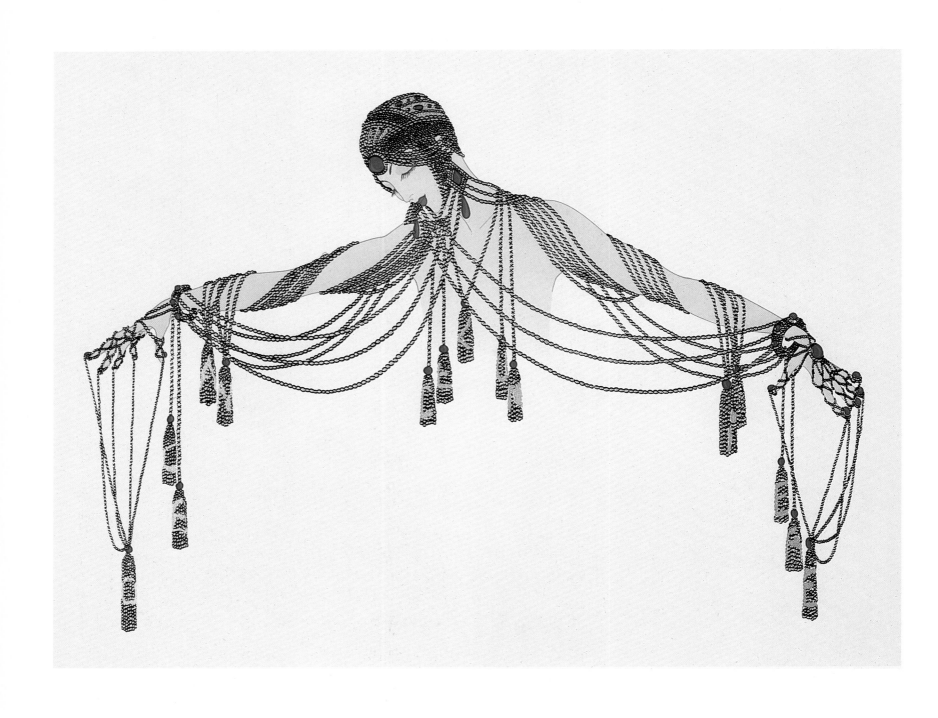

Océan de lumière
Océan de lumière
Oceano di luce
Lichtmeer

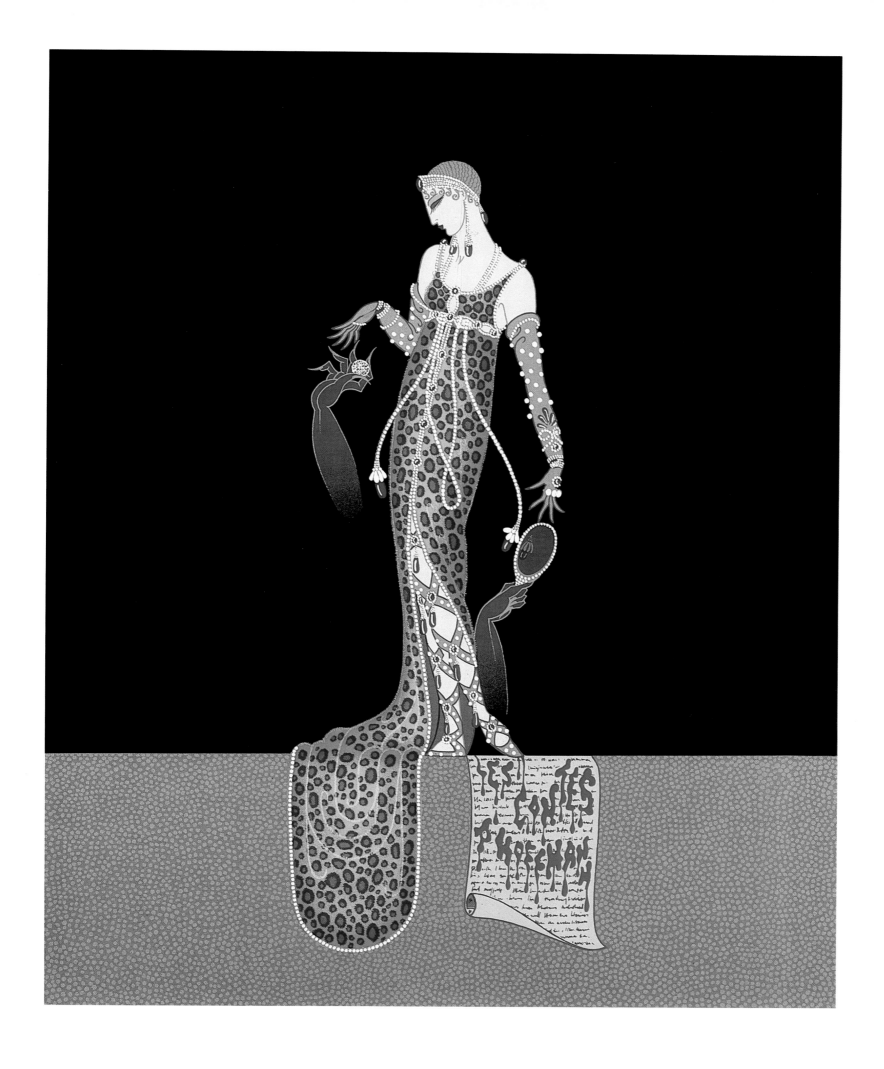

Giulietta
Juliette
Giulietta
Giulietta

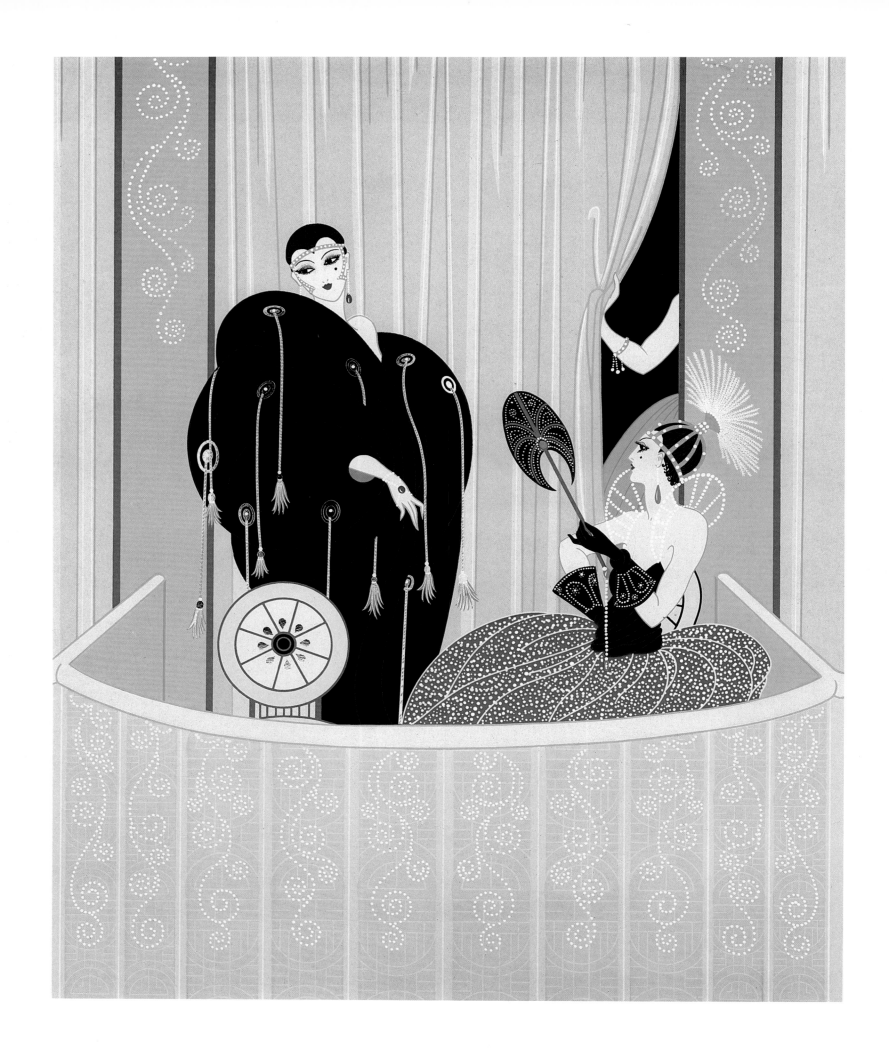

Loge de théâtre
Loge de théâtre
Palco di teatro
Die Theaterloge

176

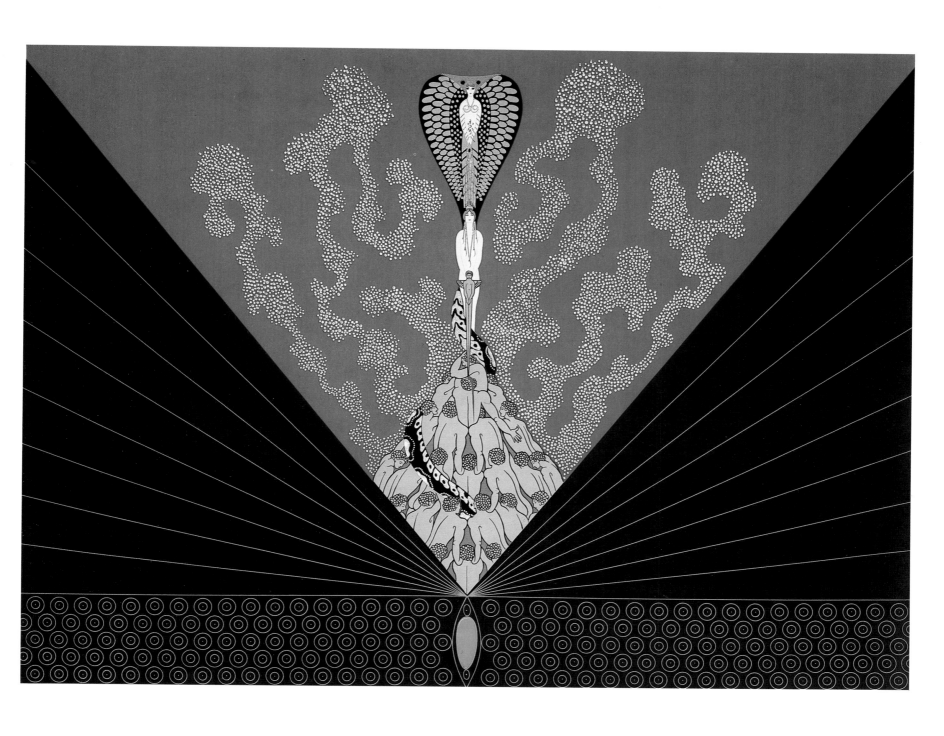

The Triumph of the Courtesan
Le Triomphe de la courtisane
Il trionfo della cortigiana
Der Sieg der Kurtisane

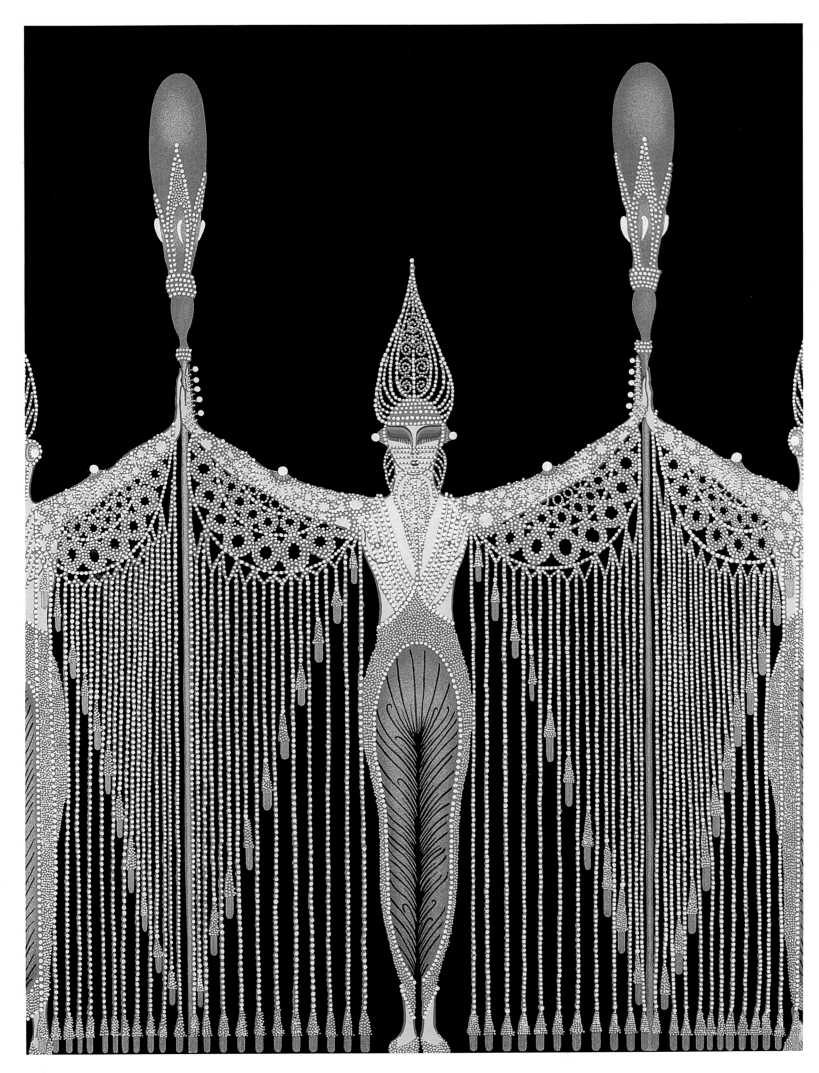

Les Bijoux de perle
Les Bijoux de perle
Gioielli di perla
Perlenschmuck

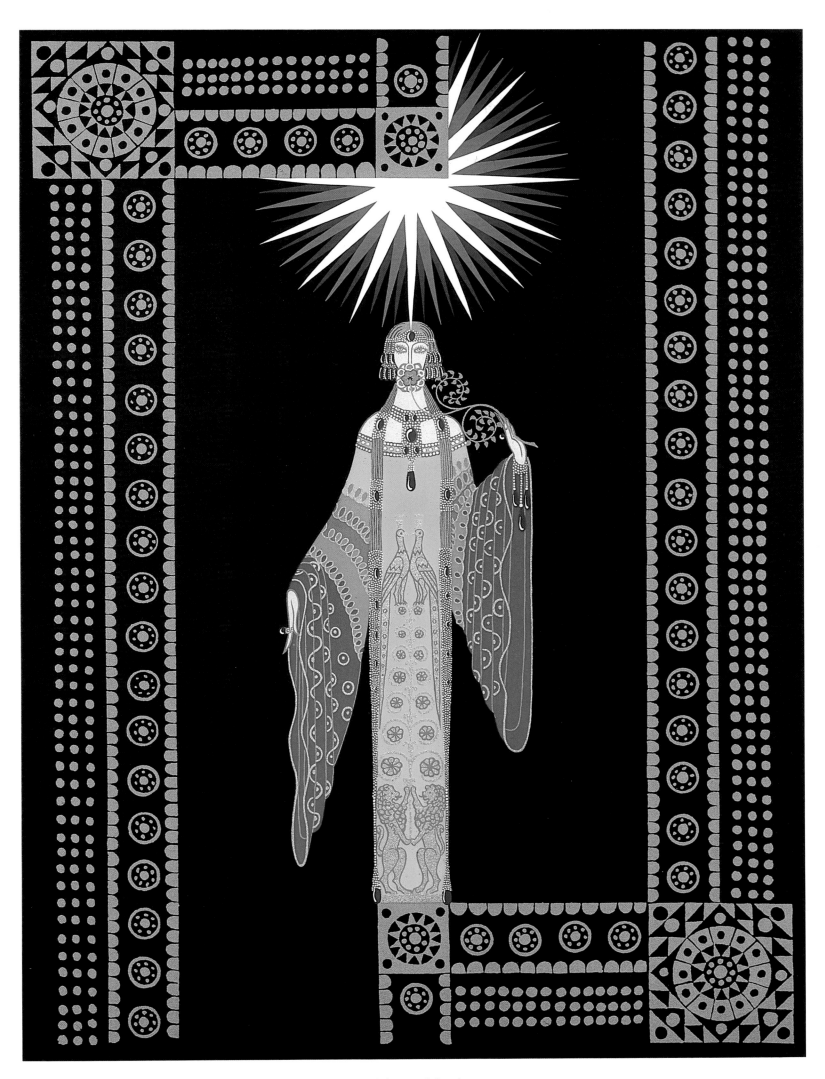

La Princesse lointaine
La Princesse lointaine
La principessa lontana
Die ferne Prinzessin

179

1

2

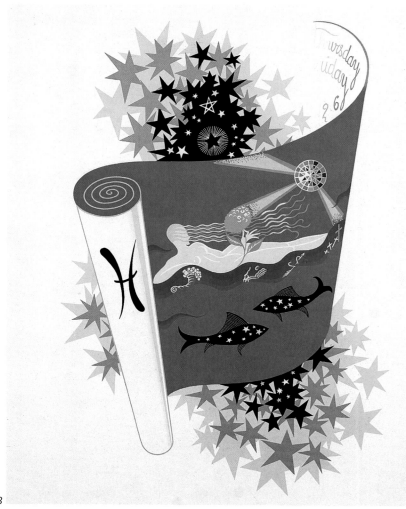

3

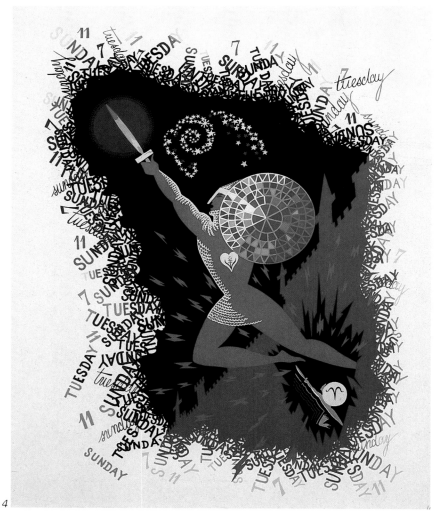

4

THE ZODIAC	Capricorn	Aquarius	Pisces	Aries
LE ZODIAQUE	Le Capricorne	Le Verseau	Les Poissons	Le Bélier
LO ZODIACO	Capricorno	Acquario	Pesci	Ariete
DER TIERKREIS	Steinbock	Wassermann	Fische	Widder
	1	2	3	4

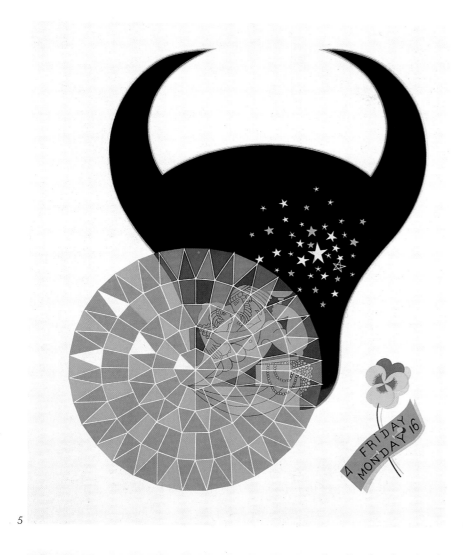

5

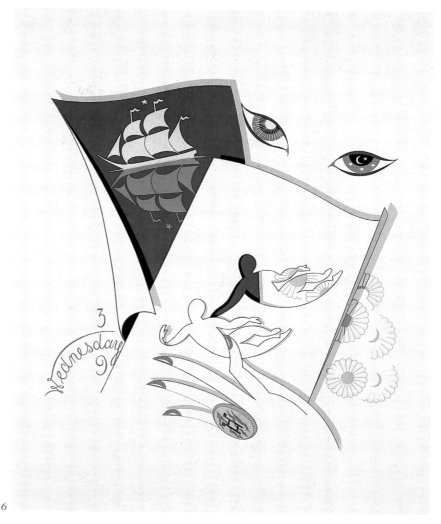

6

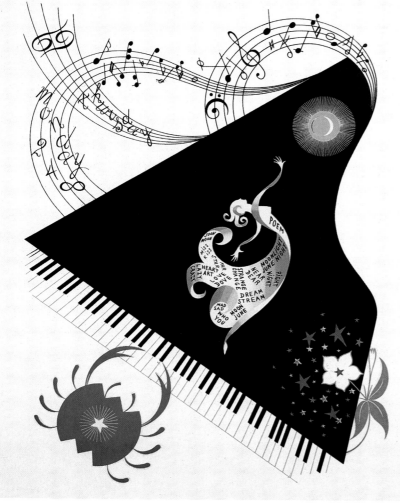

7

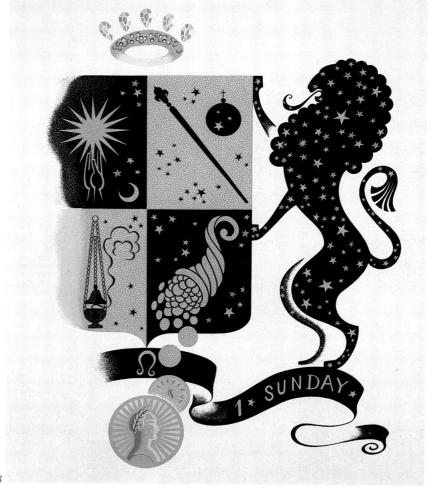

8

Taurus	Gemini	Cancer	Leo	THE ZODIAC
Le Taureau	Les Gémeaux	Le Cancer	Le Lion	LE ZODIAQUE
Toro	Gemelli	Cancro	Leone	LO ZODIACO
Stier	Zwillinge	Krebs	Löwe	DER TIERKREIS
5	6	7	8	

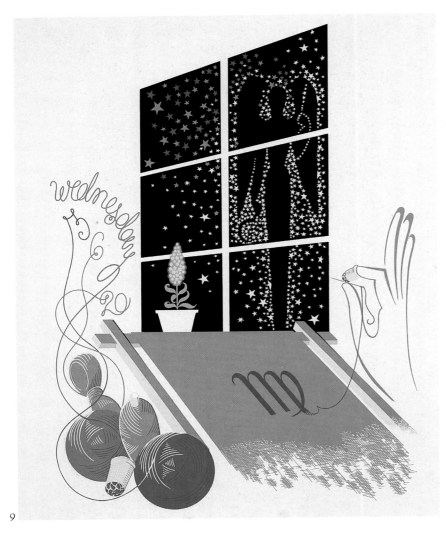

9

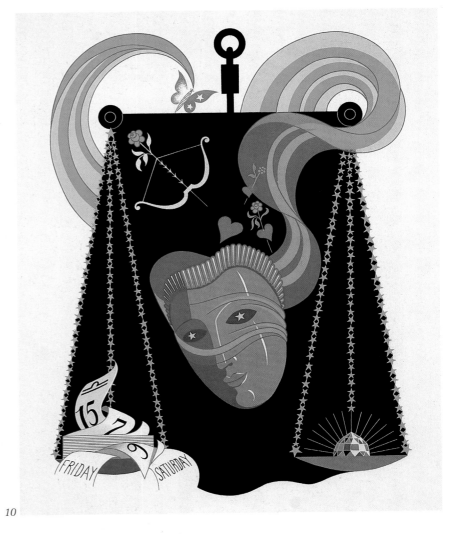

10

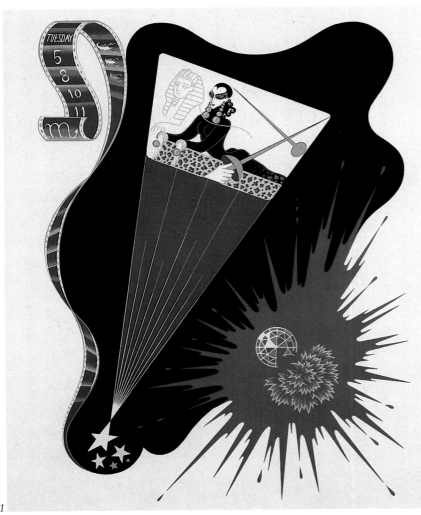

11

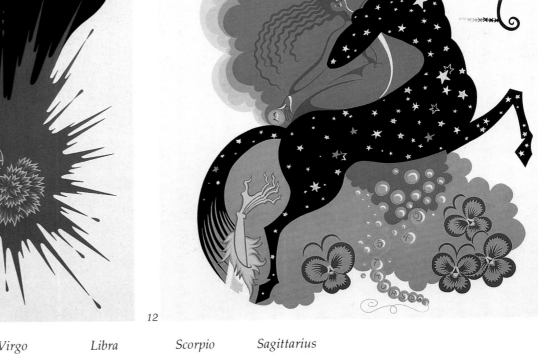

12

THE ZODIAC		Virgo	Libra	Scorpio	Sagittarius
LE ZODIAQUE		La Vierge	La Balance	Le Scorpion	Le Sagittaire
LO ZODIACO		Vergine	Bilancia	Scorpione	Sagittario
DER TIERKREIS		Jungfrau	Waage	Skorpion	Schütze
		9	10	11	12

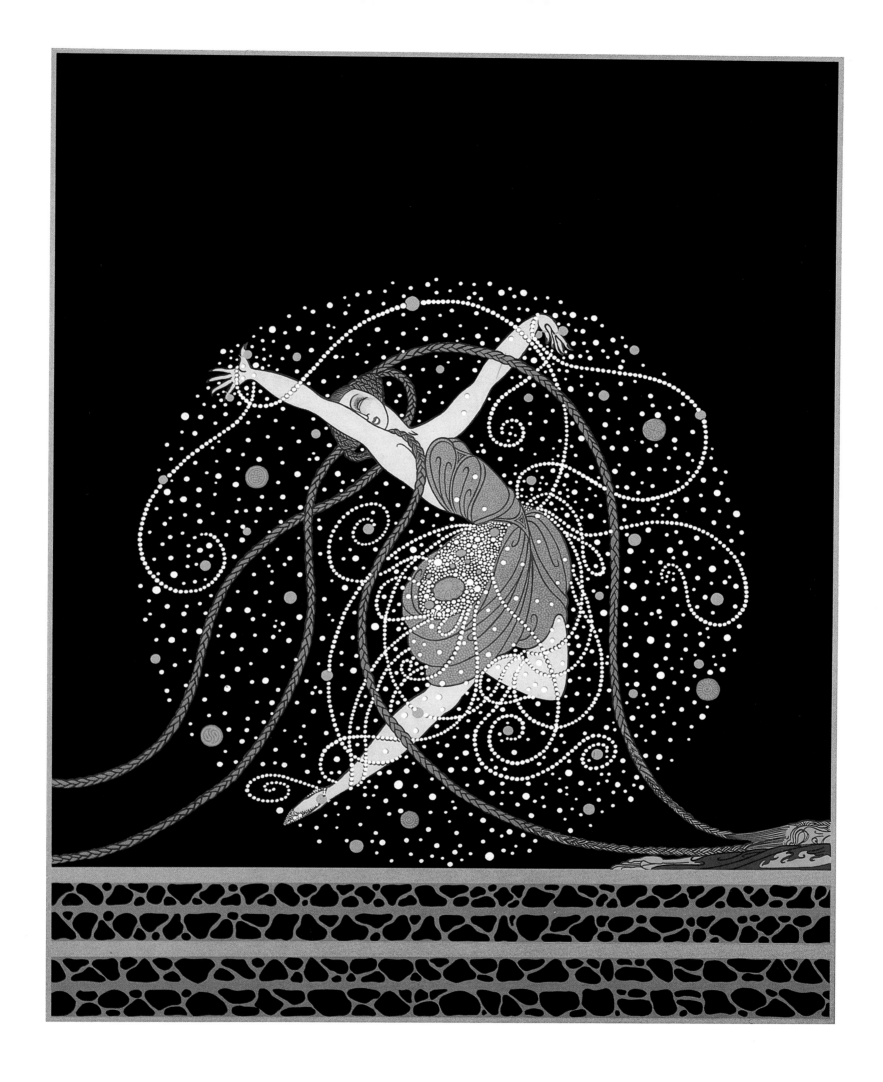

Ondée
Ondée
Acquazzone
Die Woge

183

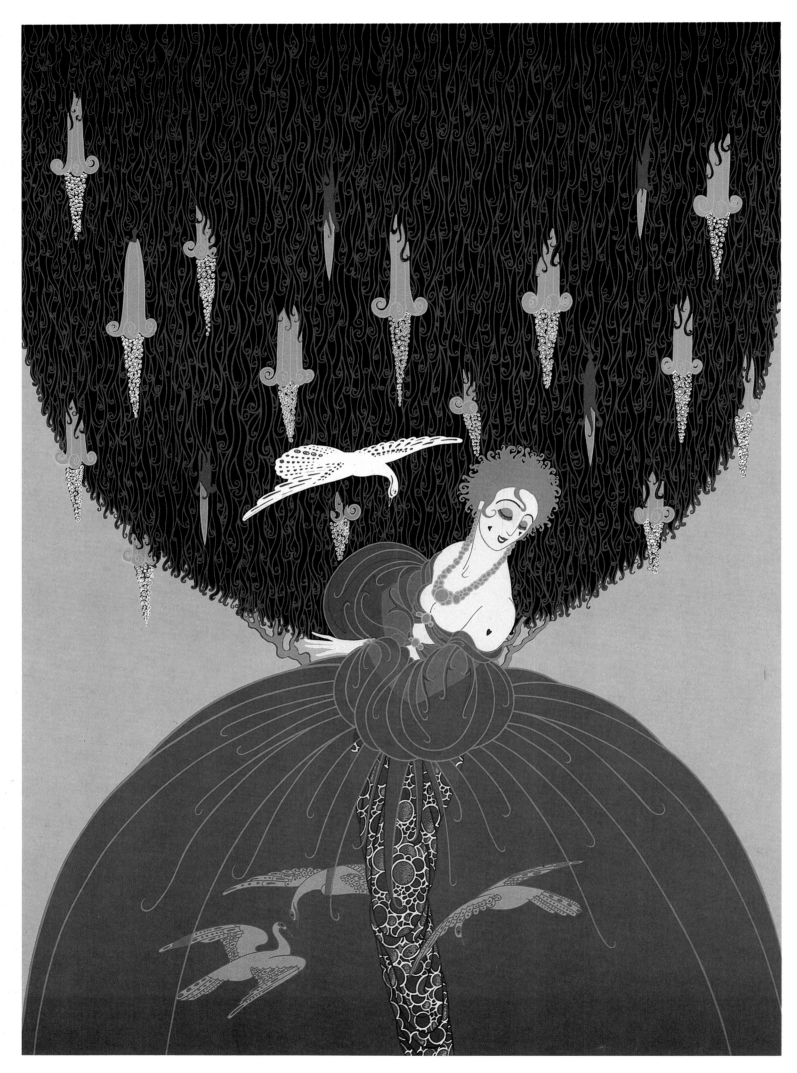

Freedom and Captivity
Liberté-captivité
Libertà e schiavitù
Freiheit und Gefangenschaft

Chronology

1892: Romain de Tirtoff, son of an admiral, born in St. Petersburg, Russia

1898: Designs a dress for his mother that she has made into a ballgown.

1900: Visits World's Fair in Paris with his mother and sister. Decides he wants to live there someday.

1906: Studies painting with portraitist Ilya Repin.

1912: His parents consent to let him study art in Paris. Studies at Académie Julian with historical painter Jean-Paul Laurens, but dislikes the regimented structure of classes and leaves after several months to become a fashion designer. Contributes sketches to Russian fashion magazine *Damsky Mir*.

1913: Works for one month with the dressmaker Caroline. She tells him he has no talent for designing. He then submits fashion sketches to Paul Poiret. Poiret recognizes his talent and hires him as one of two full-time designers. Creates costumes for his first theatrical production, *Le Minaret*, featuring Mata Hari. Contributes drawings to *La Gazette du Bon Ton*, leading fashion magazine of Paris. First use of signature "Erté."

1914: Poiret closes because of war. Erté designs for Henri Bendel and Altman's in New York. Submits designs to *Harper's Bazar*.

1915: *Harper's Bazar* publishes first cover design (January) and designs on interior pages, beginning a twenty-two-year collaboration.

1916: Erté contributes work to *Vogue* magazine. After six months, William Randolph Hearst, owner of *Harper's Bazar*, signs ten-year exclusive contract with Erté to prevent him from creating more designs for *Vogue*. First costume and set designs for a music hall: Madame Rasmini's Théâtre Bataclan in Paris.

1917: Creates costumes for revue, *Marvels of the Orient*, starring Maurice Chevalier and Mistinguett at Théâtre Femina, Paris.

1919: Designs costumes for Gaby Deslys, Théâtre Femina. First designs for Folies-Bergère. Works with Max Weldy, head of Folies-Bergère costume workshop, and thoroughly learns architecture of theater and mechanics of stage. Will continue costume and set designs for Folies-Bergère for eleven years.

1920: Costumes for Ganna Walska of Chicago Opera Company for *La Bohème*, *I Pagliacci*, and *Faust*, among others. Costumes for Mary Garden of Chicago Opera Company for *L'Amore dei Tre Re*. His costume designs used in film *Restless Sex*, starring Marion Davies (Cosmopolitan Films). Exhibition at Knoedler Gallery, New York.

1921: Costume designs for Anna Pavlova.

1922: Costume and set designs for George White's *Scandals*, Irving Berlin's *Music Box Revue*, and Winter Garden in New York. Costume designs for Ganna Walska in *Rigoletto* at Paris Opera.

1923: Costume and set designs for *Ziegfeld Follies*, New York. Illustrations for *La Gazette du Bon Ton*. Fashion drawings for *Ladies' Home Journal*.

1924: Costume designs for *Le Secret du Sphinx* by Maurice Rostand at Théâtre Sarah Bernhardt, Paris. Illustrations for *The Sketch*, London, and *Ladies' Home Journal*.

1925: Goes to Hollywood, under contract to Metro-Goldwyn-Mayer, to design sets and costumes for film *Paris*. Costume and set designs for George White's *Scandals*. Exhibition at Madison Gallery, New York. *Paris* production delayed, and Erté designs costumes for other films, *The Mystic*, *Dance Madness*, *A Little Bit of Broadway*, and King Vidor's *La Bohème*, starring Lillian Gish.

1926: Returns to France, dissatisfied with caricature the producers of *Paris* have created. Makes cover designs and illustrations for Paris magazine *Art et Industrie*. Signs second ten-year contract with *Harper's Bazar*. Costume and set designs for *George White's Scandals* and Folies-Bergère.

1927: Costume designs for Lucrezia Bori in *Pelléas et Mélisande*, *L'Amore dei Tre Re*, and *Les Contes d'Hoffmann* at Metropolitan Opera. Costume and set designs for George White's musical comedy *Manhattan Mary* at Majestic Theater, New York. Exhibition at Studio Gallery, Brussels.

1929: Article and illustrations for *The Encyclopaedia Britannica* (14th ed.). Costume and set designs for *La Princesse Lointaine* by Edmond Rostand at Théâtre Sarah Bernhardt. Exhibition at Galerie Charpentier, Paris, and William Fox Gallery, New York. Illustrations for *International Cosmopolitan* and *The Sketch*. Collection of fabric designs for Amalgamated Silk Corporation, New York.

1930: Second collection of fabric designs for Amalgamated Silk. Illustrations for *Art et Industrie*, *International Cosmopolitan*, and *The Sketch*.

1931: Costume and set designs for Folies-Bergére. Costume designs for Ganna Walska in *Pelléas et Mélisande* (Chicago Opera Company).

1932: Set designs for *Faust* and *Don Pasquale* at Riga Opera.

1933: Designs for Bal Tabarin, Paris.

1934: Costume and set designs for *Au Temps des Merveilleuses* at Théâtre du Châtelet, Paris. Costume designs for *Les Travaux d'Hercule*, operetta by Claude Terrasse at Théâtre des Capucines, Paris. Exhibition at Waldorf-Astoria Hotel, New York.

1935: Costume and set designs for Théâtre Alhambra and Bal Tabarin, Paris, and French Casino, New York.

1937: Costume and set designs for *Plaisir de France*, Bal Tabarin; *It's in the Bag*, by Cecil Landeau, Saville Theatre, London; and Scala Theatre, Berlin. Resigns from *Harper's Bazaar* in dispute with editor Carmel Snow.

1938: Costume and set designs for *London Symphony*, Palladium, and *Fleet's Lit Up*, Hippodrome, London.

1939: Costume and set designs for George White's show at San Francisco Exposition. Costume and set designs for *Un Vrai Paradis*, Bal Tabarin, and *Black Velvet*, Palladium, London.

1942: Costume and set designs for Lecocq's operetta, *Les Cent Vierges*, Théâtre-de l'Apollo, Paris; Lido, Paris; and André Messager's operetta, *Coupe de Roulis*, Théâtre Marigny, Paris.

1943: Costume and set designs for Van Parys's operetta, *Une Femme par Jour*, Théâtre des Capucines; *Belamour*, Théâtres des Nouveautés; Lido; and Bal Tabarin; all Paris. Decoration of windows of Au Printemps department store, Paris.

1945: Costume and set designs for Rossini's *The Barber of Seville* for French television. Costume and set designs for Lido and Bal Tabarin.

1947: Costume and set designs for Francis Poulenc's opera *Les Mamelles de Tirésias*, at Opéra-Comique,

Paris. Costume and set designs for Bal Tabarin, and a revue at Opera House, Blackpool.

1948: Costume and set designs for Maurice Ravel's ballet *Ma Mère l'Oye*, at Opéra-Comique, Paris, and *Sueños de Viena* at Teatro Comico, Barcelona.

1949: Costume and set designs for *Puss in Boots* at Palladium, London.

1951: Costume and set designs for *La Traviata*, Paris Opera; *Fancy Free*, Prince of Wales Theatre, London; *Histoires d'Eve*, La Nouvelle Eve, Paris; *Happy Go Lucky*, Opera House, Blackpool; and *La Leçon d'Amour dans un Parc*, a musical comedy by Guy Lafarge at Théâtre des Bouffes Parisiens.

1952: Costume and set designs for *Pelléas et Mélisande* and Albert Roussel's *Padmavâti*, at Teatro San Carlo, Naples; Mozart's *Cosi fan Tutti*, Opéra-Comique, Paris; *Ring Out the Bells*, Victoria Palace, London; *Bet Your Life*, Hippodrome, London; and *Les Filles d'Eve*, at La Nouvelle Eve. Costume and set designs for *Maske in Blau* for Bavaria-Films, Munich.

1953: Costume designs for *Die Geschiedene Frau*, for Bavaria-Films. Costume and set designs for *Caccia al Tesoro*, Teatro delle Quattro Fontane, Rome.

1955: Costume and set designs for Jacques Ibert's opera, *Gonzague*, at Cannes and Rouen opera houses; *Campañas de Vena*, Teatro Comico, Barcelona; and *La Plume de Ma Tante*, Garrick Theatre, London.

1957: Costume and set designs for Richard Strauss's *Capriccio*, Opéra-Comique, and *Pommes à l'Anglaise*, Théâtre de Paris.

1958: Costume and set designs for Massenet's opera, *Don Cezar de Bazan*, Rouen Opera; *La Plume de Ma Tante*, Royal Theatre, New York; and revues at Drap d'Or and Folies-Pigalle, Paris.

1959: Costume and set designs for Donizetti's *Don Pasquale*, Opéra-Comique, Paris, and *Crown Jewels*, Victoria Palace, London.

1960: Costume and set designs for Racine's *Phèdre*, Théâtre du Vieux Colombier, Paris; set designs for Robert Thomas's *Piège pour un Homme Seul*, Théâtre des Bouffes Parisiens. Costume and set designs for ballet films of Louis Cuny: *Le Coiffeur-Miracle* and *Èdition Speciale*.

1961: Costume and set designs for Rameau's *Castor et Pollux*, Théâtre Antique de Fourvières, Lyons Festival and Moulin Rouge, Paris. Set designs for *Olé*, Deutschlandshalle, West Berlin.

1963: Costume and set designs for Latin Quarter, New York.

1964: Costume and set designs for *Wonderworld*, New York's World's Fair; Terence's *The Eunuch*, Comédie de Paris; and Latin Quarter, New York. Exhibition of Formes Picturales (metal sheet sculpture decorated with oil pigment) at Galerie Ror Volmar, Paris.

1965: Exhibitions at Galerie Motte, Paris, and Galleria Milano, Milan.

1966: Exhibition, "Les Années 25", at Musée des Arts Décoratifs, Paris, commemorating 1925 exhibition that marked emergence of Art Deco movement. Exhibition at Galerie Jacques Perrin, Paris, and "100 Years of Harper's Bazaar", New York.

1967: Costume and set designs for "Flying Colors", Expo '67, Montreal. Exhibition at Grosvenor Gallery, New York; this entire exhibition of 170 works was purchased by Metropolitan Museum of Art, New York. Exhibition at Grosvenor Gallery, London, with numerous works purchased by Victoria and Albert Museum. Exhibition at Galerie Jacques Per-

rin, Paris; Galleria Viotti, Turrin; and Galleria d'Arte Cavalletto, Brescia.

1968: Costume designs for *The Silent Night*, a ballet for television, New York. First lithographs, *The Numerals*, published by Grosvenor Gallery. Exhibitions at Metropolitan Museum of Art; Neues Kunst-Zentrum, Hamburg; Galleria Paolo Barozzi, Venice.

1969: Illustrations for two books, *Ermyntrude and Esmeralda*, by Lytton Strachey, and *The Beatles Illustrated*. Exhibition at Galerie René Drouet.

1970: Awarded title "Chevalier du Mérite, Artistique et Culturel" by French government. Costume and set designs for *Zizi Jeanmaire Show*, produced by Roland Petit, Casino de Paris. Exhibition at Galeria Arvil, Mexico City.

1971: Exhibitions at Galleria della Rocchetta, Parma; Galleria Marino, Rome; Galerie Proscenium, Paris; and Club dei Bibliofili of Milan, Bologna, and Palermo.

1972: Costume and set designs for *Zizi, Je T'Aime*, produced by Roland Petit, Casino de Paris. Exhibition at Rizzoli Gallery, New York.

1974: Creates *Splendeur*, his first serigraph. This begins collaboration with Circle Fine Art as his publisher of prints. Exhibition at Galerie Proscenium, Paris. Costume and set designs for *Ragtime Ballet*, Ballet Théâtre, Angers. Poster designs for Alcazar nightclub and Folies-Bergère.

1975: Costume designs for *Schéhérazade*, produced by Robert Hossein. Publication of autobiography, *Things I Remember*.

1976: Awarded title "Officer of Arts and Letters," by French government. Exhibition at Shiseido Gallery, Tokyo.

1977: Honored with Ziegfeld Award of Excellence at the Ziegfeld Ball, New York. Publication of *The Alphabet* portfolio, combining lithography and serigraphy. Graphics restrospective exhibitions at Circle Galleries, New York, Los Angeles, San Francisco, San Diego, Chicago; Gallery in the Square, Boston; and Cherry Creek Gallery of Fine Art, Denver.

1978: Honored by Eugene O'Neill Foundation at gala "Broadway's in Fashion" celebration, New York. CBS-TV film on Erté, narrated by Diana Vreeland. Exhibition of Erté costumes for New York's Latin Quarter, Boston Center for the Arts.

1979: French documentary, *Erté—Or a Magician in the Twentieth Century*, released. Smithsonian Institution organizes traveling retrospective exhibition that tours the United States, Canada, and Mexico for three years.

1980: Costume and set designs for Glyndebourne Opera Company's performance of *Der Rosenkavalier*.

1982: Major Erté exhibition in Copenhagen, Denmark. Awarded Médaille de Vermeil de la Ville de Paris.

1983: Collaborated on a musical autobiography, *Erté*. Participated in designing a collection of women's haute couture clothing and millinery.

1984: Designed Christmas packaging for a Swiss hosiery company. Created new posters for Folies-Bergère and Campari.

1985: Costume and set designs for Arthur Schnitzler's *Anatol*, premiering in Los Angeles. Awarded the Legion of Honor by France.

1986: Commission to design cover of January 1987 *Playboy* magazine. Commission to design offical poster for new Theatre Museum, London. Commission to design a bottle for Courvoisier cognác. Retrospective exhibition Boulogne-Billancourt (Paris), "75 Ans de Creation, 1918-1986". Ninety-fourth birthday exhibition, Grosvenor Gallery, London.

BIBLIOGRAPHY
Books by and about Erté

Barthes, Roland. *Erté*. Franco M. Ricci, Milan, 1972 (lim. ed.).

Blum, Stella. *Designs by Erté*. Dover, New York, 1976.

Cox, John. (Introduction) *Erté's Costumes and Sets for ''Der Rosenkava-
lier''*. Dover, New York, 1980.

Erté, *Erté Fashions*. St. Martin's, New York, 1972.

———. *Erté—Things I Remember*. Quadrangle, New York, 1975.

Erté's Fashion Designs. Dover, New York, 1981.

Estorick, Salomé. (Preface) *Erté Graphics*. Dover, New York, 1978.

———. (Preface) *Erté's Theatrical Costumes*. Dover, New York, 1979.

———. (Preface) *New Erté Graphics*. Dover, New York, 1984.

Johnston, Susan (Rendered by). *Erté Fashion Paper Dolls of the 20s*.
Dover, New York, 1980.

Lee, Marshall (Editor). *Erté at Ninety: The Complete Graphics*. E. P. Dut-
ton, New York, 1982.

———. *Erté Sculpture*. E. P. Dutton, New York, 1986.

Spencer, Charles. *Erté*. Clarkson N. Potter, New York, 1970, rev.
1981.

Walters, Thomas. *Erté*. Rizzoli, New York, 1978.

Index

Alphabetical list of the works with technical data

The data are given in the following order:
title (series)
medium (size of edition) date printed
sheet size
printer
page

The publisher of each work is identified
by a symbol following the title:

 * *Chalk & Vermilion Fine Arts, Ltd.*
 † *Sevenarts, Ltd.*
 o *Circle Fine Art, Inc.*
 • *Wellsart, Ltd.*
 + *Kane Fine Art, Ltd.*

Adam and Eve *
embossed serigraph (1-300, I-CXXV,
AP 1-48) August 1982
37×21"
Studio Heinrici, Ltd., New York
54

Adoration †
serigraph (1-300, I-XX) January 1986
28×22"
Coriander Studio, London
87

Air (The Four Elements) †
serigraph (1-175, AP I-XVII)
December 1984
23¾×20"
Coriander Studio, London
120

Aladdin and His Bride +
serigraph (1-300, I-L, AP 1-50) 1984
31×37"
Coriander Studio, London
124/125

L'Amour (The Four Emotions) o
embossed serigraph with foil stamping
(1-300, AP I-XXXV, AP 1-50, HC
1-4, PP 1-4) October 1982
22¾×17¾"
Chicago Serigraphic Workshop
Cooke-Burger Embossing, Chicago
159

The Angel *
serigraph (1-300, I-CL, AP 1-60)
February 1983
26½×38"
Chromacomp, New York
28/29

Anger (The Seven Deadly Sins) •
serigraph (1-350, I-XC, AP 1-35)
January 1983
26¼×20¾"
Chromacomp, New York
172

Aphrodite *
embossed serigraph with foil stamping
(1-300, I-CL, AP 1-50, HC 1-50)
June 1985
40×30¾"
Chromacomp, New York
34

Aquarius (The Zodiac) •
serigraph (1-350, I-XC, AP 1-35)
October 1982
25½×20"
Chromacomp, New York
180

Aries (The Zodiac) •
serigraph (1-350, I-XC, AP 1-35)
October 1982
25½×20"
Chromacomp, New York
180

Athena *
embossed serigraph with foil stamping
(1-300, I-CL, AP 1-50, HC 1-7)
August 1986
35×26¼"
Chromacomp, New York
96

Avarice (The Seven Deadly Sins) •
serigraph (1-350, I-XC, AP 1-35)
January 1983
26¼×20¾"
Chromacomp, New York
172

Bamboo (Asian Princess Suite) *
embossed serigraph with foil stamping
(1-300, I-CL, AP 1-35, HC 1-9) June
1986
28½×20½"
Chromacomp, New York
44

Bayadère †
embossed serigraph (1-300, I-XX)
April 1986
28×22"
Coriander Studio, London
82

Les Bijoux de perle +
embossed serigraph (1-300, I-L, AP
1-50) 1983
22×30"
Coriander Studio, London
178

Blue Asia *
embossed serigraph with foil stamping
(1-300, I-CXXV, AP 1-50, HC 1)
September 1985
29×22"
Chromacomp, New York
78

Byzantine *
embossed serigraph with foil stamping
(1-300, I-CL, AP 1-50, HC 1-15)
September 1985
35×25½"
Chromacomp, New York
126

Cancer (The Zodiac) •
serigraph (1-350, I-XC, AP 1-35)
October 1982
25½×20"
Chromacomp, New York
181

Capricorn (The Zodiac) •
serigraph (1-350, I-XC, AP 1-35)
October 1982
25½×20"
Chromacomp, New York
180

Carnations *
embossed serigraph with foil stamping
(1-300, I-XXV, AP 1-8) February

1987
21¾×23½"
Chromacomp, New York
36

Carnaval †
embossed serigraph (1-300, I-XX)
January 1986
22×28"
Coriander Studio, London
52/53

Circe (The Myths Suite) *
embossed serigraph with foil stamping
(1-300, I-CL, AP 1-60, HC 1-15)
September 1985
33½×24½"
Chromacomp, New York
70

The Clasp *
embossed serigraph with foil stamping
(1-300, I-CL, AP 1-50) August 1983
42½×25½"
Chromacomp, New York
60

Cléopâtre †
serigraph (1-300, I-XX) January 1986
22×27"
Coriander Studio, London
129

Columbine *
serigraph (1-300, I-L, AP 1-40, HC
1-3) February 1983
33¼×25¾"
Chromacomp, New York
95

The Coming of Spring *
serigraph (1-300, I-CXXV, AP 1-58)
August 1982
30×24"
Studio Heinrici, Ltd., New York
142

The Contessa *
embossed serigraph with foil stamping
(1-300, I-CL, AP 1-60, HC 1-15)
June 1985
39⅛×23¼"
Chromacomp, New York
150

Copacabana *
embossed serigraph with foil stamping
(1-300, I-LXXV, AP 1-25)
September 1983
34⅛×29⅛"
Chromacomp, New York
108

The Dancer (At the Theater
Suite) +
serigraph (1-300, I-L, AP 1-50) 1983
30×22"
Coriander Studio, London
166

Daydream *
embossed serigraph with foil stamping
(1-300, I-CXV, AP 1-3) April 1986
14¾×28¾"
Chromacomp, New York
55

Debutante *
serigraph (1-300, AP 1-50, HC 1-8)
July 1983
33¼×24¾"
Chromacomp, New York
74

Deception *
serigraph (1-300, I-XXX, AP 1-16)
November 1983
33×25"
Chromacomp, New York
98

Diana (The Myths Suite) *
embossed serigraph with foil stamping
(1-300, I-CL, AP 1-60, HC 1-15)
September 1985
33½×24½"
Chromacomp, New York
71

Directoire *
embossed serigraph with foil stamping
(1-300, I-CL, AP 1-60, HC 1-7) July
1986
42¼×31¼"
Chromacomp, New York
119

Diva I (Diva Suite) *
embossed serigraph with foil stamping
(1-300, I-XL, AP 1-20, HC 1-10)
March 1984
36×28" (black paper)
Chromacomp, New York
58

Diva II (Diva Suite) *
embossed serigraph with foil stamping
(1-300, I-XL, AP 1-20, HC 1-10)
March 1984
36×28" (white paper)
Chromacomp, New York
59

Earth (The Four Elements) †
serigraph (1-175, AP I-XVII)
December 1984
23¾×20"·
Coriander Studio, London
122

Ebony and White †
serigraph (1-300, 1-50) January 1982
22×30"
Coriander Studio, London
171

The Egyptian *
embossed serigraph with foil stamping
(1-300, I-CL, AP 1-20, HC 1)

October 1986
28×30¼"
Chromacomp, New York
128

Emerald Eyes *
*embossed serigraph with foil stamping
(1-300, I-CL, AP 1-65, HC 1-20, PP
1-2) November 1985*
35×28"
Chromacomp, New York
31

Emerald Vase I *
*embossed serigraph with foil stamping
(1-275, I-XV, AP 1-4) October 1986*
44×32" (white paper)
Chromacomp, New York
26

Emerald Vase II *
*embossed serigraph with foil stamping
(1-275, I-XV, AP 1-7) October 1986*
44×32" (black paper)
Chromacomp, New York
27

Enchanted Melody *
*embossed serigraph with foil stamping
(1-300, I-CL, AP 1-50, HC 1-15)
August 1983*
42½×29¾"
Chromacomp, New York
99

Enchantress *
*embossed serigraph with foil stamping
(1-300, I-CL, AP 1-60, HC 1-35, PP
1-3) October 1986*
33×26"
Chromacomp, New York
114

Envy (The Seven Deadly Sins) •
*serigraph (1-350, I-XC, AP 1-35)
January 1983*
26½×20¾"
Chromacomp, New York
172

Evening, Night (Morning, Day,
Evening, Night Suite) *
*embossed serigraph with foil stamping
(1-300, I-CL, AP 1-50, HC 1-5) July
1985*
44×33½"
Chromacomp, New York
81

(Mysteries Through the Eyes
of The Mask)

Eyes of Jealousy *
*serigraph (1-150, I-L, AP 1-15, HC
1-2) August 1983*
25×40"
Chromacomp, New York
64/65

Eyes of Love *
*serigraph (151-300, LI-CL, AP 16-60,
HC 3-4) August 1983*
25×40"
Chromacomp, New York
66/67

Fantasia *
*serigraph (1-300, I-CXXV, AP 1-55,
HC 1-8) September 1982*

33×25"
Chromacomp, New York
110

Feather Gown *
*embossed serigraph with foil stamping
(1-300, I-CL, AP 1-50, HC 1-15, PP
1) November 1985*
29½×20½"
Chromacomp, New York
35

Fire (The Four Elements) †
*serigraph (1-175, AP I-XVII)
December 1984*
23¾×20"
Coriander Studio, London
123

The Flowered Cape °
*serigraph (1-300, I-XL, AP 1-60, HC
1-20) December 1981*
27×21"
Chicago Serigraphic Workshop
152

Fox Fur *
*embossed serigraph with foil stamping
(1-300, I-CL, AP 1-50) October 1986*
33½×26½"
Chromacomp, New York
131

Freedom and Captivity *
*serigraph with foil stamping (1-300,
I-CXXV, AP 1-70) September 1982*
32¾×24⅜"
Chromacomp, New York
184

Fringe Gown (June Brides
Suite) *
*embossed serigraph with foil stamping
(1-300, I-CL, AP 1-75, HC 1-25, PP
1-2) December 1985*
38½×30¼"
Chromacomp, New York
56

Gemini (The Zodiac) •
*serigraph (1-350, I-XC, AP 1-35)
October 1982*
25½×20"
Chromacomp, New York
181

Giulietta †
serigraph (1-300, I-L, AP 1-50) 1983
30×22"
Coriander Studio, London
175

Glamour *
*embossed serigraph with foil stamping
(1-300, I-CXXV, AP 1-75, HC 1-15,
PP 1-3) December 1985*
27¼×20¾"
Chromacomp, New York
115

Gluttony (The Seven Deadly
Sins) •
*serigraph (1-350, I-XC, AP 1-35)
January 1983*
26¼×20¾"
Chromacomp, New York
173

The Golden Calf (At the Theater
Suite) †
serigraph (1-300, I-L, AP 1-50) 1983

30×22"
Coriander Studio, London
169

The Golden Fleece *
*embossed serigraph with foil stamping
(1-300, I-CL, AP 1-60, HC 1-20, PP
1-4) August 1986*
35½×29½"
Chromacomp, New York
155

Harlequin *
*serigraph (1-300, I-CXXV, AP 1-63)
August 1982*
31×24"
Studio Heinrici, Ltd., New York
83

Harmony *
*embossed serigraph with foil stamping
(1-300, I-CL, AP 1-65, HC 1-6)
April 1986*
33×27¾"
Chromacomp, New York
164

Heart I Purple *
(Hearts and Zephyrs Suite)
*embossed serigraph with foil stamping
(1-300, I-CL, AP 1-25, HC 1-35)
July 1985*
12×12"
Chromacomp, New York
50

Heart II Red *
(Hearts and Zephyrs Suite)
*embossed serigraph with foil stamping
(1-300, I-CL, AP 1-25, HC 1-35)
July 1985*
12×12"
Chromacomp, New York
50

Helen of Troy *
*serigraph with foil stamping (1-300,
I-CXXV, AP 1-25, HC 1-30) June
1985*
35¾×31⅜"
Chromacomp, New York
109

Her Secret Admirers *
*serigraph (1-300, I-CXXV, AP 1-50,
HC 1-6) September 1982*
33×24"
Chromacomp, New York
47

L'Indifférence (The Four
Emotions) °
*embossed serigraph with foil stamping
(1-300, I-C, AP 1-50, HC 1-4)
October 1982*
22¾×17¾"
*Chicago Serigraphic Workshop
Cooke-Burger Embossing, Chicago*
157

Indochina †
*serigraph (1-350, AP I-XXXV) March
1984*
25¾×22"
Coriander Studio, London
134

La Jalousie (The Four Emotions)°
*embossed serigraph with foil stamping
(1-300, I-C, AP 1-50) October 1982*

22¾×17¾"
*Chicago Serigraphic Workshop
Cooke-Burger Embossing, Chicago*
158

Kiss of Fire (Love and Passion
Suite) *
*embossed serigraph with foil stamping
(1-300, I-CLXXV, AP 1-45, HC
1-30) August 1983*
34×29"
Chromacomp, New York
91

Kissing †
*embossed serigraph (1-300, AP I-XX)
April 1986*
27×21½"
Coriander Studio, London
92

Leo (The Zodiac) •
*serigraph (1-350, I-XC, AP 1-35)
October 1982*
25½×20"
Chromacomp, New York
181

Libra (The Zodiac) •
*serigraph (1-350, I-XC, AP 1-35)
October 1982*
25½×20"
Chromacomp, New York
182

Loge de théâtre *
*embossed serigraph with foil stamping
(1-300, I-CL, AP 1-40) January
1984*
33×27"
Chromacomp, New York
176

Love's Captive *
*serigraph (1-300, I-CXXV, AP 1-60,
HC 1-7) September 1982*
32×28"
Chromacomp, New York
140

Lust (The Seven Deadly Sins) •
*serigraph (1-350, I-XC, AP 1-35)
January 1983*
26¼×20¾"
Chromacomp, New York
173

Mah-Jongg *
*serigraph with foil stamping (1-300,
I-CL, AP 1-50, HC 1-10) February
1985*
30×40½"
Chromacomp, New York
100/101

Marriage Dance (Love and
Passion Suite) *
*embossed serigraph with foil stamping
(1-300, I-CLXXV, AP 1-45, HC
1-15) May 1984*
29×34"
Chromacomp, New York
90

Méditerranée †
*serigraph (1-300, AP 1-20) January
1986*
22×30"
Coriander Studio, London
76/77

Melisande (At the Theater
 Suite) +
*embossed serigraph (1-300, I-L, AP
 1-50) 1983*
22×30"
Coriander Studio, London
167

Melisande and Golaud *
*embossed serigraph with foil stamping
 (1-300, I-CXXV, AP 1-15, HC 1-8)
 February 1987*
31½×25"
Chromacomp, New York
154

Memories *
*serigraph with foil stamping (1-300,
 I-CXXV, AP 1-25, HC 1-10)
 December 1984*
26¼×31½"
Chromacomp, New York
136/137

La Mer blanche +
*serigraph with foil stamping (1-300,
 AP I-XX) April 1986*
22×31"
Coriander Studio, London
160/161

The Mirror *
*embossed serigraph with foil stamping
 (1-300, I-CL, AP 1-10, HC 1-3)
 December 1985*
29×24¾"
Chromacomp, New York
141

Monaco *
*embossed serigraph with foil stamping
 (1-300, I-CL, AP 1-50, HC 1-8)
 September 1986*
39×31½"
Chromacomp, New York
93

Monte Carlo +
serigraph (1-350, AP I-L) July 1983
24⅞×18⅜"
Coriander Studio, London
162

Moonlight *
*serigraph with foil stamping (1-300,
 I-CXXV, AP 1-20) April 1984*
19½×20"
Chromacomp, New York
103

Morning, Day (Morning, Day,
 Evening, Night Suite) *
*embossed serigraph with foil stamping
 (1-300, I-CL, AP 1-50, HC 1-5) July
 1985*
44×33½"
Chromacomp, New York
80

The Mystery of the Courtesan *
*embossed serigraph with foil stamping
 (1-300, I-CL, AP 1-65, HC 1-6)
 August 1986*
26×31¼"
Chromacomp, New York
45

Nature's Vanity *
serigraph (1-300, I-CXXV, AP 1-58)

August 1982
32×24"
Studio Heinrici, Ltd., New York
138

New York, New York *
*embossed serigraph with foil stamping
 (1-300, I-CL, AP 1-60, HC 1-30, PP
 1-2) February 1987*
33¾×29½"
Chromacomp, New York
163

The Nile º
*serigraph (1-300, AP 1-60, HC 1-7, PP
 1-8) October 1982*
22½×27½"
*Mark Rowland Studios, Lake Zurich,
 Ill.*
40/41

Nocturne *
*embossed serigraph with foil stamping
 (1-300, I-CXXV, AP 1-25, HC 1-25,
 PP 1-4) March 1985*
35×25"
Chromacomp, New York
143

Océan de lumière º
*serigraph with foil stamping (1-300,
 AP 1-60) November 1982*
16⅔×18¾"
*Mark Rowland Studios, Lake Zurich,
 Ill.*
174

Océan pacifique +
*serigraph (1-300, AP I-XX) January
 1986*
28×22"
Coriander Studio, London
86

On the Avenue (Metropolis
 Suite) *
*embossed serigraph with foil stamping
 (1-300, I-CL, AP 1-30, HC 1-2)
 December 1985*
25¼×29¾"
Chromacomp, New York
104

Ondée +
serigraph (1-300, I-L, AP 1-50) 1983
30×22"
Coriander Studio, London
183

Opening Night (Metropolis
 Suite) *
*embossed serigraph with foil stamping
 (1-300, I-CL, AP 1-30, HC 1-15)
 December 1985*
25¼×29¾"
Chromacomp, New York
105

Opium *
*embossed serigraph with foil stamping
 (1-300, I-CL, AP 1-50, HC 1-10)
 January 1985*
34×26½"
Chromacomp, New York
79

Oriental Tale *
*serigraph (1-300, I-CXXV, AP 1-55)
 August 1982*
30×24"

Studio Heinrici, Ltd., New York
68

L'Orientale +
serigraph (1-300, AP I-L) October 1983
29¼×22¼"
Coriander Studio, London
145

Pas de deux +
*embossed serigraph (1-300, AP I-XX)
 April 1986*
27½×22"
Coriander Studio, London
118

Pearls and Diamonds *
*embossed serigraph with foil stamping
 (1-300, I-CL, AP 1-50, HC 1-7)
 November 1986*
37¼×27½"
Chromacomp, New York
48

Perfume *
*embossed serigraph with foil stamping
 (1-300, I-CL, AP 1-50, HC 1-20)
 March 1986*
40×23½"
Chromacomp, New York
30

Phoenix Reborn (The Phoenix
 Suite) *
*serigraph (1-300, I-CL, AP 1-65, HC
 1-3) August 1983*
28×40"
Chromacomp, New York
62

Phoenix Triumphant (The
 Phoenix Suite) *
*serigraph (1-300, I-CL, AP 1-65)
 August 1983*
28×40"
Chromacomp, New York
63

Pillow Swing *
*embossed serigraph with foil stamping
 (1-300, I-CXXV, HC 1-40, AP 1-25)
 September 1985*
28¾×21"
Chromacomp, New York
151

Pisces (The Zodiac) •
*serigraph (1-350, I-XC, AP 1-35)
 October 1982*
25½×20"
Chromacomp, New York
180

Plum Blossom (Asian Princess
 Suite) *
*embossed serigraph with foil stamping
 (1-300, I-CL, AP 1-35, HC 1-3) June
 1986*
28½×20½"
Chromacomp, New York
43

Pride (The Seven Deadly Sins) •
*serigraph (1-350, I-XC, AP 1-35)
 January 1983*
26¼×20¾"
Chromacomp, New York
172

La Princesse lointaine +
serigraph (1-300, I-L, AP 1-50) 1984

30×22"
Coriander Studio, London
179

The Puppet Show *
*embossed serigraph with foil stamping
 (1-300, I-CXXV, AP 1-10, HC 1-4)
 March 1986*
29×20¾"
Chromacomp, New York
133

The Pursuit of Flore *
*embossed serigraph with foil stamping
 (1-300, AP 1-25, HC 1-5) January
 1985*
33×26½"
Chromacomp, New York
130

Queen of the Night *
*embossed serigraph with foil stamping
 (1-300, I-CL, AP 1-65, HC 1-25, PP
 1) December 1985*
28½×33"
Chromacomp, New York
148/149

Radiance (The Celestial Virtues
 Suite) *
*embossed serigraph with foil stamping
 (1-300, I-CL, AP 1-75, HC 1-35)
 November 1985*
34×26½"
Chromacomp, New York
72

Red Sea +
*serigraph (1-350, AP I-XXXV) April
 1984*
25¾×22"
Coriander Studio, London
135

Rigoletto *
*embossed serigraph with foil stamping
 (1-300, I-CL, AP 1-50, HC 1-5)
 April 1985*
38×31¼"
Chromacomp, New York
49

Rose Dancer *
*embossed serigraph with foil stamping
 (1-300, I-CXXV, AP 1-25) June
 1984*
26½×19½"
Chromacomp, New York
61

Roses *
*embossed serigraph with foil stamping
 (1-300, I-XXV) February 1987*
21¾×23½"
Chromacomp, New York
37

Sagittarius (The Zodiac) •
*serigraph (1-350, I-XC, AP 1-35)
 October 1982*
25½×20"
Chromacomp, New York
182

The Salon *
*embossed serigraph with foil stamping
 (1-300, I-VL, AP 1-3) October 1986*
21¾×29¼"
Chromacomp, New York
38

Sandstorm *
serigraph (1-300, I-LXXV, AP 1-30, HC 1-8) September 1985
27¾ × 20¾"
Chromacomp, New York
97

Scorpio (The Zodiac) •
serigraph (1-350, I-XC, AP 1-35) October 1982
25½ × 20"
Chromacomp, New York
182

Sisters *
embossed serigraph with foil stamping (1-300, I-CL, AP 1-60, HC 1-20, PP 1-3) February 1987
22½ × 28¾"
Chromacomp, New York
153

The Slave *
serigraph (1-300, I-CXXV, AP 1-70) February 1983
34½ × 26½"
Chromacomp, New York
117

Sleeping Beauty *
serigraph (1-300, I-L, AP 1-40, HC 1-3) July 1983
26½ × 33"
Chromacomp, New York
112/113

Sloth (The Seven Deadly Sins) •
serigraph (1-350, I-XC, AP 1-35) January 1983
26¼ × 20¾"
Chromacomp, New York
173

La Somptueuse †
embossed serigraph (1-300, AP 1-XX) April 1986
28 × 21"
Coriander Studio, London
139

The Spring Dress of Venus *
serigraph with foil stamping (1-300, AP 1-35) August 1983
31½ × 24"
Chromacomp, New York
147

Spring Shadows I Silver *
embossed serigraph (1-100, I-LIII, AP 1-45, HC 1-4) July 1983
32 × 31"
Chromacomp, New York
106

Spring Shadows II Gold *
embossed serigraph (101-200, XCVI-CXXV) July 1983
32 × 31"
Chromacomp, New York
107

Spring Shadows III Purple *
embossed serigraph (201-300, LIV-XCV) July 1983
32 × 31"
Chromacomp, New York
106

Spring Showers *
embossed serigraph (1-300, I-L, AP 1-30, HC 1-4) February 1984
31 × 36¾"
Chromacomp, New York
88/89

Starfish *
embossed serigraph with foil stamping (1-300, I-CL, AP 1-30, HC 1-10, PP 1) April 1986
39½ × 29¼"
Chromacomp, New York
111

Starstruck *
embossed serigraph with foil stamping (1-300, I-CL, AP 1-65, HC 1-6) December 1985
33 × 24"
Chromacomp, New York
127

Statue of Liberty, Day (Statue of Liberty Suite) *
embossed serigraph with foil stamping (1-300, I-CL, AP 1-75, HC 1-10, PP 1-4) February 1986
34⅝ × 26⅛"
Chromacomp, New York
32

Statue of Liberty, Night (Statue of Liberty Suite) *
embossed serigraph with foil stamping (1-300, I-CL, AP 1-75, HC 1-10, PP 1-10) February 1986
34⅝ × 26⅛"
Chromacomp, New York
33

Stolen Kisses *
serigraph (1-300, I-CXXV, AP 1-55) August 1982
29 × 24"
Studio Heinrici, Ltd., New York
132

Stranded *
serigraph (1-300, I-CXXV, AP 1-75, HC 1-20) February 1983
33 × 26½"
Chromacomp, New York
165

Sunrise *
serigraph with foil stamping (1-300, I-CXXV, AP 1-60, HC 1-10) March 1984
13¾ × 21¼"
Chromacomp, New York
85

The Surprises of the Sea *
serigraph (1-300, I-CXXV, AP 1-55, HC 1-6) September 1982
33 × 25"
Chromacomp, New York
46

Swept Away *
serigraph (1-300, I-CXXV, AP 1-60) February 1983
33 × 24"
Chromacomp, New York
69

The Swing *
serigraph with foil stamping (1-300, I-L, AP 1-31) January 1984
22½ × 31¾"
Chromacomp, New York
94

Symphony in Black (At the Theater Suite) +
serigraph (1-300, I-L, AP 1-50) 1983
22 × 30"
Coriander Studio, London
170

Taurus (The Zodiac) •
serigraph (1-350, I-XC, AP 1-35) October 1982
25½ × 20"
Chromacomp, New York
181

Three Graces *
embossed serigraph with foil stamping (1-300, I-CXXV, AP 1-25, HC 1-10) May 1985
33 × 24¾"
Chromacomp, New York
39

The Trapeze (At the Theater Suite) +
serigraph (1-300, I-L, AP 1-50) 1983
30 × 22"
Coriander Studio, London
168

La Traviata *
serigraph (1-300, I-CXXV, AP 1-64) August 1982
32 × 24"
Studio Heinrici, Ltd., New York
146

La Tristesse (The Four Emotions) º
embossed serigraph with foil stamping (1-300, I-C, AP 1-50) October 1982
22¾ × 17¾"
Chicago Serigraphic Workshop
Cooke-Burger Embossing, Chicago
156

The Triumph of the Courtesan *
embossed serigraph with foil stamping (1-200, I-VL, AP 1-4) February 1987
29¼ × 35¾"
Chromacomp, New York
177

Tuxedo *
embossed serigraph with foil stamping (1-300, I-CXXV, AP 1-45, HC 1-2) April 1986
30¾ × 22"
Chromacomp, New York
84

Veil Gown (June Brides Suite) *
embossed serigraph with foil stamping (1-300, I-CL, AP 1-75, HC 1-25, PP 1-9) December 1985
38½ × 30¼"
Chromacomp, New York
57

Venus *
embossed serigraph with foil stamping (1-300, I-CL, AP 1-50) June 1986
39½ × 28½"
Chromacomp, New York
75

Virgo (The Zodiac) •
serigraph (1-350, I-XC, AP 1-35) October 1982
25½ × 20"
Chromacomp, New York
182

Water (The Four Elements) †
serigraph (1-175, AP I-XVII) December 1984
23¾ × 20"
Coriander Studio, London
121

Willow Tree (Asian Princess Suite) *
embossed serigraph with foil stamping (1-300, I-CL, AP 1-35, HC 1-11) June 1986
28½ × 20½"
Chromacomp, New York
42

Winter's Arrival *
embossed serigraph with foil stamping (1-300, I-CXXV, AP 1-25, HC 1-10) June 1984
33 × 24½"
Chromacomp, New York
102

Winter Flowers *
serigraph (1-300, I-L, AP 1-25, HC 1-2) September 1983
33 × 28¾"
Chromacomp, New York
144

Wisdom (The Celestial Virtues Suite) *
embossed serigraph with foil stamping (1-300, I-CL, AP 1-75, HC 1-35) November 1985
34 × 26½"
Chromacomp, New York
73

Writer in Landscape †
serigraph (1-300, AP 1-50) June 1982
30 × 22¼"
Chromacomp, New York
116

Zephyr I Gold *
(Hearts and Zephyrs Suite)
embossed serigraph with foil stamping (1-300, I-CL, AP 1-25, HC 1-35) July 1985
12 × 12"
Chromacomp, New York
51

Zephyr II Red *
(Hearts and Zephyrs Suite)
embossed serigraph with foil stamping (1-300, I-CL, AP 1-25, HC 1-35) July 1985
12 × 12"
Chromacomp, New York
51